CW01202851

Chateaux OF THE LOIRE

Reproduced on pages 4–5: Chateau de La Ferté Saint-Aubin

Copyright © Sté Nlle des Éditions du Chêne, Paris
This edition copyright © 1992 by Thames and Hudson Ltd, London,
and The Vendome Press, New York

All rights Reserved. No part of this publication may be reproduced or
transmitted in any form or by any means, electronic or mechanical,
including photography, recording or any other information storage and
retrieval system, without prior permission in writing from the publisher.

Printed in Italy by Stige, Turin and bound in France.

Chateaux
OF THE LOIRE

Serge Chirol Philippe Seydoux

Thames and Hudson

Map

SARTHE
- Le Rocher
- **LAVAL**
- **LE MANS**
- Craon
- **CHÂTEAU GONTIER**
- Poncé
- **LA FLÈCHE**
- Le Lude
- La Lorie
- Raguin
- Le Plessis-Bourré
- Serrant
- **ANGERS**
- Montgeoffroy
- Brissac
- Langeais
- Villaudry
- Azay-le-Rideau
- **SAUMUR**
- Monsoreau
- Ussé
- **TOURS**
- **MAINE ET LOIRE**
- Montreuil-Bellay
- **CHOLET**
- **CHINON**
- Champigny-sur-Veude
- Oiron
- **CHATEAUDUN**
- Montigny-le-Ganhelon
- **LOIR ET CHER**
- **VENDÔME**
- **BLOIS**
- Beauregard
- Chaumont
- **AMBOISE**
- Gué-Péan
- Chenonceaux
- **INDRE ET LOIRE**
- Loches
- Azay-le-Ferron

Contents

Introduction	9
Amboise	16
Angers	22
Azay-le-Ferron	24
Azay-le-Rideau	26
Beauregard	30
Blois	34
Bouges	42
Brissac	46
Chambord	50
Champigny-sur-Veude	56
Châteaudun	60
Chaumont	64
Chenonceaux	68
Cheverny	76
Chinon	82
Craon	84
La Ferté Saint-Aubin	88
Le Gué-Péan	92
Langeais	96
Loches	100
La Lorie	104
Le Lude	108
Montgeoffroy	112
Montigny-le-Gannelon	116
Montreuil-Bellay	120
Montsoreau	124
Le Moulin	128
Oiron	132
Le Plessis-Bourré	138
Poncé	144
Raguin	148
Le Rocher	152
Saumur	158
Serrant	162
Sully-sur-Loire	168
Ussé	172
Valençay	178
Villandry	184
Villegongis	190
Villesavin	196
Index/Guide to the Châteaux of the Val de Loire	201
Bibliography	231

INTRODUCTION

It would be fascinating, in this age of endless search through data banks, to discover what might be retrieved for contemporary society by such a concept as the "châteaux of the Loire." First off, one would no doubt find memories of certain historical *clichés*, "plates" in old textbooks: François I receiving the Emperor Charles V in the sumptuous environment of Chambord; the beautiful Diane de Poitiers at Chenonceaux; or, at Blois, Catherine de' Medici's poison cabinets and the bloodied corpse of the Duc de Guise. One might also hope to recover those dreams susceptible to stimulation by picturesque or even fantastic architecture. Here, the expectation will surely be satisfied by the photographs of Serge Chirol. Finally, one will encounter the idea—and a profoundly accredited notion it is—that the Val de Loire is inextricably bound up with the Renaissance, or, more precisely, with the penetration into France of a new art imported from Italy.

If this book were required to have a single, overriding purpose, it would be to refute this abusive and peculiarly reductive synonymy. The abundance and plastic quality of limestone have always made the Loire Valley a country of builders, from the fortresses of Foulques Nerra at the end of the 10th century to the astonishing châteaux of Hodé in the 19th.

Poncé: A stairway vault
Opposite: The pagoda "folly" at Chanteloup

Moreover, if the Loire has indeed been the crucible from which the art of building was reborn, before maturing into the architecture *à la française* of the 17th century, the region did not owe this "revolution" solely to Italian influence, essential as it was. Favored by the presence of the court, that gestation occurred from the mid-15th century onward, through a process of assimilating into the French tradition influences from Burgundian Flanders and then, after 1495, the example of Italy. Around 1530, however, the gestation period ceased, when the court moved from the Val de Loire to the Île-de-France, taking with them the ateliers or workshops responsible for the architectural innovation.

A brief overview will permit us to establish the phases of this development.

At Doué-la-Fontaine, Anjou possesses the remains of the oldest habitable *donjon* or keep in France, whose construction archaeologists have generally agreed should be dated to around 900. Although better preserved as well as more evocative, the ruins of Langeais, in the Touraine, are slightly more recent. They originated in one of the fortified outposts that the redoubtable Foulques Nerra spread all along the frontiers of his county of Anjou.

The other *donjons* were, for the most part, reconstructed in the

Chenonceaux

Romanesque era (c.1000–c.1150). These are quadrangular structures, reinforced with huge buttresses, such as those at Montbazon, Beaugency, Le Grand-Pressigny, Montrichard, and, particularly, Loches (c.1100), which remains one of the most powerful and best preserved. A slightly later work, the keep at Châteaudun is cylindrical and, moreover, preserved from ruin by its handsome conical roof. Here we find vaulted halls, defensive galleries, stairs, and passages, even latrines and cupboards used by the garrison.

Duc d'Anjou as well as King of England, Henry II Plantagenêt transformed Chinon—where he would die in 1189—into a mighty fortress. Still, at Chinon as well as in Normandy, his sons were to find themselves dislodged by the pugnacious Philippe Auguste. Then, at Anjou, Saint Louis (Louis IX, r.1226–70) constructed a gigantic château, which has lost the crowning battlements of its towers but nothing of its force and grandeur.

The Hundred Years War, a dynastic conflict between England and France, dragged on from the English victory at Crécy in 1346 to 1453, when the French retook Bordeaux, leaving their nation the most unified in Europe. During this devastating century, the crown virtually ceased to build, but not the feudal lords. Among the sumptuous châteaux of Charles V's brothers illustrated in the renowned miniatures of the *frères* Limbourg, only the one at Saumur has come down to us, stripped of its décor yet structurally intact. Another capital work is the huge *donjon* at Sully, erected in the late 14th century, from plans by the famous Raymond du Temple, and possessed of a tall, pointed roof justifiably admired by the great 19th-century neo-medievalist Viollet-le-Duc.

Following Agincourt, when the English added political triumph to military victory, the dispossessed Dauphin found a safe haven with the Duchesse d'Anjou. He then began a life of wandering through the provinces still loyal to him—Berry and the Touraine—leading his small court back and forth between Melun, Loche, Chinon, and, soon, Amboise. Was it therefore a matter of forced absence from Paris that made the French royals so fond of the Val de Loire?

Introduction

Certainly the heir to the throne felt himself very much at ease in this environment, and it would take the will power of a Joan of Arc to set him back on the road to his capital. Yet, even when the reconquest had been achieved, Charles VII continued to revisit the Touraine and there spend blissful days in the company of Agnès Sorel.

Charles VII authorized the provincial grandees to raise the defenses of their châteaux, but also to add comfortable *logis* or living quarters. Thus, Jean de Chambes rebuilt Montsoreau, while Pierre de Brézé followed suit at Brissac. Jean de Daillon transformed Le Lude, and Pierre d'Amboise fortified Chaumont. Dunois, the celebrated "bastard" of Orléans and valorous companion to Joan of Arc, commissioned the *logis* at Beaugency, then the one at Châteaudun, which his successors would enlarge.

In Anjou, at some remove from the ongoing war, King René set the tone by increasing the number of his rural *logis*, often elementary but also elegant and comfortable. Bertrand de Beauvau, the grand master of the King's household and his companion in poetry, imitated the monarch at Pimpéan, whose chapel contains the period's most beautiful frescoes. Louis de Clermont, the royal chamberlain, rebuilt Gallerande, Gilles de Maillé and Jean de Beauvau their fortresses at Brézé and La Haute Guerche.

Louis XI (r.1461–83), who succeeded Charles VII on the throne of France, did little to improve the look of the court. Realist and politician, he distanced himself from the high nobility and relied on the services of simple but competent and devoted folk. As a consequence, it was from these "new men" that innovation would now develop. Already at Isle-Savary, Guillaume de Varye—onetime courier for Jacques Coeur, the tax collector who bankrolled the French effort against England—brought together under the same roof, around a single courtyard, both *logis* and *communs* or outbuildings (c.1460). At Le Plessis-Bourré and at Oiron (c.1465–80) Jean Bourré, master of royal finances, and Guillaume Gouffier, former master of the household to Agnès Sorel, had genuine *demeures de plaisance* built, open on to courtyards bordered by service quarters. On the exterior, however, windows remained few and the moats or fosses wide, since the countryside was far from secure. Yet, the new walls were not high, and what they enclosed had nothing in common with the somber courtyards of the fortresses erected at the beginning of the century.

At Le Plessis-lès-Tours, where he felt most at home, surrounded by his dogs and his guards, Louis XI lived in a modest *logis*, constructed of brick and embellished with a double gallery. Brick masonry—very likely the product of Flemish influence—became a veritable school at Gien, in the dwelling of Anne de Beaujeu, the King's daughter, at Jallanges in the Touraine, and in the Sologne, where the material was rare. As for the double gallery—one on the ground floor, open on to the courtyard, the other closed and providing access to the apartments on the *étage noble*, the main floor—it would become a standard feature.

As visionary as Louis XI had been realist, Charles VIII (r.1483–98) rode off for Naples to claim his Angevin inheritance from King René. Although frustrated in this mission, he would return with eyes bedazzled by the Italian Renaissance, as well as with a whole train of artisans and artists, in addition to a multitude of art works. A northern monarch had made the breathtaking discovery in the south of a new, incomparably brilliant way of life. Charles set about renovating his table, his garden, and his court; he also recognized the poor appearance of his châteaux, but could do little about it. To abandon established building practice, the King needed architects of strong personality, such as France would not see for another two generations. Was it only in the reign of Charles VIII that civilization discovered what it meant to be an architect?

Except for the gardens—inevitably lost—and a few imported sculptures, nothing at Amboise reflected the *air nouveau* brought from Italy. Moreover, Flemish influence retained its hold, thanks to the team of sculptors at work in the Saint-Hubert Chapel.

Louis XII (r.1498–1515), drawn in his own turn to Italy, this time by a claim through marriage to the Viscontis' Milan, proved slightly more innovative as a builder. At Blois, which for the duration of one reign was the center of the kingdom, Louis ordered a new *logis*. In the richness of its sculpture and the polychromy of its façades, the building remained firmly within the tradition of flamboyant, or late, Gothic. Only the motifs on the capitals in the gallery would reflect the new style, albeit in a manner still rather awkward. Lancelot du Lac and Jean de Brillac, cupbearer and head steward to the King, also persisted in their loyalty to Gothic décor at Chamerolles and at Argy. It took the per-

Brissac

sonality of Georges d'Amboise, Cardinal and Papal Legate as well as all-powerful minister of state, to begin forming major collections of sculpture and other works of art and to introduce the tramontane vocabulary into the construction work then under way at Gaillon, Meillant, and, most of all, Chaumont, where the prelate would play host to the King.

At the juncture of the reigns of Louis XII and François I, another great personality caused architecture to take a decisive step forward. Financier, clever diplomat, and a collector steeped in Classical humanism, Secretary of State Florimund Robertet brought into being at Bury, near Blois, a dwelling designed in an entirely new way, notable for the rigor of its architecture—a work of equilibrium and symmetry—as well as for the sobriety of its décor. Far more novel than the royal châteaux, Bury—unfortunately lost—was to serve as a model until the second half of the century.

From the time of his accession, François I (r.1515–47) evinced an absolute rage to build. At Blois, he undertook a new *logis*—distinguished by its monumental Gothic stairway, derived from those at Châteaudun but "dressed" *à l'italienne*—and decided, in mid-course, to enlarge it beyond the medieval wall. From this came the extraordinary façade of the loggias, inspired directly by the work of Bramante at the Vatican.

Soon, however, François I required an entirely new abode, which was to be Chambord, based on drawings by Leonardo da Vinci, the King's guest in the Loire Valley. As at Blois, the composition of the façade and the decorative program clearly came from Italy. Yet, in the four corner towers of the "*donjon*," or in the wealth and fantasy of the upper parts, Chambord recalls the medieval châteaux of the sort envisioned by the master builders of the 14th century.

The nobility shared the royal passion for stone, as witnessed by Jacques de Daillon, who transformed his Château du Lude, and François de Bouillé, the King's grand falconer, who had the Château du Rocher rebuilt. At Villegongis, Jacques de Brizay erected a dwelling based on the most ambitious prototypes. Simultaneously, however, the grandees of France revealed themselves to be remarkably attached to the traditional attributes of feudalism. It was the power of these as symbols, more than a "nationalist" reaction to the impact of Italy, that explains the persistence of a military apparatus—real or simulated *donjons*, towers, machicolations, drawbridges—by then utterly passé.

The powerful Tourangelle bourgeoisie, who managed the royal purse, also evinced a desire to make a show. Gilles Berthelot at Azay-le-Rideau and Thomas Bohier at Chenonceaux created charming country residences in which a fondness for Gothic forms became a pretext for fantastic invention of the most elegant sort. Jacques Hurault did the same at Veuil, and so too Philibert Babou at La Bourdaisière, but the criminal conviction of Jacques de Beaune-Semblançay soon inspired the financiers to more restraint. Adjacent to these great houses rose large chapels, as at Ussé, at Montrésor, and, especially, at Champigny-sur-Veude, the only one whose complete set of stained-glass windows has miraculously survived intact.

In the wake of Pavia, François I returned the court and the seat of government to Paris. De l'Orme, Lescot, Bullant, Du Cerceau, and the Italian Serlio—the whole second generation of the Renaissance, that of the architect-humanists—would work in the Île-de-France. Nonetheless, their new conception of the dwelling, as a place where imported Classicism blended with the national tradition, found its expression in the Loire region. At Villandry, pavilions replaced the corner towers of old. At Beauregard, Jean du Thier, controller-general of finances, had a double gallery built independent of the apartments and engaged the same artists as those in service to the crown, Scibec de Carpi and Nicolo dell'Abbate. At Oiron, Claude Gouffier, France's master of the horse, arranged for his long hall to be ornamented with a cycle of paintings truly royal in their quality. Finally, at Chenonceaux, Diane de Poitiers and then Catherine de' Medici summoned their favorite architects, Philibert de l'Orme for the bridge and Jean Bullant for the galleries.

Despite the taste Henri II had given her for Montceaux, the Queen preferred staying at Chenonceaux, where, right up to the darkest days of the Religious Wars, she gave free rein to her love of staging elaborate *fêtes*. On two different occasions during this grim period,

*S*aint-Ouen
Opposite: Fougères

Luyne

the Estates-General assembled at Blois, where Henri III, driven from Paris as Charles VII had been before him, ended up establishing his sad court. But Chenonceaux would provide a home for his widow, who finished her days amidst a funereal décor.
The 17th century was an ostentatious period for the Val de Loire. Maximilien de Béthune transformed Sully, a domain elevated to duchy for him. His brother Philippe rebuilt the château of Selles-sur-Cher, for which Jacques II Androuet Du Cerceau had prepared the magisterial design. At Brissac, Charles de Cossé, Duke and Marshal of France, hoped to confirm his fortune by putting up an enormous château, whose unfinished façade remains one of the most extraordinary expressions of the Baroque spirit. While encouraging Gaston d'Orléans to forget his intrigues in favor of reconstructing Blois, Cardinal de Richelieu spent a decade creating, in a remote valley in the Touraine, not only a colossal château, designed by Lemercier, but also an entire town. His minister Bouthillier copied him at Chavigny, then Guillaume Bautru at Serrant but in a Renaissance style of the most scrupulous order.
Near towns and cities, delightful *gentilhommières*—manor houses—were built with ideas found in the treatises of Du Cerceau, among them Les Grotteaux close to Blois, Vonnes on the outskirts of Tours, and, again, Le Plessis-Saint-Armand.
In these houses, a relatively plain exterior usually contrasts with the richness of the apartments, where polychrome paintings cover beams and wainscoting. The Mosniers, father and son, worked at Menars, at Cheverny, for the Marquise de Montglat, and at Beauregard, in the extraordinary gallery of President Ardier.
Brought back to life in the 17th century—by the young Louis XIV, who, for more than twenty years, made it the setting of entertainments on which Molière and Lully collaborated—Chambord did not, however, flourish in the 18th, despite the presence there of such luminaries as deposed King Stanislas of Poland, Louis XV's father-in-law, and the Maréchal de Saxe. Two other sites, however, would glitter during the reign of Louis XV, thanks to a pair of

remarkable personalities. Menars, facing the magnificent landscape of the Loire, was one, a château in which Madame de Pompadour and her brother Marigny—director of the King's buildings—employed the very best artists; and the other, Chanteloup, built for the Princesse des Ursins, but embellished by the Duc de Choiseul, who made the château the setting for a veritable court throughout long years of exile. And the construction of country mansions grew apace towards the end of the 18th century. The *fermier général*, or tax collector, Legendre de Villemorien transformed the Château de Valençay, while Leblanc de Marnaval, director of forges, built from scratch at Bouges. Other financiers sponsored construction projects at La Moustière and Saint-Senoch; Jacques de Viennay, the intendant for Alsace, at Le Grand-Lucé; Le Grand de Marizy, the grand master of rivers and forests, at Fresne; the Marquis d'Armaillé at Craon; and the Maréchal de Contades at Montgeoffroy. As for the Marquis de Sourches, high provost of France, he commissioned Gabriel de Lestrade to prepare plans for an immense country house in the Maine. Finally, at the very gates of Angers, Avril de Pignerolles, director of the illustrious riding school, erected an extremely elegant *petit Trianon*.

With the exception of Anjou, ravaged by the Vendean wars, the Revolution brought destruction only to a few places. However, it did set off considerable pillage, while also prompting impoverished owners to abandon their châteaux or even turn them over to demolishers. This was the fate of Châteauneuf-sur-Loire, Chanteloup, Selles-sur-Cher, Chavigny, and, most disastrously of all, Amboise and Richelieu.

The post-Revolutionary 19th century brought the historicized fantasies and the gardens. For the wealthy nobility turned away from politics by the accession of Louis-Philippe, Hodé in Anjou and Delarue in the Maine created numerous picturesque châteaux or "enriched" existing ones. Other architects followed their lead: Sanson at Chaumont, Parent at Le Lude and Montigny-le-Gannelon. And then there was Combreux, entirely "redressed" in a medieval style almost beyond imagining. Thanks to the quality of the climate, the gardens of the Loire attracted the very best landscape architects: Bühler at Azay-le-Ferron and Le Rocher, the Duchênes at Chaumont, Fresne, and La Bourdaisière, Édouard André at Le Lude and Chanteloup, Chouloup at Challain-la-Potherie, and, early in the present century, Dr. Carvallo, who at Villandry re-created a suite of precious Renaissance gardens, unique works of their kind.

More than three-quarters of the visitors to the Val de Loire concentrate on a mere half-dozen sites. Obsessed with mass tourism, a source of valuable foreign currency, the present policy appears to direct the flow even more narrowly towards the Blésois region. It has even been proposed that a center devoted to the Renaissance be established, a facility capable of "handling" hundreds of thousands of visitors. Lodged in an audacious structure, resembling at once a pyramid and a ziggurat, this "cultural complex" would, it is said, be planted at the very gates of Chambord, in utter contempt for ecology as well as for the very spirit of this marvelous edifice, born of the contrast between court life and wild nature, the latter an immense forested park preserved, incredibly, right into our own time. May the reader, once presented with the diversity of the *ligérien* patrimony, make the effort to leave the beaten path and attempt to discover the Val de Loire from an expanded if not renewed perspective!

*A*rgy

Amboise

The "Estates Hall" was finally restored to its original form, after having long been vaultless and broken up into apartments for prisoners of rank. Four slender columns, decorated with lilies and ermines, divide the hall into two naves.

Built like an island in the Loire or a steeply inclined buttress, Amboise proved ideal for both defense and surveillance, which long made it one of the gateways to passage along the river. In the 12th century, the triangular promontory, which had been fortified in Romanesque times, became one of the key strongholds of the Middle Loire, held by the successors of one Lisois, to whom it had been entrusted by Geoffroy Martel, son of the redoubtable Foulques Nerra, Comte d'Anjou.

Compromised in a plot against Georges de La Trémoïlle, the King's favorite, Louis d'Amboise, Vicomte de Thouars, received a death sentence in 1431 from the parliament of Poitiers, which also confiscated the whole of his estate. Charles VII allowed Louis his life but made Amboise crown property. Restored and enlarged, the château now joined those of Loches, Chinon, and Mehun as the setting for the small court of "the King of Bourges," as Charles was known during the worst days of the Hundred Years War, when the English occupied Paris.

Louis XI chose Le Plessis-lès-Tours for his own principal residence and Amboise for his family—Charlotte, the Queen, his daughter Anne, and also his young cousin, Louise de Savoie. Anne, who married Pierre de Beaujeu, was declared by her father to be "the least foolish woman in France, since he knew no prudent ones." It was she who served as regent during the minority of her brother Charles. Born at Amboise in 1470, the Dauphin had fragile health and required the full attention of Adam Fumée, the King's physician. Two remarkable educators, Jean Bourré and Jean de Daillon, kept Louis XI regularly informed of his son's condition and company. The Queen maintained a large household, including fifteen ladies-in-waiting, a dozen maids, and more than a hundred officers. Still, despite his separate arrangements, Louis XI often visited Amboise, where he instituted the Order of Saint Michael in response to that of the Golden Fleece, established by his rival, the Duke of Burgundy.

Several months before his death, Louis XI attempted to crown his victory over Burgundy by engaging the Dauphin to three-year-old Marguerite, the granddaughter of Charles the Bold. The child joined the court at Amboise, which she would leave eight years later when, for reasons of state, Charles VIII decided to marry Anne of Brittany.

All, however, would not be lost, since from the bonds formed with Louise de Savoie would come the *Paix des Dames*, or "Ladies' Peace." Charles VIII took up full residence at Amboise. Towards the end of 1492, he initiated the construction of two large towers, for both access and defense, and two main buildings joined by a chapel dedicated to Saint Hubert, the latter projecting from the western façade. It was thus from Amboise that Charles set out on his Italian campaign, which took him all the way to Naples. Despite reverses at Fornovo di Taro, he would return, at the beginning of 1496, with not only a great mass of furniture and art works but also a throng of artists from every field, as well as bedazzled memories of an incomparably more refined manner of living.

The effects of the Quattrocento on Amboise would remain slight—a few terra-cotta statues on the "Building of the Seven Virtues," pulled down in the last century, some decorative details on the upper walls, and, most of all, a terrace garden laid out by the Neapolitan Fra Pacello da Mercogliano, now, of course, completely vanished.

On 7 April 1498, Charles VIII and the Queen descended into the château's fosses on their way to the tennis court. "Even though quite short in stature," wrote Commynes, the King bumped his head violently against a lintel in one of the galleries. Nonetheless, he attended the party, only to fall back all of a sudden, losing consciousness and dying after a brief agony. Louis XII, his successor, oversaw the completion of the main building on the Loire side, as well as the galleries surrounding the courtyard at the edge of the cliff, but remained at Blois, where he had always lived. He assigned Amboise to his cousin Louise de Savoie, Comtesse d'Angoulême, and her children, François and Marguerite. Brought up at Amboise by Anne de Beaujeu, Louise transformed it into a small literary court, where she enjoyed the counsel of the old hermit François de Paule, whose canonization she would obtain in 1519.

Erected on a promontory, the château was reinforced with two round, stout towers at the end of the 15th century. They housed wide helical ramps that, together with their ribbed ogival vaults, permitted horses—as well as artillery—to gain the upper terrace.

■ *Preceding page: On the vaults of the Saint-Hubert Chapel, stone-carved rosettes and stars accent the keystones of the many ribs that spring from a canopy-like base forming a veritable frieze completely round the interior. Stained glass by Max Ingrand, narrating the life of Saint Louis, has replaced the Sèvres windows designed by Princesse Marie d'Orléans during the reign of Louis-Philippe. These had been shattered in 1940 by blasts from nearby explosions. An engraved plaque signals the presence of bones thought to be those of Leonardo da Vinci, taken from the château's Romanesque collegiate chapel when this was pulled down during the Napoleonic Empire.*

For seven years, surrounded by companions of his own age, such as Anne de Montmorency, the future François I underwent a well-balanced education, taking part in literature and sports alike as prescribed by his tutor, the Maréchal de Gié. Then, even before the Prince had turned fourteen, Louis XII engaged him to his daughter, Claude de France, and took the boy home to Blois.

The first years of François I's reign, from 1515 to 1518, would bring Amboise to the pinnacle of its glory. In recognition of the "pleasures and recreations" he had known there, the Vallois monarch exempted the town from many taxes. There too he received Leonardo da Vinci, whom he lodged in the neighboring manor of Clos-Lucé, where the great Florentine master would die in 1519. François also enlarged the wing built by Louis XII, the evidence of which can still be seen on the upper levels, with their Renaissance pilasters and dormers. Most of all, he made Amboise the scene of lavish festivities. In 1515, six months after his accession to the throne, François received his wife's claim to Milan, which served as the pretext for a wild-boar chase in the courtyard, converted for the occasion into a closed field. The animal knocked over the chests blocking a passage, broke into a hall, and charged the King, who ran him through with his sword, to the great applause of the entire court.

In 1518, the marriage of Lorenzo de' Medici, Duke of Urbino, to Madeleine de La Tour d'Auvergne coincided with the baptism of François's first son. Banquets, dances, tournaments, and jousts followed one upon the other in the courtyard, this time hung with tapestries and covered with an immense blue awning. Lorenzo de' Medici brought two paintings by Raphael—*The Holy Family* and *Saint Michael*—from his uncle, Pope Leo X, who had arranged the match. To this union was born Catherine de' Medici, for whom another Medici Pope, Clement VII, would negotiate a marriage to the Dauphin's brother, the future Henri II.

Louise de Savoie continued for some years to live at Amboise, before retiring to Romorantin and then to Nérac. It was at Amboise, on 18 October 1534, that François I found on the door to his own bedchamber a violent pamphlet, which marked the onset of *l'affaire des placards*, causing the first of the measures taken against the Reformation. In 1539, the arrival of Charles V gave rise to a new round of festivities. While the Emperor and his host were mounting the ramp in the Heurtault Tower, so illuminated by torch "that one could see almost as clearly as in open country at high noon," a tapestry caught fire and created a very inopportune panic.

Henri II and Catherine de' Medici found the air at Amboise more salubrious than at either Saint-Germain or Fontainebleau, and thus chose to have their children—natural as well as legitimate—raised there, together with the young Mary Stuart. Their governess was the Duchesse de Bouillon, daughter of Diane de Poitiers, who reigned over a mob of servants, doctors, and apothecaries.

Overlooking the Loire, the great windows of the "Estates Hall" give access to the ironwork balcony—an innovation for its time—where, following hasty trials in the hall, some of those caught in the "Amboise conspiracy" of 1560 were hanged.

■ *Opposite: Originally attached to the Queen's logis, the chapel of Saint-Hubert was erected in 1493 on a narrow, quadrangular turret projecting beyond the château's walled enclosure. Destroyed by Revolutionaries, the large figures in the tympanum relief have been replaced by images of the Virgin, Charles VIII, and Anne de Bretagne. But the lintel over the entrance, with figures representing Saint Christopher and Saint Hubert, are justly ranked among the finest works to come from the Flemish ateliers serving the courts of Louis XI and Charles VIII.*

In 1560, the court was at Blois when the Duc de Guise, lieutenant-general of the realm, learned of a conspiracy hatched by Protestant or Huguenot "malcontents" against the power he had gained over young François II and his mother, Catherine de' Medici. Guise then escorted the court to Amboise, a more easily defended château, before giving the plotters hot pursuit. The execution of the ring leaders took place in the castle courtyard, under the very eyes of the Queen Mother, François II, his wife Mary Stuart, the ten-year-old future Charles IX, the Papal Legate, and the Prince de Condé, one of the principal authors of the conspiracy.

Three years later, it was at Amboise that Catherine de' Medici, now Regent, promulgated the edict which, under certain conditions, granted freedom of worship to the Huguenot gentry.

In the early 17th century, both the castellany of Amboise and the county of Blois passed to Gaston d'Orléans, the brother of Louis XIII, the second of the Bourbon Kings. Dismantled in reprisal against that eternal conspirator, Amboise returned to the crown and became a state prison, among whose noble inmates would be the Duc de Vendôme, Superintendent Fouquet, and the Duc de Lauzun—the husband of the Grande Mademoiselle, Gaston's daughter.

At the beginning of the next century, the Duchesse de Berry commissioned Robert de Cotte to study the possibility of restoring Amboise. Louis XV gave the castellany to the Duc de Choiseul, one of the King's greatest ministers, and elevated it to peerage duchy. Choiseul's heirs sold the property to the immensely rich Duc de Penthièvre for about four million *livres*. Confiscated during the Revolution, the château was in a pitiful state when, under the Consulate, Bonaparte had it assigned to Senator Roger Ducos, onetime member of the Directory. A survey of Amboise by the architects Baragney and Chalgrin confirmed the catastrophic condition of the buildings, two-thirds of which had to be demolished.

Returned to the Duchesse d'Orléans, the château was restored by Louis-Philippe, who would spend summers there. Once again confiscated in 1848, it served as the residence of the Emir Abd el-Kader during his internment in France. In 1873, the Orléans family regained possession of Amboise, which now underwent a series of major repairs. Today, after fresh restoration of damage wrought during the defense of the Loire in June 1940, the château belongs to a foundation established by the Comte de Paris, pretender to the throne of France. ■

ANGERS

Despite the loss of its crowning features—demolished in the 16th century—the towers of the Château d'Angers bear splendid witness to royal military architecture in the era of Saint Louis. Standing forward in strong relief, they consist of masonry fashioned from local red schist, handsomely reinforced with courses of light-gray stone.

Gallo-Roman masonry, discovered a quarter-century ago, confirms the antiquity of Angers as a place of human habitation, a rocky spur overhanging the river Maine along a 100-foot stretch. Following the bishops who first occupied the château site, the counts of Anjou took possession, standing watch over the invasion routes along the rivers of western France. All about the fortress one senses the ghost of Foulques Nerra, the real source of Anjevin power at the end of the first millennium, a celebrated leader known in the chronicles for his audacity, courage, and atrocities, as well as for his sudden access of Christian humility.

Dispatched by Blanche of Castille to fend off Henry III of England, Saint Louis had the present enormous château built between 1228 and 1238. Measuring 660 meters, or 2,165 feet, long and reinforced by 17 stout towers—except on the river front protected by the natural cliff—the great wall encloses an area of more than 700 acres.

The King entrusted Anjou to his brother Charles, who soon abandoned it for his Neapolitan dream. Jean le Bon (the Good), elevated the domain to the rank of duchy before giving it to his son Louis, son-in-law of the Duke of Brittany, who had the château done over—its defenses as well as its living quarters. For his chapel he commissioned the wonderful *Apocalypse Tapestry*, executed around 1375 by the Parisian weaver Nicolas Bataille from the cartoons of the painter Hennequin de Bruges.

Louis II of Anjou continued working on the château, whose defenses he strengthened in response to advances in siege artillery. He also renovated the main building as well as the chapel, here depositing a relic of the True Cross around 1410. Yolande of Aragon, his wife, "Queen of four realms"—Naples, Sicily, Aragon, and Jerusalem—gave refuge to the unfortunate Dauphin—the future Charles VII—after he had been driven from Paris by the Burgundian *écorcheurs* ("skinners"). To his scolding mother, Isabeau of Bavaria, she replied: "A woman well supplied with lovers has no need of children. I keep him for myself." Yolande successfully held her ground and even gave Charles her daughter in marriage.

The reign of Yolande's son René, titular King of Sicily, is now remembered as a Golden Age or an Age of Peace, of the arts, painting, and *joie de vivre*, a moment in which the horrors of the Hundred Years War could be forgotten: "He seized every joy, repulsed sorrow, and cast out despair." René of Anjou had several manors

built, modest but agreeable, well-decorated places, and led his small court from one to the other. Still, he never forgot the Château d'Angers, which he embellished with pavilions, galleries, gardens, and even an aviary and a menagerie. When Louis XI forced René to abandon Anjou and retire to Provence, the castle's main building contained as many as fifty habitable rooms.

In 1562, Catherine de' Medici ordered Philibert de l'Orme to transform Angers into a powerful fortress, rewarding the architect with a living from the abby of Saint-Serge. In 1585, her son Henri III had the work reversed, for, by stripping the towers and walls of their battlements, he could deny the Huguenots a place of entrenchment. Nevertheless, artillery installed on the upper terraces during the 16th-century Religious Wars made it possible for Angers once again to play a military role a century later, at the time of the 17th-century urban revolts, especially in December 1793. Raked by cannonades, the Vendean army had no choice but to retreat.

Still under the command of the French Army, the old fortress suffered serious damage in 1944 when munitions stored there by German troops exploded. The restoration of the royal buildings—the *logis*, the *châtelet*, or gatehouse, erected by King René, and the chapel with its "angevin" vaults—occurred in tandem with the château's conversion into a museum sober enough to provide a setting for an important collection of tapestries, the centerpiece of which is the *Apocalypse Tapestry*. ∎

AZAY-LE-FERRON

A terrace planted with trimmed boxtrees leading to a beautiful landscaped park, its redesign carried out by the Bühler brothers, beginning in 1856.

An ancient seigniory dependent on the neighboring barony of Preuilly-sur-Claise, the château of Azay-le-Ferron belonged to the Turpin de Crissé family in the 13th century. At the beginning of the 15th, the King confiscated the property from Gilles de Preuilly, as punishment for his part in the rebellion of the Duc d'Orléans against his rival, the Duc de Bourgogne, then all powerful in Paris. Antoine de Preuilly, his brother and the King's chamberlain, regained the estate and restored the château, which had been damaged during the Hundred Years War.

By his marriage, Pierre Frotier became lord of Azay as well as official tutor to Jeanne de France, one of the children born to Charles VII and Agnès Sorel, while his son Prégent gained entitlement to a thousand gold *écus*. Although obliged to yield this revenue to Louis XI, Prégent finally received restitution and used the money to rebuild his château. Most notably he erected the massive, machicolated tower, which constitutes the oldest part of the present structure. Passed by marriage to Guillaume de Varie, then to Gaspard de Chamborant, Azay devolved upon Louis de Crevant, a gentleman of Louis XIII's bedchamber who became governor of Ham and Compiègne, as well as Marquis d'Humières, and died in 1628 *"en son chasteau d'Azay."* His grandson, who lived until 1695, would end up as grand master of French artillery, Marshal of France, and Duc d'Humières. In 1714, Charles-Louis d'Hautefort, Marquis de Surville, sold Azay to Louis-Nicolas Le Tonnelier de Breteuil, who overhauled the château completely. To this reconstruction is attributed the last but less important pavilion, erected during the 18th century and adorned with a pediment bearing the Breteuil arms.

Under the Directory, Citizen Louis Lecomte sold the domain, for around 875,000 francs, to Ouvrard, a military supplier and famous speculator detested by Napoleon, who nevertheless could not do without his services. Six years later, Ouvrard sold Azay to one of his colleagues, Michel Le Jeune. Having made his fortune, Le Jeune now sought to enhance it with respectability. Thus, he introduced into Azay a remarkable set of Empire salon furniture signed by Jacob, all of which remains in place.

Entirely restored in 1935, Azay-le-Ferron was left to the city of Tours by Mme Georges Hersent, *née* Luzarche d'Azay, whose family had owned the château for more than a century. ■

The originality of the château lies in the diversity of its elements, the results of what each century brought, from the 15th through the 20th. On the left, the Frotier tower dates back to the years 1480-90, but owes the shape of its tapering "pepper-pot" roof to the 16th century. Beyond the so-called "d'Humière wing" (c.1630), it finds an echo in a large Renaissance pavilion, con- *structed probably during the reign of François I, as evidenced by the style of the dormers, but modified around 1570 by the addition of substantial corner pilasters. Altered several times since the Revolution, the apartments contain interesting collections assembled by M. and Mme Hersent, notably a beautiful ensemble of furniture and décor from the beginning of the 19th century.*

Azay-le-Rideau

Medieval in its architecture, Azay is, however, entirely Renaissance in its sculpture. Here, French artists exploited the usual Quattrocento models, but with vigor, finesse, and charm, the product of a certain gaucherie in their interpretations. The corridor running through the west wing led to a footbridge that crossed the exterior moat, the latter expanded in the 19th century into a vast sheet of water. The frame about the portal reflects the quality of the sculpture, here less tampered with by restorers than the relief work on the upper walls.

If there is one building that expresses the Loire Renaissance in all its picturesque grace, it is the Château d'Azay, whose dreamlike silhouette floats on the waters of a vast lake. Having been garrisoned, like Chenonceaux, by Burgundians, the old fortified château at Azay was destroyed in 1411 by forces loyal to the King. Throughout a period of several decades, "Azay-le-Brulé" substituted for Azay-le-Rideau, a name derived from the knight-banneret Hugues Ridel, a companion of Philippe Auguste. At the end of the 15th century, Martin Berthelot acquired the major part of the Azay lands. A courtier with responsibility for finances (*Maître de la Chambre aux Deniers*) under Louis XI, and then Charles VIII, Berthelot came from a bourgeois family in Tours. His son Gilles married Philippa Lesbahy, who had inherited the rest of the Azay seigniory. Brilliant and ambitious, Gilles Berthelot became mayor of Tours in 1519. At the same time, he could also boast close family ties to Chancellors Fumée and Briçonnet, as well as to Superindendent of Finances Beaune-Samblançay, who fostered his advancement to chief financial officer for Normandy and then treasurer of France.

The Azay accounts, preserved for the years 1518–19, mention a workshop numbering 110 laborers employed in laying the château's foundations. They were abetted by 7 carpenters and 2 sawyers in charge of fashioning the wooden pilings made necessary by the marshy character of the subsoil. In the following year, Étienne Rousseau, a master mason, directed a 6-man team. The King himself came to inspect the project, the supervision of which Gilles Berthelot, owing to his official duties, soon relinquished to his wife. Always short of money, François I established a commission in 1524 to audit the accounts of his financiers, especially those of Semblançay, a man deeply involved in lucrative loans to the royal treasury, where he had placed his cousin Berthelot. The Superintendent went to the gallows at Montfaucon. As for Berthelot, he was banished and his property confiscated, shortly after which he died at Cambrai. A few years later, François I gave the Château d'Azay to Antoine Raffin, one of his old companions from the battles at Marignan and Pavia. The *logis* had not yet been completed, since the deed mentions some dozen trees to be cut from the Chinon forest for the beams.

At the end of the 17th century, Azay devolved upon Henri de Beringhen, first equerry to Louis XIV, who is believed to have built the stables. In 1791, the Marquis de Biencourt, acquired the domain. Halfway through the 19th century, his grandson and his wife became very attached to the château. They restored its dormers, finished the sculptural program for the stairway, and, most of

all, completed the courtyard façade by flanking it at either end with a fat tower on the right and a slender one on the left consistent with those at the other corners. The couple also laid out the landscape garden, right across several branches of the river Indre.
Purchased by the state at the beginning of this century, Azay was restored and refurnished from scratch with Renaissance pieces of diverse provenance. ■

Formed by two right-angled buildings capped by steep roofs and sectioned by towers and turrets, the château remains medieval as an overall form, elegant and picturesque in the extreme. The decisive feature in this fantasy décor—the chemin de ronde crowning the exterior façades—is a vestige of a military apparatus long passé by this time, thus designed mainly to flatter the pretensions of a châtelain only recently arrived.

■ *Above: The stairway constitutes the principal innovation at Azay. It is, like that at Bury, one of the first in France designed after the Italian manner of straight ramps right-turning under flat vaults. Inspired by the example at Châteaudun, the stairway façade assumes a monumental character. Within a framework of columns, niches, and pilasters, twinned bays rise through four stories to become veritable loggias, which from the beginning were free of all fenestration. The sign of the ermine, representing Claude de France, near the salamander of François I, makes it possible to date the construction before 1524, the year of the Queen's death.*

BEAUREGARD

"There is something strange but singular and great about this house that causes people of the Blésois country to call it Beauregard-le-Royal." At the time he wrote this in his *History of Blois*, during the reign of Louis XIV, Bernier must have been thinking of the "Gallery of the Illustrious," a virtually unique witness in France to the 17th century's taste for portrait collections.

Measuring 90 feet long and 18 wide, the gallery at Beauregard was built in the mid-16th century by Jean du Thier, controller-general of finances under Henri II. Yet, apart from the white marble chimneypiece, imported from Italy, the château's extraordinary décor resulted from work undertaken during the following century by the Ardier family.

Paul Ardier, who bought Beauregard in 1617, had a long career as treasurer of national savings—an extremely lucrative post—under Henri III, Henri IV, and Louis XIII. "Very capable, with a wit that charmed both in the city and at court," according to Saint-Simon—who had little affection for men of finance—Ardier played host to Richelieu in 1626, while Louis XIII stopped at Blois, and died at a great age. His son Paul, president of the chamber of audits in Paris, succeeded him at Beauregard. His granddaughter Anne married Gaspard de Fieubet, himself treasurer of national savings, who led a brilliant life before retiring, on the advice of the Abbé de Rancé. "I perish of boredom, but that is my penance," he later and often said to his visitors.

In Jean du Thier's gallery, Paul Ardier and his son had 327 portraits hung, arranged on 12 panels corresponding to the reigns of the French Kings, from Philippe VI de Valois (14th century) to Louis XIII de Bourbon. Executed by Parisian ateliers from famous models, the effigies are valuable less for their pictorial quality than for their choice of subjects. Already much admired by contemporaries, the Beauregard gallery actually reflects a methodical plan, in that not one member of the commissioner's family appears there, but instead the sovereigns and the most remarkable men of

An intimate of the Connétable de Montmorency, whose favor at court he shared, Jean du Thier utilized the same artists who worked for the King. The chapel "painted in fresco" by Nicolo dell'Abbate has disappeared. However, the little cabinet des grelots—"small bells study"—is one of the most precious examples in France of the studiolo after the Italian manner. Delivered around 1556, the paneling on the walls and ceilings is the work of Francisque Scibec de Carpi, who also created the wainscoating at Fontainebleau as well as that in the Henri II hall at the Louvre. The study takes its name from the golden grillets, or grelots, featured in Jean du Thier's coat of arms and employed as a theme in the décor. The nine allegorial paintings, with subjects borrowed from the Ulysses Gallery at Fontainebleau, were executed in 1559 by Nicolo dell'Abbate but then destroyed in the 18th century.

The "Gallery of the Illustrious" is celebrated not only for its portrait collection but also for its decorative ensemble, still exceptionally well preserved. On the beams of a ceiling à la française, painted with cartouches and vines by Jean Mosnier, blue dominates a palette composed as well of browns, reds, and gold. Jean Mosnier and his son Pierre are thought, in addition, to have painted the scenes on the wall panels—allegories, royal emblems, trophies, and religious themes.

each reign, political and military, allies and enemies. One can recognize the Black Prince under Philippe VI and Joan of Arc under Charles VII. Such a selection owed much to the book of *Eloges*, a manuscript narrating the high exploits of great persons still preserved at Beauregard. Originally, President Ardier ordered an additional 46 portraits, all devoted to the first years of Louis XIV's reign, and installed them in his father's bedchamber. These pictures disappeared at the beginning of the last century—as did the chapel and its precious paintings from the School of Fontainebleau—when the Comte de Gaucourt had the château restored, on the eve of the Revolution. Acquired during the Restoration by the Comtesse de Sainte-Aldegonde, widow of Marshal Augereau, the domain has subsequently known several different proprietors. The restoration now under way in the gallery should relieve the portraits of repaints and additions accumulated over the last two centuries. ■

"*The edifice may not be large, but it is refined and as comfortable as could be,*" *wrote Androuet Du Cerceau, the 16th-century engraver of châteaux and parks who devoted several plates to Beauregard in his "most excellent buildings in France." Executed in 1550 by Jean du Thier, the château comprised two corps de logis linked by a double gallery: one on the ground floor opening on to the courtyard through an arcade; the other, on the floor above, illuminated by windows on either side.*

At the beginning of the 17th century, Paul Ardier transformed the logis into two parallel wings. One of them was demolished in the 19th century, along with the porch tower and the chapel. The gallery was then doubled in depth and the windows restored for the sake of an overall unity.

■ *Above: The floor of the "Gallery of the Illustrious" is entirely paved in precious tiles from Delft, delivered in 1627 to M. le Trézorier de l'Épargne and laid down some twenty years later by President Ardier. Aware of the fragility of faïence—a material rarely placed on the floor—Paul Ardier took the precaution of maintaining a reserve of tiles in the attic. Together, the ceramics represent an army on the march, their order in keeping with the treatise on military art by Jacques De Gheyn.*

. BLOIS .

More than any other "château of the Loire," Blois evokes the succession of princes and kings who lived there, from the bright aftermath of the Hundred Years War through the somber days of the Wars of Religion. In this regard, the wing built by François I is exemplary: The spiral staircase, a unique work of its kind, recalls the young monarch's festive court; the secret compartments behind the wooden paneling, the ambiguous intrigues of Catherine de' Medici; and the tortuous corridors, the assassination of the Duc de Guise by Henri III's "gangsters." However, Blois is more than these. The different buildings that surround the vast courtyard constitute a veritable retrospective of monumental architecture, from the 13th century to the 17th. The house of Chatillon, which had the great hall of "the Estates" built at the beginning of the 13th century, lived at Blois until the end of the 14th century. Urged by his wife, Marie de Namur, Guy de Chatillon decided to sell the county to the ambitious Louis d'Orléans, brother of the unfortunate Charles VI, a monarch who suffered not only madness but defeat at the hands of Henry V of England. Assassinated in 1407 by his rival, Jean sans Peur (John the Fearless of Burgundy), the Duc d'Orléans left a widow, Valentine Visconti. She was the daughter of the Duke of Milan whose inheritance justified the Italian ambitions of her progeny. Louis d'Orléans also left a young son, Charles, who, having been taken prisoner at Agincourt, spent twenty-five years in England. During his absence, Joan of Arc passed through Blois, where she had her standard blessed by the Archbishop of Reims before departing with 3,000 men to lift the siege of Orléans.

Finally set free, thanks to a heavy ransom, Charles d'Orléans returned to Blois. From his marriage to Marie de Clèves, a niece of the Téméraire—Duke Charles the Bold of Burgundy—who shared his love of the arts and poetry, came a son, Louis, who would succeed to the throne of France upon the death of Charles VIII. Married by royal command to the daughter of Louis XI, Jeanne de France, Louis d'Orléans had this union annulled by the Pope in

The décor of the apartments is most notable for the restorations carried out in the last century by Félix Duban and his successors, in the historicized style associated with Rochegrosse. Vandalized by Revolutionaries, the emblems of Louis XII and François I—the porcupine and the salamander—were repaired, multiplied, gilded, and painted in vivid colors.

The Louis XII wing comprises two tiered galleries. The upper one provides a convenient outlet for the royal apartments. As to the one below, it opens on to the courtyard through wide, flat arcades (opposite) springing from pillars whose stone reliefs reflect the first manifestation in France of influence from the Italian Renaissance. Although borrowed from the Quattrocento repertoire, the motifs betray an essential Frenchness through the slight ineptitude and naïveté in their treatment. As at Montreuil-Bellay—a château still entirely Gothic—the newel post of the small winding stairs in the Louis XII wing climaxes in the harmonious burst of a "palm tree," from which springs the beautiful star vault.

■ *Overleaf: Universally admired, François I's stairway at Blois combines a traditional medieval spiral with an entirely new decorative vocabulary.*

order to marry Queen Anne, his predecessor's widow, and thus definitively link Brittany to the Kingdom of France. He chose Blois as the seat of his court and commissioned the team at work on Amboise to provide Blois with a new *corps de logis*. François de Pontbriand took charge of the project, aided by Colin Biart, the principal contractor, as well as by Jacques Sourdeau and Pierre Trinqueau, both master masons.

The brick and stone façades of the "Louis XII wing" retain all the richness and fantasy of late or flamboyant Gothic. However, the equestrian statue of the King, housed in a large niche above the

vaulted passage, is already "modern." The interior façade, on the courtyard, is even more so, with its two wide spiral staircases and its "basket-handle" arcades.

The court of Louis XIII, more brilliant than that of his predecessors, was also more populous. The staff had grown considerably, not because of the King, in whom the Venetian ambassador saw "an avaricious and withdrawn nature," but, rather, because of the Queen, Anne of Austria, who enjoyed a large income from her estates in Brittany and the Île-de-France. Louis XII had also tried to cut a fine figure when he received Archduke Philippe the Fair, son of the Holy Roman Emperor Maximilian, whom he represented at the investiture of the Duke of Milan.

The death of Anne de Bretagne, which came unexpectedly at Blois in 1514, preceded that of Louis XII by only a few months. Twenty-year-old François d'Angoulême, their son-in-law and heir, inaugurated his reign with a torrent of liberalities and fiscal exemptions, as well as the stunning victory at Marignan, since he too had been drawn by the same Italian mirage that had captivated his predecessors. After three years at Amboise, where the King had known a happy childhood and adolescence, the Valois court returned to Blois, a place dear to Queen Claude. There François I ordered the construction of the great wing that bears his name and whose apparent homogeneity conceals several intermingled campaigns. Soon neglected in favor of Chambord, the work on Blois ceased altogether once the King established his court in the Île-de-France. At Blois, François I possessed one of the period's most important libraries, a collection continually enriched with purchases made in Italy. An order issued at Montpellier in 1537 promised it a great future, since every printer would thenceforth be required to deposit at Blois a copy of every new book. But in 1544, the King decided to transfer the library to Fontainebleau, where it was to form the nucleus of the Bibliothèque Nationale.

The court repaired to Blois during the dark days of the Religious Wars. Driven from Paris, Henri III installed himself in the François I wing. It was here that, on 23 December 1588, he had his detested rival, the Duc de Guise, assassinated.

Unlike his father, Henri IV, the first Bourbon monarch, who had a gallery built at Blois, Louis XIII did not frequent the château. As soon as he got rid of the ambitious Concini, Louis forced his mother, Marie de' Medici, to live there under house arrest. In 1626, at the time of the marriage of his brother Gaston to Mademoiselle de Montpensier, the King included the county of Blois in the bridegroom's appanage. When, several years later, Louis XIII exiled Gaston, the eternal conspirator, to Blois, he vigorously encouraged his plan for rebuilding the château, as a useful outlet for his love of intrigue. However, the reconstruction had been no more than a third completed when it was suddenly halted. With the birth of the future Louis XIV, Gaston d'Orléans lost all hope of succeeding his brother—as well as all credit among his contractors. Built between 1635 and 1638 from plans by François Mansart, on the site of Anne de Bretagne's *logis* and partially on that of François I's, "the Gaston d'Orléans wing" constitutes a powerful architecture. However, it has long sheltered nothing but empty, bare spaces, except for the double vault over the stairway, the work of Michel Anguier and Simon Guillain.

Orphaned thereafter, the immense edifice had fallen into deep decay by the eve of the Revolution, when it became a billet for the Royal Comtois regiment. The Revolutionaries did not overlook the château; indeed, they sacked it and stripped away every sign of the *ancien régime*—statues, ciphers, emblems, coats of arms. Once again plans were made to demolish it, save for the Gaston d'Orléans wing, which was to have housed the prefecture. Its classification as a Monument Historique, in 1841, brought about the departure of the first troops—with the last of them not to leave for another quarter-century—and the beginning of restoration work, carried out by Duban in the "historical" style much favored during the reign of Louis-Philippe. ∎

An especially important feature at Blois is the cornice on the François I wing, a feature imported from Italy. It offers an abundance of sculpture, protected not only from weather but also from the overzealous hands of 19th-century restorers.

■ *Opposite: The sculptural reliefs on the vault of the* escalier d'honneur—*work attributed to Simon Guillain and Michel Anguier—constitute the sole witness to the décor planned by François Mansart for the Gaston d'Orléans wing.*

■ *Overleaf: Less famous than the honor stairway, the "façade of loggias" may be more original and certainly more innovative. Eager to enlarge the apartments he was preparing on the courtyard side, François I doubled the size of the* logis *already under construction by adding a parallel building, back to back with the wall of the medieval* enceinte *and overlooking the town below.*

.BOUGES.

In 1759, when Charles Leblanc de Marnaval acquired title to the beautiful lands of Bouges, "situated in the most precious climate of Berry," he was one of the region's most prominent men. An active and ambitious personage, he took over the ironworks from his father, who had come from the Marnaval forges in Champagne. To his inheritance the son added the directorship of the royal cloth mills recently created at Châteauroux. Having entered the best society in Bourges through marriage, Leblanc de Marnaval lacked only the means to "live nobly on a noble land." With his purchase of Bouges, he obtained it, for the considerable sum of 275,000 *livres*.

In the salons, the grace of the Louis XV period is evinced in boiseries of quiet elegance.

The author of the plans remains unknown, but he must have been someone knowledgeable about current styles in Paris, given the equilibrium of the volumes, the sober elegance of the façades, and the original conception of the interior space, organized around a sort of atrium illuminated by a skylight. In 1777, Leblanc de Marnaval had the honor of celebrating the marriage of his daughter to the Comte de Barbançois, a member of one of the oldest families in Berry.

Described by a contemporary document as "very old, constructed like a kind of pavilion, having a moat and a drawbridge," the château that Leblanc found could not satisfy the princely manner to which he aspired. Nevertheless, he gained permission to exercise all the feudal rights attached to the domain. Then he demolished the ancient seignorial house in order to replace it with a modern residence, a place more in keeping with the latest fashion, by its comfort as much as by the quality of its interior décor.

Was Leblanc de Marnaval too conspicuous in his display of personal wealth? He is said to have imported the Paris Opera for performances at Bouges. According other sources, even the daughters of Louis XV were scandalized by his luxury during their stay in the country for the waters at Plombières. Certainly, his *train de vie* aroused the curiosity of the intendant of finances, who, in 1773, launched an investigation of this royal tax collector. Relieved of the ironworks and then the textile mill, Leblanc soon found his estate put on the block to satisfy creditors.

Sold to the Marquis de La Roche-Dragon, who lived there quietly, the château survived the Revolution without the loss of anything

Remarkably balanced, as well as extremely sober, the façades display an "urbane" classicism, quite removed from any regional style.

more than its grillework, which disappeared into the Clavières forges. For a while Talleyrand had Bouges attached to his domain at Valençay, but then it came into the hands of Comte de Montalivet, before falling into those of Mahmoud Benaïad, onetime farmer-general, or tax collector, for the Bey of Tunis, who sought a safe haven where he could store the fruits of his rapacious harvests. Around 1880, Adolphe Dufour had the outbuildings reconstructed in a fine classical style, but at the death of his son, in 1913, he sold the estate, which resulted in the dispersal of the château's furnishings. The "rebirth" of Bouges began in 1917, thanks to M. and Mme Henri Viguier, who set about not to reconstitute but rather to re-create a décor and a suite of furniture in perfect harmony with the character of the architecture. In 1967, M. Viguier left the domain to the Caisse Nationale des Monuments Historiques, expressing the wish that it be made accessible to the public at large. ∎

With its windows opening wide on to gardens à la française, *the large salon provides the setting for a suite of Louis XVI chairs covered in flowered chintz. The other furniture—commodes, consoles, tables, and guéridons—bear the stamps of Boudin, Levasseur, Virrig, and other prestigious ebenists of the 1760s. The pale-green color chosen for the wall paneling echoes the tones of the Aubusson carpet partially covering the parquet floor.*

BRISSAC

Served by a wide flight of stone stairs, the grand apartments have preserved their beautiful beamed ceilings à la française, painted with reinceaux or vines, landscapes, and bouquets, all heavily restored at the end of the last century.

■ *Opposite: Erected on a massive foundation with sloping profiles, girded about by a noble cordon, and emblazoned with armorial cartouches, the Château de Brissac exudes a rather fierce sumptuosity and power, not unlike the character of its builder, the Maréchal de Brissac.*

An ancient fortification of the counts of Anjou, taken by Philippe Auguste and conferred upon Guillaume des Roches, the château of Brissac comprises a *donjon* or keep, moats, and a lower courtyard. Pierre de Brézé, who had it rebuilt in the mid-15th century, was not only one of Charles VII's chief ministers; he was also a brilliant military leader who perished in 1465 at the battle of Montlhéry. René de Cossé, who acquired Brissac in 1502, was a native Angevin. Pantler to the King, then grand falconer, he "reigned" over 50 men and more than 300 birds, while managing a "budget" of more than 36,000 *livres*. François I named him governor of Anjou and Maine. His son Charles, a Marshal of France like his brother Artus, distinguished himself in the Piedmont campaign and then at Le Havre. Heir to his father's offices, he persuaded Charles IX to elevate Brissac to the rank of county.

The Wars of Religion did not spare Brissac. In 1589 the old fortress fell into the hands of Henri de Navarre, the future Henri IV of France, and the following year it came under siege, as well as again in 1591. Finally breached by cannonade, the castle was condemned to demolition. Charles (II) de Cossé, governor of Paris, decided to rally behind Henri IV and open the city to the King, thereby sparing it the horrors of civil war. *Tu es sauvé, Paris*, it was written. *Ton gouverneur Brissac a gardé ton navire et du bris et du sac*.

For Charles de Cossé, royal gratitude translated into the dignity of a Marshal of France, the title of Duc de Brissac, and important gifts that, in 1611, made possible the reconstruction of the château. There the Duke would receive the Queen Mother, Marie de' Medici, who returned on several occasions. On 12 August 1620, a meeting between Louis XIII and his mother in the "Judith bedchamber" became a prelude to a brief reconciliation formalized several days later.

Charles de Cossé died the following year, heavily indebted, as much by his rebuilding as by the *fêtes* given at the château. His son failed to continue the construction work—as did his successors—even though he managed to pay off his creditors and to finish decorating the interior.

Governor of Paris like his ancestor, the eighth Duke died tragically at Versailles in 1792. Within a year revolutionaries had sacked the château at Brissac. In Year IV, the martyred Duke's nephew came into possession of the estate and had a more comfortable residence built nearby—a structure that was pulled down in 1848—as well as a Neoclassical mausoleum designed by the architect Delaunay. First restored beginning in 1844, the château underwent another restoration after 1871, a campaign carried out by the Marquise de Brissac with an excess of the "historicism" typical of the period. ■

Installed at the end of the last century by the Marquise de Brissac, née Jeanne Say, the little theater occupies a two-story space behind the southern chemin de ronde. *It was restored a dozen years ago, in all its original wealth of red and glittering gold. As a setting for the annual Val de Loire Festival, Brissac's theater has taken a new lease on life.*

■ *Above:* "Château half-constructed in a château half-demolished," *as the present Duc de Brissac often describes it, this imposing edifice presents a façade totally unlike any other of its kind. Three-quarters finished, it is organized about a stair pavilion rising to a height of some 130 feet, which, before the Revolution, was extended by a bell tower covered in lead.*

CHAMBORD

At the time of his accession to the throne, François I was only twenty years old. The young monarch inaugurated his reign with pomp and joy, distributed tax exemptions, led his army to victory at Marignan, and gave endless balls, banquets, and hunt parties. Following several years of residence at Amboise and Blois, the cradle of his childhood, François decided to create a château along modern lines, built on a fresh site. Dominico da Cortona, known as *le Boccador* in France, where he arrived among the Italian artists brought back by Charles VIII, is thought to have made a wooden model—now lost—from a design prepared by Leonardo da Vinci, François's guest at Clos Lucé, who died before work could begin on the château. Although centralized in its plan, and endowed with four fat round towers intended, as in the Middle Ages, to assert the royal power, Chambord is also perfectly regular. On the interior, the separate apartments are organized about a space reserved for festivities. Initiated in 1519, construction advanced at a good rate, thanks to the King, who often visited the building site. However, the foundations had scarcely been laid in 1524 when François issued a stop-work order.

On every floor, four great halls on cross axes open out from the central stairwell, filled with the famous helical steps, and lead separately to the apartments housed in corner towers. While these have beamed ceilings, the halls are coffer-vaulted to support the upper terraces. One can only imagine what it was like when deep-pile carpets covered the floors and silk tapestries threaded with gold and silver hung from the walls. It is estimated that some 200 tapestries joined the royal furnishings during the reign of François I. Most disappeared, together with many other treasures, when the disastrous regime of the prodigal and corrupt Directory ordered them burnt in order to obtain their gold.

He had been obliged to return to Pavia for a new battle, which would end disastrously. Released from captivity two years later, François reactivated the project, changed the construction team, and reinforced it until some 800 men were at work on Chambord. It was now that the King decided to make the planned *donjon* or "keep" a place for *fêtes* and to add a pair of towers, linked by tiered galleries, to house the chapel and his own private apartments. In 1537, the *donjon* was practically finished. Two years later, François I received at Chambord his old adversary, the Emperor Charles V, whom he permitted to travel across France in order to attain the Imperial provinces in Flanders, then in revolt. "Short cuts make human beings productive," exclaimed the Emperor. By the time François died in 1547, the King's tower had been completed, together with the galleries linking it to the *donjon* and the dormers, whose classical design stands in striking contrast to the exuberance of the dormers built earlier. Henri II had the work continued at Chambord, although more in the spirit of filial duty, since the court deserted the château, leaving the chapel tower to await its roof for another 125 years. In 1639, Louis XIII's conspiratorial

brother Gaston d'Orléans, forced to reside at Blois, commissioned François Mansart to study the possibility of restoring Chambord. Finally, Chambord gained a new lease on life under Louis XIV. The young King stayed there on July 9, 1660, while returning from his wedding. He ordered the restoration of the *donjon* and furnished the royal apartments. Soon he even decided to have stables built for as many as 300 horses, to finish the chapel wing, and to add staff facilities on the terraces, with Mansart roofs that proved aesthetically unfortunate. In all, Louis XIV and his court made nine sojourns at Chambord, during two of which Molière and Lully created *Monsieur de Pourceaugnac* and *Le Bourgeois gentilhomme*.

Abandoned in 1685, Chambord once more became a burden for the crown as heavy as it was useless. In 1725, Louis XV turned the château over to his father-in-law, Stanislas Leszczynski, the dethroned King of Poland. In 1746, Chambord found a new beneficiary, the Maréchal de Saxe, who took up residence after the victory at Fontenoy, doing so with his customary magnificence. He installed his regiment in the stables, fitted out a theater, and entertained lavishly, only to die in a duel in 1750.

When the Revolution erupted, Chambord had long since fallen into a deep sleep. After the first depredations came the sale of the furnishings. In 1792, the Department proposed to the Convention that the said château, "a vultures' nest," be replaced with fifty pavilions as the home of a "happy colony." Thanks to the architect Marie, who inflated the estimated cost of demotion, the project languished. Finally, even the royal emblems survived intact.

In 1820, during the Restoration, Comte Adrien de Calonne, minister of the interior, launched a drive to finance the purchase of Chambord for the newborn son of the Duc de Berry, the assassinated heir of the Comte d'Artois, who would reign as King Charles X (1824–30). After serving as a field hospital during the Franco-Prussian War of 1870, the château was visited the following year by the Comte de Chambord, where he called for the revival of the old royal "white flag." His heirs actively pursued the refurbishing of Chambord until the 1914–18 war, when the domain would be sequestered. Acquired by the state in 1930, the château underwent full restoration from 1947 to 1974, a task supervised by Michel Ranjard, chief architect of the Monuments Historiques. ■

Universally celebrated, the terraces at Chambord constitute a sort of enchanted village, populated by pavilions arranged about an extraordinary lantern, which was once pierced. The dormers and tall chimneystalks provided the occasion for a burgeoning décor, composed not only of sculpture, but also of polychromy, the latter thanks to the presence of slate plaques simulating marble. Originally, these were amplified by such crowning features as ridges, crests, and weathercocks in painted and gilded lead.

CHAMPIGNY-SUR-VEUDE

Although transformed by the Grande Mademoiselle in the mid-17th century, the château did not receive its large windows until the 19th century.

One must consider the size of the town of Richelieu and that of its immense château—unfortunately pulled down during the Restoration—in order to appreciate the great prestige still accorded Champigny-sur-Veude in the 17th century. The domain of the Princes of Bourbon-Montpensier constituted an obstacle to the one the Cardinal wished to create.

Having been acquired through marriage by Gaston d'Orléans, the turbulent younger son of Henri IV, Champigny came into the hands of Richelieu when the Cardinal took advantage of Gaston's disgrace, in 1635, to force the Prince to cede Champigny to him in exchange for his lands at Bois-le-Vicomte. In this, Gaston paid a heavy price, exacted by his nearly life-long habit of fomenting plots against the power of Louis XIII, his brother, and, above all, against that of the King's prime minister, whom he detested. The Cardinal set about immediately to have the château razed, but he spared the chapel, thanks, it is said, to the intervention of Pope Urban VIII.

This splendid domain had come into being a century earlier at the behest of Louis I de Bourbon, the heir of Pierre de Beauveau, lord of Champigny only in the 15th century. Shortly after his marriage to Louise de Bourbon-Montpensier in 1504, Louis de Bourbon had set upon the construction of a grand château, together with a chapel dedicated to Saint Louis and served by a college of canons. Probably interrupted by the death of Louis in 1520, construction work was recommenced by his son Louis II, whose marriage in 1538 to Jacqueline de Longwy permitted him to indulge his love of building. However, one must look to the Princess's uncle, Cardinal de Givry, Bishop of Langres, humanist, and a great connoisseur of architecture, for the source of the marvelous windows in the chapel. The realization of these stained-glass paintings must have occurred in several phases, since they contain the portraits of Henri de Bourbon and Antoinette de Joyeuse, whose marriage did not take place until 1597.

In 1656, at the end of a long suit, the daughter of Gaston d'Orléans—the famous Grande Mademoiselle—regained control of the family estate. Despite a 550,000-*livre* indemnity paid for the demolition, she decided not to reconstruct the château and, instead, to transform the outbuildings into a new *logis*.

*E*rected between 1508 and 1543, but only later given its porch designed à l'antique, the chapel must be counted among the happiest expressions of the French Renaissance. Unlike those at Ussé and Montrésor, the Champigny chapel is privileged by the survival of its stained-glass windows virtually intact (above and overleaf), works attributed to the Tourangeau glazier Robert Pinaigrier and created around 1550–60. Their iconographic program is divided into three registers: at top, episodes from the Passion, the Ascension, and Pentecost; at bottom, a gallery of portraits representing the dukes of Montpensier and the counts of Vendôme; at center, the life of Saint Louis, which unfolds in a series of grand scenes, superbly realized both in their sense of epic, deep-breathing life and in their sumptuous palette, especially the reds and blues relieved against the limestone of the surrounding walls.

Despite its amplitude and the quality of its architecture, the present château consists merely of the outbuildings to the residence erected in the 16th century by the Montpensier princes.

Halfway through the 18th century, the Maréchal de Richelieu managed to reattach Champigny to his enormous domain, but in 1825, the Duc de Richelieu, the founder of Odessa in Russia and prime minister under Louis XVIII, had the whole of his estate sold at auction. Luckier than Richelieu, Champigny was bought by the Marquis Costa de Beauregard, who thereby saved it from the *bande noire*—death at the hands of speculators and demolition experts. Alerted by Ferdinand de Lasteyrie, a glass painter, Prosper Mérimée, the author of *Carmen* but also one of France's first Inspectors-General of Historic Monuments, took account of the fragile condition of the chapel, which, for a while, encouraged the notion of reinstalling the windows in the future Sainte-Clotilde Church in Paris. Yet another emergency arose when, after the project for transforming the chapel into a parish church failed, the chapel was threatened with destruction. Had this occurred, the windows would have been transferred to the archdiocese of Tours, since they alone enjoyed protection by the Monuments Historiques. Fortunately, the purchase of Champigny by the La Roche-Aymon family led to the restoration of these precious buildings. ■

CHATEAUDUN

At the center of the vast expanse of the Beauce plateau, the Loire Valley, hollowed out by its great river, exposes several limestone cliffs that proved to be ideal for the construction of fortified sites. By the 5th century, Châteaudun, one of the steepest slopes, had already been fortified, according to Gregory of Tours. The Norman Rollon ordered its destruction in the 10th century. However, Thibault le Tricheur (the Trickster), the first Comte de Dunois, rebuilt the defenses around 935, and it was his successors who would construct the superb 12th-century keep that still dominates the entire region.

The stairway in the Longueville wing clearly reflects the new art recently imported from Italy. The first two levels of extremely tall, twinned loggias lead to the main apartments. The less developed third tier corresponds to the roof line, while the topmost pair form a sort of belvedere, entirely "gratuitous," covered with a pavilion roof, and reached by small spiral stairs housed in corbeled turrets. The flat or "basket-handle" arches announce the Renaissance, present as well in medallions, pediments, and pilasters mixed together with Gothic canopies.

interest in Châteaudun. Upon his return to France, Charles established himself at Blois and gave the county of Dunois to his half-brother, Jean, who had effectively served his cause throughout the captivity.

Born to Duc Louis d'Orléans and Mariette d'Enghien, Jean, the bastard of Orléans, came into his own as one of the most glorious of the companions to Joan of Arc. In 1451, Charles VII expressed his gratitude by bestowing upon Jean not only letters of legitimation but also the county of Longueville in Normandy. Now, Jean de Dunois and Marie d'Harcourt took up residence at Châteaudun and had the big *logis* completely rebuilt around 1460.

In 1391, Louis d'Orléans, bought Châteaudun, destined, together with Blois, to serve his ambitions. At Châteaudun he did no important building, since, for him, it was not a truly strategic place, unlike his domains in Valois, which he transformed into redoubtable fortresses. His son Charles, taken prisoner at Agincourt and then to England for a long period of captivity, showed no

On the river side, Châteaudun is resolutely military. On the courtyard side, however, tall windows with double mullions illuminate the capacious apartments, served by a spiral stairway on the exterior. At the foot of the keep, Dunois added a large chapel, whose status would soon be elevated to collegiate. François d'Orléans-Longueville, who finished the sanctuary, extended the nave by one

Châteaudun boasts one of the most beautiful donjons in France. This enormous, perfectly cylindrical tower contains two dome-vaulted rooms protected by masonry more than 13 feet thick. Within the thickness of the walls spiral the stairs (overleaf) giving access to the rooms, but also to a pair of annular defensive galleries built right around the vaults. They also climb to the topmost level, where a superb 15th-century timber frame radiates in triple, spoke formation to support a tall pepper-pot roof. The entire tower is splendidly preserved right down to the last detail, including cupboards, sinks, latrines, and vertical conduits used to lift materials and munitions.

■ *Opposite: The exterior of the Dunois wing rests on the base of the cliff, which is particularly steep at this point. The immense buttresses shouldering the severe façades rise from the river bed all the way to watchtowers projected from the chemin de ronde.*

bay in order to link the chapel to the main *logis*. Somewhat overpowered by the neighboring *donjon*, the chapel includes two levels, the first vaulted and the second roofed in open timbers. It still contains its suite of statues representing saints, all rendered in a style of incomparable nobility and grace. The figures give striking witness to the talent of local sculptors at work in France during the 15th century. Among the carved effigies, one can recognize the "prudent and wise" Dunois, accompanied by his wife, Marie d'Harcourt, as well as François de Longueville and Agnès de Savoie, portrayed with the attributes of their patrons saints.

François de Longueville also initiated the "Longueville wing," perpendicular to the "Dunois wing" raised by his father. In the new structure he installed a marvelous staircase of an entirely novel conception. It makes a wide spiral within the building—not in an exterior tower—while three generous, vaulted loggias, pierced by paired bays, flood the stairs with light. On the other hand, the flamboyant decoration of the windows and gables belongs entirely to the Gothic tradition of around 1490.

Begun in 1511 by François II de Longueville, the north wing was completed in 1532 by his brother, Cardinal de Longueville. Despite the loss of dormers, the wing remains very medieval in its organization. The stairway at the end, from about 1525, recalls the first stairs built at Châteaudun, even though it displays an interesting evolution, both conceptual and stylistic, towards the Renaissance.

The Longueville dukes, successors to the Cardinal, would virtually never reside at Châteaudun, any more than would the Luynes dukes to whom the estate passed by marriage at the turn of the 18th century. In 1723, when a fire destroyed most of the town, the Duc de Luynes allowed many dispossessed families to take shelter in the château, threatening the collapse of its overburdened floors. Stressed anew by Prussian occupation, in 1815 and again in 1870, Châteaudun had deteriorated badly at the time of its acquisition by the state in 1930. An exemplary restoration saved the place from ruin and gave it a new, interesting lease on life. ■

CHAUMONT

The incomparably sited Château de Chaumont owes its birth to Eudes, Comte de Blois, the adversary of the legendary Foulques Nerra at the beginning of the 11th century. After coming under the sway of a certain Gelduin, Chaumont entered by marriage into the Amboise family and served as the residence of its junior branch.
In the 15th century, Pierre d'Amboise made the mistake of joining the princes rebelling against Louis XI "for the public good." As a result, Chaumont was condemned in 1465 to be "burned and razed," a sentence duly carried out, according to the chronicles. However, the King pardoned Pierre and, four years later, granted him indemnities for rebuilding the château. When Pierre d'Amboise died at Meillant, in 1473, Charles, the eldest of his seventeen children, continued the reconstruction. Royal chamberlain, governor of the Île-de-France, and beneficiary of substantial gifts "for the repair and rebuilding of his castle and place at Chaumont," Pierre died prematurely in 1481.

On the towers flanking the entrance, the arms of the d'Amboise family appear together with a large decorative frieze in which the interlaced Cs of Catherine de Champignu alternate with flaming mountains, or chauds monts.

■ *Opposite: At the bottom of the interior courtyard, open since the 18th century onto the Loire Valley, the broad winding stairs are enriched with sculptural reliefs evincing the first manifestations of Renaissance art.*

Retained in Milan by his functions as "lieutenant-general beyond the mountains," young Charles d'Amboise consigned the work at Chaumont to his uncle, Georges d'Amboise, Cardinal of the Church and prime minister of France, who received the King at Chaumont in 1503. At his death in 1511, the still young Charles d'Amboise was Marshal of France and governor of Lombardy. Thirteen years later, his son would be killed in the battle of Pavia, at the age of twenty-two.
Chaumont devolved upon Catherine and then Pierre de Beaujeu, before passing to the latter's niece, who, in 1560, ceded the domain to Catherine de' Medici. It was in one of the towers at Chaumont that the Queen Mother is said to have summoned the most renowned astrologers of the age. Nostradamus would have foretold the number of years in the reigns not only of her sons but also of Henri de Navarre, whom she detested. In exchange for Chenonceaux, the Queen gave Chaumont to Diane de Poitiers, who nevertheless preferred to live

at Anet.

The Luchese banker Scipione Sardini, who had married the beautiful Mademoiselle de Lemeuil, one of Catherine's most zealous "agents," bought Chaumont for his daughters. Chosen from the Queen's famous "flying squad" to distract the redoubtable Prince de Condé from his political ambitions, Sardini's wife had acquitted herself beyond the wildest dreams of her royal patron.

In the second half of the 18th century, Chaumont became the property of the colossally rich Jacques-Donatien Le Ray, a shipowner from Nantes who brought in the Italian Nini, a ceramist specializing in profile portraits of contemporaries, terra-cottas much admired in Paris. Le Ray generously financed the American "insurgents" and played host to Benjamin Franklin. His son James founded the town of Chaumont in Ohio and managed Necker's interests in Pennsylvania.

In 1810, after being ordered by Napoleon to reside no closer to Paris than 200 miles, Mme de Staël established herself at Chaumont. There she finished *De l'Allemagne* and gathered her circle of friends, including Juliette Récamier and Benjamin Constant.

In 1875, eighteen-year-old Marie-Constance Say bought the estate "with the savings of her young womanhood." A few months later, she married Prince Amédée de Broglie, second son of the Duc de Broglie, president of the Council. The couple undertook a complete renovation of the domain. With their support, the architect Paul-Ernest Sansen "enriched" the façade and refitted the apartments in keeping with his vision of the 15th century, but as well with all the most modern comforts. He designed the extraordinary chimneypiece in the dining room, commissioned cartoons from the history painter Jean-Paul Laurens for stained-glass windows in the chapel, and placed all the objets d'art imported by the Broglie, among them a Venetian well in the courtyard and, in the "council chamber," a remarkable set of floor tiles from Palermo representing a hunt scene.

In the stables, princely luxury mingled with the most astonishing modernity—running water, main drainage, and electric lighting. The park—embellished with cedars in 1840 and enlarged by the removal of hamlets and farms—was overseen by the landscape gardner Duchêne, who succeeded in making the most of the site. A life filled with incredibly brilliant receptions and other extravagances depleted several very large fortunes. By the time the state acquired Chaumont in 1938, the domain consisted of no more than 42 acres, all that remained of what had been 600 million. ■

Rebuilt beginning in 1470, Chaumont retains the traditional look of medieval châteaux forts, complete with stout towers, crowning machicolations, low gun loopholes, and a drawbridge.

.CHENONCEAUX.

Much altered in the 18th and 19th centuries, the apartments have nonetheless retained several monumental chimneypieces. Marie de' Medici's apartment consisted of a large bedchamber, a study or cabinet with furniture upholstered in velvet and fringe, and a library, the latter projected onto one of the exposed piers and covered with a superb ceiling of polychromed coffers.

Jean Marques, lord of Chenonceaux at the beginning of the 15th century, sided with Burgundy, which caused the château on the Cher to be torched by royal troups. His son, meanwhile, supported the Dauphin, who in 1432 authorized the refortification of the site. The "Marques tower" is all that survives of this building campaign, carried out on a terreplein surrounded by moats linked to the Cher. Pierre Marques contracted a flattering alliance with the daughter of his neighbor Pierre Bérart, only to find himself installed in a hopeless ruin. As a result, he was obliged to dispose of the Chenonceaux seigniory. Although his family managed to have this transaction revoked, it was only a matter of time before creditors seized Chenonceaux in 1512. The estate was awarded to Thomas Bohier, the purchaser thwarted in 1496, who had set up at nearby Houdes manor, patiently awaiting the ruin of the Marques family.

Thomas Bohier was one of the most brilliant figures within the new "class" of administrators and financiers who were then solidifying themselves in high royal office. A native of Auvergne and a cousin of Chancellors Étienne Poncher and Antoine Duprat, Bohier became a member through marriage of the Briçonnet, one of the families closest to Charles VII as well as to his successors. Chamberlain and secretary to Charles VIII, Thomas Bohier joined the royal party for the first expedition into Italy. Back in France, he was named *général* of finances for Normandy. Subsequently, he spent several years in Milan as the envoy of Louis XII. Upon his acquisition of Chenonceaux, Bohier set about having the domain elevated to castellany; at the same time, he also initiated the building of a new residence on the foundations of the Marques's mill. Reassigned to Italy by François I—where he had been given the rather considerable responsiblity for the finances of Milan—Bohier left his wife in charge of the construction work at Chenonceaux.

In 1521, Thomas Bohier returned to Italy, this time as general treasurer for war. Following long and difficult negotiations with the Swiss mercenaries, he died in 1524, during the retreat of the

Catherine de' Medici restyled the entrance façade, reflecting the taste of the Second Renaissance, only for the changes to be undone in 1865, by Mme Pelouze, who preferred the earlier arrangement. Dismissed as "coarse," the four large caryatids added by the Queen Mother were redeployed in a clump of trees.

■ *Overleaf: The two sphinxes flanking the* grande allée *leading to the château's entrance came from the gardens of the Duc de Choiseul at Chanteloup.*

French Army. Catherine Briçonnet continued decorating Chenonceaux, but she too perished within a few years.

Their son Antoine would also become *général* of finances, but in an atmosphere no longer euphoric. Strapped for money, François I ordered an audit of his chief ministers. Antoine Bohier saw the indictment of his closest associates. His brother-in-law Louis Poncher, treasurer-general, went to the scaffold; Superintendent Semblançay was hanged at Montfaucon; Gilles Berthelot, president of the chamber of credits, survived only through flight. In 1535, at the end of eleven years of litigation, Bohier was able to retire a portion of his debt in exchange for Chenonceaux. *Grand seigneur* that he was, François I allowed the estate to be valued at 90,000 *livres*, even though it was worth only 50,000.

The King brought Charles V to Chenonceaux for the hunt, but never made it one of his residences. At the death of François, in 1547, Henri II offered the château to Diane de Poitiers, in recogni-

tion of important services rendered to the crown by her husband, Louis de Brézé. The favorite became passionately attached to Chenonceaux, and, aware of how royal gifts could be subject to review, she had the act of 1535 annulled and a new judgment made in her favor. Having prudently taken refuge in Italy, Antoine Bohier would no longer be troubled about the 40,000 *livres* thus denied the treasury.

Diane de Poitiers decided to carry out the project for a bridge planned by Thomas Bohier as far back as 1517. Her architect, the great Philibert de l'Orme, sounded the river bed, designed five arches for the bridge, and placed his brother, Jean de l'Orme, in charge of construction. From the Montrichard forest, the King provided fifty trees for building the caissons.

Henri II died in 1559 just as the bridge was being finished, but the precautions taken by Diane de Poitiers proved futile against the will of the widowed Queen. Catherine de' Medici seized Chenonceaux. Instead of the long gallery planned for the bridge, she had two tiered galleries built and made Chenonceaux her favorite residence. When the state ran into stubborn financial difficulties, she staged sumptuous *fêtes* at Chenonceaux in the hope of winning favor for her policies.

In 1560, a "mythological" festivity marked the accession of François II and Mary Stuart, at the same time that it helped to forget the horrors of the Amboise conspiracy. The fireworks shot off on this occasion would have been the first ever seen in France. A year later, the accession of Charles IX furnished a new pretext. In the gardens, which had just been created, the Queen deployed "nymphs"—ladies of the court attired in white tunics—whose assignment was to bring enemies over to her cause.

At Chenonceaux, Catherine also summoned the Queen of Navarre, to arrange the marriage of her daughter Marguerite to the future Henri IV. Ill but firm in her Protestant faith, Jeanne d'Albret took a dim view of her son's entry into this papist and dissolute court.

Intended to seal the reconciliation of her last two sons, the nocturnal *fête* of 9 June 1577 surpassed all preceding ones in cost (esti-

The parterres at Chenonceaux began under Diane de Poitiers, who, once in possession of the estate, planted along the river a vast garden of vegetables, flowers, and fruit trees, laid out in four regular triangles. To protect it from the Cher's overflow, she had the garden enclosed by stone terraces planted with willows.

■ *Opposite: Erected across the Cher for Catherine de' Medici, the galleries were divided up in the 18th century to create apartments and a small theater. During the last century, restorers cleared the galleries and recovered their original open spaces.*

mated at 200,000 *livres*) as well as in extravagance. A thousand torches illuminated the château and its gardens. Henri III, painted, powdered, and glittering with diamonds, wore a court gown deeply cut in the latest feminine fashion. Like those of his brother, the Duc d'Anjou, his *mignons* wore huge ruffs from which their heads emerged like that of "John the Baptist on a platter." As for the three Queens—the Queen Mother, the Queen Regnant, and Queen Margot of Navarre—they were enveloped in a cloud of ladies-in-waiting. A hundred half-naked young women, chosen for their beauty, served a banquet that ended as a bacchanal in the bosky dells. The fires lit along the river banks echoed those placed on small rafts in the water to illuminate the arches of the bridge.

Catherine de' Medici wanted to enlarge the château. She did modify the façade by adding the four colossal figures of Athena, Hercules, Apollo, and Cybele; she also built the long service wing known as the "Domes." But resources were in shorter supply than ever, and the temper of the times growing ever more somber. In 1587, Queen Catherine was at Chenonceaux when the overwhelming news arrived that her daughter-in-law, Mary Stuart, Queen of Scots, had been executed in England.

At the death of Catherine de' Medici, Louise de Lorraine inherited Chenonceaux, along with her mother-in-law's debts, which she paid off by selling the pearls given her by Henri III. It was at Chenonceaux that she learned of the King's assassination, and it was here that she lived out her widowhood, in rooms hung with black tapestries depicting tears, gray nuns, skulls, and bones.

Abandoned by Queen Louise's heirs, the domain did not come back to life until the 18th century. The financier Claude Dupin, a protégé of the great Samuel Bernard, bought Chenonceaux in 1732 and spent the summer months there. He had the apartments refitted and installed a small theater in the upper gallery. His daughter-in-law, Marie-Aurore, whose father was the Maréchal de Saxe, retired to Chenonceaux, which she would manage to protect from Revolutionary malice. Parties arrived in 1793 to burn the portraits and vandalize the monograms, but the local curé, who had become president of the Committee of Public Safety for Amboise,

showed up to confirm the utility of the only bridge in place between Montrichard and Bléré. The granddaughter of Marie-Aurore Dupin de Francueil, George Sand, would come in 1842 on a visit to her cousins, the Villeneuve family.

In 1864, Mme Eugène Pelouze purchased the estate. The daughter of Daniel Wilson, a Scotsman who had made his fortune bringing gaslight to Paris, she commissioned Félix Roguet to restore the château from top to bottom. His credentials included collaboration with the architect Théodore Ballu on the revivalist churches of Sainte-Clothilde and La Trinité in Paris. For the task at Chenonceaux, he recruited the talents of the sculptor Guesdon and the glass painter Steinheil.

To support the political ambitions of her brother, Daniel Wilson, Mme Pelouze renewed the tradition of *fêtes* at Chenonceaux. In 1869, she organized regattas, nautical games, fireworks, and the flight of a hydrogen balloon. After Jules Grévy won the presidency of France, the festivities redoubled until they ruined the châtelaine and caused Chenonceaux to be seized. First awarded to an American, the château was bought in 1913 by the Menier family, who still own it. ■

■ JEAN-JACQUES ROUSSEAU ■

"In 1747, we spent the autumn in Touraine, at the château of Chenonceaux, a royal house on the Cher…. One is well entertained in this beautiful place; here we were made most welcome; I grew fat as a monk. We made music all the time. I composed several trios for voice…. There is also theater. In a fortnight I wrote a three-act play…. While there I composed several other short works, among still others a piece in verse, entitled 'l'Allée de Sylvie,' the name of a path in the park on the banks of the Cher."
J.J. Rousseau. *Les Confessions* II, Book VII.

*L*ike *Azay-le-Rideau, an almost contemporary château, Chenonceaux mingles the picturesqueness of late Gothic with the delicate charm of the First Renaissance, nowhere more evident than in the crested dormers. Resting on the piers of an ancient mill, the chapel enlivens the façade with its polygonal projections (page 69). Built sixty years later, the two galleries present an almost classical façade, the majestic proportions of which tend to overwhelm the little château built by the Bohiers. The unique situation of the whole, the rapid waters of the Cher, and the ever-changing foliage of the neighboring woods combine to make Chenonceaux a dreamlike residence.*

CHEVERNY

Born to a family established in the Loire Valley since the 13th century, Jacques Hurault became treasurer for war to Louis XI, *général* of finances, and bailiff as well as governor of Blois under Louis XII. It was his son, however, who, after building a manor house on the family lands, won permission to fortify it. *Général* of finances in his own right, but compromised in the fall of Semblançay, his father-in-law, Raoul Hurault died during the siege of Naples, after which his wife was obliged to forfeit the estate.

Raoul's son Philippe repurchased the domain from Diane de Poitiers and succeeded in having it elevated to county. Nonetheless, after assuming the chancellorship of France, he would prefer to reside at Esclimont, nearer Paris. This left Cheverny to acquire its great château from Henri Hurault, who sited the new structure at some distance from the old one. The project developed with the active assistance of Henri's wife, Marguerite Gaillard de La Morinière. Commenced in 1624 under the supervision of Jacques Bougier, the overall complex had been finished by 1629, and the stairway sculptures by 1634. Elisabeth Hurault, the Marquise de Monglat, took personal charge of the décor for the apartments. The magnificent results brought words of praise from the Grande Mademoiselle, the powerful and independent daughter of Gaston d'Orléans, during her visit to Mme Hurault.

An antichamber to the King's apartment, the "armory" has preserved its monumental chimneypiece, its wall panels decorated in grisaille by the Blésois artist Jean Mosnier, and the beams of its ceiling à la française, ornamented with putti and polychromed vines.

■ *Opposite: Ablaze with the whiteness of its limestone masonry, the main façade of the château now stands at the center of an immense open lawn. A paved courtyard, framed by a gallery and a screen-wall, made it difficult to expand the façade, but ended by reinforcing its majesty. Surrounded by moats, the large side pavilions appear to lie beyond the visual field.*

The busts aligned in niches escaped Revolutionary violence thanks to Dufort de Cheverny's presence of mind. For the moment, he had the Roman emperors replaced with philosophes sans-culottes grecs.

Owing to their active military or diplomatic careers, the Hurault heirs paid little attention to Cheverny. And scarcely had the Comte d'Harcourt taken the domain off their hands when he too wanted to be rid of it, since his wife refused to leave Geneva and the care of the famous Tronchin. He offered the château—together with its attendant office of lieutenant-general for Blésois—to Dufort de Saint-Leu, master of ceremonies at Versailles, who sought a place of retreat from the court. Meanwhile, another connoisseur of fine things came forward—the Marquis de Marigny, director of the King's buildings,

Constructed of stone and barrel-vaulted, the ramps of the escalier d'honneur *are embellished with sculptural reliefs featuring such motifs as vines, military trophies, musical instruments, and falls of fruit and foliage, all realized in a manner both suave and opulent (right and opposite).*

and, as it so happened, the brother of Madame de Pompadour, who was then redoing the neighboring estate at Menars. Marigny had the structures inspected by Soufflot, drove up the bidding, but then assumed new duties and lost interest in Cheverny.

In 1765, Dufort took possession of a "superb château whose interiors must all be created." Once he had brought in furniture from Saint-Leu and added it to what was already at Cheverny, Dufort considered himself at home, after his fashion. Six weeks later, he opened "a delightful theater" in the right wing and invited not only his friend Cypierre, the intendant for Orléans, but also the entire district. He restored the façades, replaced the old windows, and systematically refitted the apartments. The work went on during the winter, while the châtelain remained in Paris, procuring all the necessary materials, among them 27 "Reformation" chimneypieces—because out of fashion—and 70 English locks made of copper.

Every summer provided the occasion for a *fête champêtre*, such as the *turquerie* given in honor of President de Salaberry, the host's brother-in-law. A verdant open-air theater consisted of columns and cabinets made of greenery and alternated in a kind of rotunda with two kiosks, one for food and the other for sweets. An Oriental spectacle, based on scenes composed by Dufort's friend Sedaine, supper, Harlequinade, fireworks, and dances unfolded by lantern light until dawn, all to the accompaniment of musicians dressed like Turks, as were the actors and the servants.

Meanwhile, Dufort neglected neither the problems of the local economy nor the inadequacies of the district's roads. Yet, come the Revolution, even good relations with his neighbors could not save Dufort from imprisonment at Blois, where he began writing his memoirs while forfeiting three-quarters of his fortune.

Sold in 1802 by Dufort's widow, the domain was recovered in 1824 by the Hurault de Vibraye family. A great hunstman like his predecessors, the last Marquis de Vibraye was also a pioneer of tourism, who dared, on the eve of World War I, to open his château to the public. His niece and nephew, the Vicomte and Vicomtesse de Sigalas, have followed his example, making Cheverny one of the great tourist draws in the Loire Valley. ∎

Above the fireplace in the large salon hangs the portrait of Marie-Jeanne de La Carr-Saumery, Comtesse de Cheverny, painted by the 17th-century master Pierre Mignard.

■ *Opposite: A veritable "holy of holies," the royal bechamber gives brilliant witness to the sumptuousness of such apartments in the mid-17th century. Sectioned in the Italian manner, the pictorial program on the ceiling narrates the history of Perseus, while the wall panels tell the story of Theagenes and Chariclea, in thirty fantasy-filled scenes.*

CHINON

Chinon owes its fame to the historic evening of 8 March 1429. Night had already fallen when Joan of Arc, just arrived from Lorraine with six men-at-arms, strode into the château's great hall, the place illuminated by fifty torches. Among the three hundred courtiers and knights gathered there, she immediately recognized the Dauphin, dressed as a simple squire in the hope of fooling her, and presented him with the message she had received from God—that he must have himself crowned at Reims and then drive the English out of France. The town of Chinon arose by virtue of the advantageous situation—the great rocky outcropping—on which the château rests. Built on the remains of a Gallo-Roman castrum, the present castle, or at least its oldest parts, dates back to work undertaken in the middle of the 10th century by Thibault le Tricheur, the Comte de Blois. Following the defeat of Thibault III in 1044, Geoffroy Martel attached Chinon to Anjou, and Henry II Plantagenêt, who was Comte d'Anjou as well as King of England, made Chinon his favorite residence. Indeed, it was he who built the château. Much distressed by his sons' rebellion, Henry died there on 7 July 1189, after having made public confession of his wrongs. In 1205, Philippe Auguste took possession of the château, where he immediately had a great cylindrical keep built, to assert his royal authority. In 1308, the *donjon* became a prison for Jacques de Molay and the high dignitaries of the Knights Templar. In the 15th century, the ill-fated Dauphin, obliged to live south of the Loire by the English, who challenged his legitimacy, divided his existence between the châteaux of Mehun-sur-Yèvre, Loches, and, most of all, Chinon. From Charles come not only the solid fortifications, designed to protect his small court, but also a *logis* suitable to his royal rank. The amplitude of the *enceinte* at Chinon and the beauty of the site, high above the town and the river Indre, persuaded him to commission a new *logis* as replete with comfort as possible. Clearly, the tragedy of the Hundred Years War need not deny him the revenge of living well.

Over 1,300 feet long and almost 230 feet wide, and endowed with a pair of wells linked to stone quarries, the Château de Chinon comprises three distinct sets of buildings, separated by deep fosses. The Tour de l'Horloge, or Clock Tower (above), which served as a gateway to the "Middle Château," is most unusual in its dimensions. Measuring 16½ feet wide and 115 feet tall, it stands high above the town like a veritable column. The tierce-pointed passage through it leads into the vast interior courtyard, bordered on the town side by the ruins of the royal logis. Some 216 feet long and reached by winding stairs, this structure contained on its ground floor the armory, the kitchen, and the wine cellar, and, on the main floor, the King's bedchamber, once known as the chambre nattée, or "matted room," because of the rug covering the floor. Then came the study, two other rooms with studies, all embellished with stone-carved chimneypieces, and latrines housed in an adjacent pavilion overhanging the moats.

"Before God, Sire," blurted La Hire, one of Charles's best captains, "I never heard of a King who so merrily lost his kingdom!"

It was to Chinon that, in 1428, Charles VII called the Estates-General from the provinces that still remained loyal to the French crown. The subsidies they provided financed the army that Joan of Arc would lead to victory. Charles frequently returned to Chinon with his court, whose glittering center was the royal favorite, Agnès Sorel, a resident of the Hôtel de Roberdeau. Again the château was the scene when, during the night of 3 June 1433, Sire de Breuil kidnapped Georges de La Trémoïlle, another royal favorite.

Louis XI named the chronicler Philippe de Commynes governor of Chinon. While Louis enjoyed hunting in the surrounding forests, his successors gradually abandoned the fortified town. Still, there came the great moment in 1498, when Louis XII received at Chinon Cesare Borgia, the son of Pope Alexander VI, who arrived wearing a doublet studded with gold and jewels and accompanied by an ostentacious retinue. More important, the legate came bearing the bull annulling the King's marriage to the unlucky Jeanne de France, daughter of Louis XI, and a Cardinal's hat for his closest minister, Georges d'Amboise.

After falling into the hands of the Huguenots in 1562, the château was again pressed into service as a state prison, this time under Henri IV. Thereafter it was left to decay, once Richelieu acquired the property, for the sake of keeping it from being appropriated by hostile parties. Occupied in 1793 by the royalist Vendeans, Chinon became the stage for one of the darkest dramas of the Revolutionary Terror—the massacre of 300 suspects by the Republican soldiers charged with conducting them to Tours.

Prosper Mérimée alerted Napoleon III to the value of the ruins and initiated the first efforts at shoring them up. ■

CRAON

The Neoclassical boiseries in the salons represent craftsmanship of a very high order.

■ *Opposite: The* escalier d'honneur *was designed and executed in the early years of this century from superb 18th-century models.*

The seat of one of the oldest baronies in Anjou, the land at Croan was enfeoffed to a certain Suhard by Foulques Nerra at the end of the 10th century. Halfway into the next century, Geoffroy Martel conferred it upon another Suhard—this one called "the Younger"—a relative of Renaud de Nevers and an ancestor of the Craon family. By the time François de La Forest d'Armaillé acquired it in 1702, the château had lost its fortifications, dismantled, together with those of the little town, on orders from Henri IV. His son François-Pierre moved into the old *corps de logis*, a structure dating for the most part to the 14th century, and died there in 1743, leaving a nine-year-old son, Pierre-Amboise. The latter grew up under the tutelage of one Petitot, the "seneschal" or steward of Craon, who endowed him with a keen sense of his seigniorial rights and a captious spirit unprepared for the rapid changes about to occur in society at large.

The fortune left him by his cousin Arroné permitted the young Marquis d'Armaillé to dream of a grand house styled in the contemporary manner. He chose a site with the Guinefort slope as backdrop, on axis with the new Pouancé road, and somewhat removed from the community whose hostility his behavior had served mainly to increase. The Marquis commissioned plans from a little-known Bordelais architect who had just finished building the modest Hôtel Picquois at Laval. Commenced in 1773, the construction work was finished three years later and the decoration of the salons in 1779. The estate records, though difficult to sort out because they include work on the Marquis's Parisian hôtel as well as on the château, nonetheless reveal the involvement at Craon of the sculptors Liottier and Bourdois—the latter a Parisian—and that of Pierre-Louis David, the father of David d'Angers. In the huge stables, the châtelain launched a stud farm with four stallions, among them the celebrated Cumberland, purchased in England for the considerable sum of a thousand guineas—that is, two-thirds of the annual revenue from the Croan lands.

Insulted and menaced by the populace on 16 August 1789, the Marquis refused to bend. However, he survived thanks to intervention by the National Guard, after which he would soon follow the prudent course of living anonymously in Paris. Requisitioned

in April 1793 as lodgings for the 150 volunteers called up in the district, the château then fell into the hands of Antichamp's Vendeans, who would themselves be dislodged in December by Westermann's "blues" (Republican troops).

After its seizure in 1798 by the Directory, the building was stripped of furnishings, appraised—with Pommeyrol taking part in the commission established for this purpose—and put up for sale. Finally, Bonaparte assigned the château to the Legion of Honor, only for it to remain empty by reason of its deteriorated condition. The stables, on the other hand, gained a new population of stallions, whose growing number—from 3 in 1807 to 29 in 1811—reflected the insatiable needs of the Grand Army. Here, then, was the origin of the famous "Craon races," which began in 1848.

In 1826, the Marquis de Champigné acquired the domain. His daughter-in-law, following the death of her husband, had the beautiful park *à l'anglaise* laid out from plans prepared by the landscape gardener Chatelain. Her guests at Craon included Louis Veuillot and Dom Guéranger. Restored in 1900 by Alain de Champagné, the château long remained the home of his widow, who, as the Marquise d'Andigné, would have the terraces redesigned *à la française*. Today, Craon belongs to her nephew, the Comte Louis de Guébriant. ∎

Built with an extremely white Saumurois stone, Craon has all the elegance of Louis XVI mansions constructed for members of the court. Profoundly classical in both its fore-part and its low wings, the garden façade is nonetheless quite original. At its lateral extremities, the façade curves gracefully away to conclude in wide corner pilasters crowned with trophies. Sculpture plays an important role here, not only in the Classical deity on the pediment at the center of the garden façade but also in the masks, garlands, and swags ornamenting windows and pilasters.

La Ferté-Saint-Aubin

Left unfinished since the 17th century, the corps de logis is in two parts: on the left, the "little château," thought to have been commissioned by François de La Ferté-Senneterre, at the end of the 16th century; on the right, the "big château," undertaken in the 1620s by the Marquis de La Ferté-Senneterre in a totally different manner. Here, slender limestone pilasters contribute to an overall effect of grandeur, whereas the rich design of the dormers evokes the last fires of the Renaissance. In the superb outbuildings framing the forecourt (c. 1670), the end pavilions house several master apartments and service quarters.

"A cannonade could not have done more," wrote the Marquis d'Argenson in his *Mémoires* concerning the extortions committed in 1748 by the armies of Marshals de Saxe and de Löwendal. "The Maréchal de Löwendal is ruined," he added. "He owes God and everybody else. He has bought the duchy of La Ferté-Senneterre, with its big dilapidated château, orangery, waterworks, etc., all of it in dreadful condition and falling to pieces." This view of things is probably a bit extreme. In any event, de Löwendal was so ecstatic at being close to the Maréchal de Saxe, his comrade in arms installed by Louis XV at nearby Chambord, that he immediately had the Château de La Ferté rehabilitated, installed in the courtyard a pair of cannons given him by the King, and began living on a grand scale. "Drowning in debts," he would nonetheless swim clear by the time he died.

An ancient holding of the powerful d'Estampes family, the land of La Ferté owed its reputation to a military man scarcely less brilliant though certainly less prodigal—the Maréchal de La Ferté-Senneterre. At the end of the 16th century, Louise d'Estampes, granddaughter of the secretary of state Florimond Robertet, died without issue, leaving La Ferté to her Aunt Saint-Nectaire. Around 1620, Henri de Saint-Nectaire, Marquis de La Ferté-Senneterre, ambassador and minister of state under Louis XIII, had initiated the construction of the château along grandiose lines and laid out the courtyards, forecourts, and perspectives in all their majestic order.

His son Henri had distinguished himself in every field of battle, from the siege of La Rochelle to Rocroi and Flanders. Elevated to Marshal of France in 1651, he decided eleven years later, at the death of his father, to retire upon his estate at La Ferté, soon raised to the status of peerage duchy. He commanded a great fortune, augmented by that of his wife, Madeleine d'Angennes—one of the *dames de La Loupe* celebrated by Bussy-Rabutin and Tallemont des Réaux, in their inimitable fashion—but failed to renew work on the *corps de logis*, which had ceased with his father's death. Instead, he preferred adding a pair of large blocks of outbuildings for stables, coaches, and small apartments.

Upon his death in 1681, "*en son chasteau de La Ferté*," the Marshal left the domain to his son. Married to the daughter of Maréchal de La Mothe-Houdancourt and a brilliant lieutenant-general in his own right, the heir would succumb prematurely some twenty years later.

The dining room owes its Louis XVI character to revisions carried out at the end of the 18th century by Nicolas Bertrand.

Nicolas Bertrand, who purchased La Ferté from the Maréchal de Löwendal, had nothing of the military about him. Gentleman of the royal hunt, he had made his fortune in naval armaments and had created a momentary sensation at court by arriving with a small albino African named Maponde in tow.

Bertrand left La Ferté to his nephew, Charles de Coué, who emigrated when the Revolution broke out. Saved from pillage and dispersal, thanks to a loyal servant named Laurois, the château would devolve upon Julienne d'Argy, Comtesse de Talleyrand-Périgord.

In 1822, François Masséna, Prince d'Essling—the son of the Maréchal d'Empire—bought La Ferté. In 1862, he was succeeded by Mme Andrieu, who built the chapel. In 1874 came M. Dessalles, who commissioned a new sanctuary in memory of his son and installed an orphanage in the outbuildings. Other owners were the Comte Hyacinthe O'Gorman in 1911, M. d'Hoffelize in 1947, and finally, in 1987, M. Jacques Guyot, who restored the domain, a considerable task, and opened it wide to the public. ■

LE GUÉ-PÉAN

Lord of Gué-Péan at the turn of the 16th century, Nicolas Alamand also owned at Châtellerault the seigniory of Châtelet, where he had a fine Renaissance mansion built in the 1520s. Because of his involvement with the Tourangeaux financiers, he was charged along with Semblançay and indicted for having misappropriated funds from the Cloth of Gold meeting between François I and Henry VIII of England. The prosecution ended only with his death, which came unexpectedly in 1527.

The disgrace seems not to have caused his son François great hardship. Named controller-general for France's *gabelles*—or salt taxes—in 1535, François became, fifteen years later, the second president of the chamber of audits. Although his duties compelled him to live in Paris, he took an active interest in Le Gué-Péan. In 1543, François arranged for the seigniory to be elevated to castellany and undertook a complete reconstruction of the château.

Jean Alamand succeeded his father, not only at Le Gué-Péan but also as counselor to the audits chamber. In 1584, he had two masons employed at Le Gué-Péan, "according to plans drawn up by Jehan Du Bourg, master mason living at Orléans." The structure must have been essentially complete by that time, since the chimneypiece in one of the towers bears the date 1581.

François Alamand, counselor to the parliament of Paris, and his wife, Charlotte de Prie, had the central block rebuilt, while the left wing would be reconstructed by their daughter Catherine and her husband, François de Picques, majordomo to Louis XIV.

Jean-Hippolyte d'Estampes, who purchased the domain in 1676, made no important changes in the château, nor did the Marquis Amelot de Chaillou, who succeeded him at the time of the Revolution.

In 1832, Baron Alphonse de Cassin moved into Le Gué-Péan, laid out and landscaped the park, and inaugurated the splendid hunts that would continue for more than century. Sold to realtors, the château has been restored by its present owner, beginning in 1961. ∎

Opening fully on to both the courtyard and the valley, the apartments retain their beautiful stone chimneypieces. On the one in the main salon, an eagle, garlands, and putti have been combined with the cipher FACP, which stands for Charlotte Alamand and François de Picques (c.1650), as well as for François Alamand and Catherine de Prie (c.1610).

∎ *Opposite: The superb timber frame within the left tower supports a picturesque, bell-shaped roof à l'impériale. It rests on a corbel table buttressed by a series of carved consoles simulating machicolations.*

*I*solated in the valley of a Cher tributary, which once fed several large ponds in an extremely beautiful, landscaped park, the château remains medieval in its quadrilateral plan sectioned by round towers. Erected in the second half of the 16th century, the entrance façade reflects the influence of the First Renaissance, but departs from that tradition by continuing to display such military features as two short towers with casemates or pillboxes and two corner towers pierced with low gun loopholes. The principal corps de logis—probably rebuilt at the beginning of the 17th century—joins at right angles a wing whose Gothic window is a vestige of an earlier residence.

LANGEAIS

Extremely sober, the garden façade is enlivened only by narrow window bays terminating in sharply pointed gables and three apsidal, polygonal towers enclosing spiral stairs.

■ *Opposite: On the interior, several large halls have preserved their monumental chimneypieces. The floor pavements of glazed tile were reconstituted after 15th-century models, but the credences, chests, stalls, and beds are authentic, as are the 15th- and 16th-century tapestries in a splendid collection assembled by M. Siegfried. Of particular interest is the marriage chamber of Charles VIII and Anne de Bretagne, which has now been elaborately re-created.*

Founded on a promontory formed by the little valley of the river Roumer, at the opening of the Val de Loire, Langeais originated in one of the oldest stone keeps in France. From that rough edifice, built on a square plan right across the spur, there remain only two faces—east and south—but nothing of either the vaults or the chimneypieces. The famous Foulques Nerra would have built this primitive redoubt in the second half of the 10th century, when he was fortifying the frontier of Anjou against his adversary, the Comte de Blois.

However, Langeais is best known for its *château fort*, one of the finest examples of late medieval architecture in its ultimate phase, the noble silhouette rising high above the town. The Plantagenêts had strengthened and enlarged the early château, which Richard Lion-Heart garrisoned with a substantial force. Nevertheless, Philippe Auguste made himself master of Langeais in 1206. Bitterly fought over during the Hundred Years War, the place was condemned by the English "to be razed and pulled down, save for the Great Tower." Louis XI decided to rebuild Langeais, this time at the end of the promontory. He assigned the project to Jean Bourré, who brought in master builders from Amboise. Construction proceeded apace in the years 1465–67, as we know from the accounts of Jean Briçonnet, *général* of finances, which survive for this period. A first campaign quickly produced the corner towers and the two *corps de logis* set perpendicular to one another, while a second campaign realized the entrance, with its drawbridges, portcullis, and stout tower. Although erected after the last major battles of the Hundred Years War, which had established the determining role of artillery, the château at Langeais remained true to the type of castle defined at Pierrefonds at the end of the 14th century. Thus, its towers and walls are very high, thick, and battered or sloped at the base. Moreover, defense focused on the level the square-notched machicolations, or corbeled parapet, whose continuous gallery—the *chemin de ronde*—faciliated the deployment of the garrison at any point along the tops of the ramparts and towers.

Work at Langeais stopped short of the west wing and the wall that was to have closed the courtyard on the north side. The rapid evolution of siege techniques put paid to the military importance of the château. The King dismissed the construction team and

attempted to "humanize" the apartments by increasing the number of large windows. The monumental chimneypieces in the large halls date from this period. One of them is ornamented with flamboyant arcature, another decorated with pampres, or vines, and fanciful crenellations alive with tiny figures, as in the celebrated palace of Jacques Coeur in Bourges.

On 6 December 1491, the great hall provided a setting for the marriage ceremony of Charles VIII and Anne de Bretagne. Come from Le Plessis-lès-Tours, the young King had taken care that the rooms of the fortress be furnished with carpets and tapestries. The fifteen-year-old Duchess arrived wearing a cloth-of-gold dress trimmed in otter and sable, and carrying in her baggage two sumptuous beds. The powerful Louis d'Amboise, Bishop of Albi, had done everything possible to hasten the ceremony, even before granting the required cononical dispensations, in order that the union of Brittany and the Kingdom of France become irrevocable.

Other monarchs would stop at Langeais as they moved about the Loire Valley, but none was ever to live there again. Let to various tenants, the château survived the Revolution relatively unscathed. In 1886, M. Jacques Siegfried purchased Langeais, had it restored, and filled it with an exemplary collection of furniture and tapestries from the late Middle Ages and the 16th century. Bequeathed to the Institut de France, the château constitutes one of the best witnesses to court life in France before the upheaval brought by the Renaissance. ∎

LOCHES

Extending along a cliff some 1,600 feet above the course of the Indre, Loches gives the appearance of an acropolis. On its north side, the château abuts the old town; within, it contains the royal logis built in the 14th century and enlarged at the end of the 15th, as well as the collegiate church of Notre-Dame—today Saint-Ours—whose towers and high domes make for quite an original silhouette.

Driven from Quercy, the 5th-century hermit Saint Ours took refuge at Loches, by which time the promontory overlooking the river Indre may have already served as a northern outpost of the Visigoth nation. And it remained so in the 9th century when Charles le Chauve (the Bald) bestowed the site upon a henchman named Allard, an ancestor of the the Counts of Anjou who would fortify it massively. Shortly before the year 1000, Geoffroy Grisegonelle founded at Loches the collegiate church of Notre-Dame—now the church of Saint-Ours—after which his successors were to make the château one of their securest retreats, a place where the terrible Foulques Nerra locked up prisoners of rank. Constructed around 1100, then encircled with a chemise and further fortified by Henry II Plantagenêt, the *donjon* at Loches was considered so impregnable that Philippe Auguste decided to avoid it at the time of his penetration into Berry and the Touraine. Soon the capture of Richard Lion-Heart yielded him an opportunity to gain control of Loches through the Treaty of Mantes. Upon his liberation, however, the English King rejoined the mercenaries who were laying siege to the castle. Finally, he took it but only after a mighty struggle against 220 defenders.

When Philippe Auguste renewed his offensive in 1204, Dreux de Mello arrived to besiege Loches, only to pass the entire winter marking time below the high walls. The royal army had to intervene before the château could be seized, in April 1205, which confirmed the recovery of Touraine by France. Granted to Dreux de Mello, Loches remained a prime stronghold, one that Saint Louis preferred to reclaim for the crown.

Loches did not, however, become a royal residence at this time, for, while situated well away from the frontiers, it lacked the *logis* essential to the lavish comforts required by the Capetians. Not until the reign of Charles VII did Loches once again play a role in the drama of the monarchy. Being close to the theater of military operations, during the Hundred Years War, Loches, with its modest *logis*, proved suitable enough for the modest court maintained by the "King of Bourges," and its defenses, once strengthened with the Martelet fort and a new keep, called the *Tour Neuve*, sufficed to protect the uncrowned sovereign from the assassins' hands.

Two illustrious women arrived to rouse Charles from his torpor. In 1429, Joan of Arc inspired him to undertake the reconquest of France. Then, beginning in 1444, it was Agnès Sorel who "reigned" over the King. Far from the Dauphin, who detested her, she transformed Loches into a "house" worthy of a princess, an establishment managed by Guillaume Gouffier. La Sorel gave banquets prepared by the chef Guillaume Tirel—known as Taillevent—and launched fashions so daring and costly that they brought down the wrath of Bishop Jouvenel des Ursins. However, they also made the

 *A*dded by Richard Coeur de Lion, after the siege of 1194, the great jutting towers were reinforced by Philippe Auguste as soon as he finally captured the fortress in 1205. Beyond the ramparts looms the donjon of the Dukes of Anjou, which constitutes one of the most formidable military structures erected in the Romanesque period. A quadrilateral measuring 82 feet by 45, it is protected by masonry walls almost 10 feet thick at the base, and strengthened above by 132-feet-high buttresses. A ruin since the 16th century but well preserved in its overall masses, Loches lacks only its four floors, its roof, and its crown of wooden sentry walks.

■ *Overleaf and opposite: Executed around 1450 by a royal atelier, the gisant of Agnès Sorel rests on the tomb that Charles VII had carved in memory of his favorite. It was mutilated in 1794 by Revolutionaries and then restored in 1806. Although meant for the collegiate church, the gisant has now been placed in the royal logis. Worked with incredible finesse, the marble—so polished as to suggest alabaster—matches and even enhances the elegance of the model herself.*

fortune of Jacques Coeur, her supplier of rare furs and fine fabrics. Following the death of Agnès Sorel near Jumièges, in 1450, it was in the collegiate church of Loches that Charles VII had his mistress' sumptuous tomb erected.

Louis XI spent his first ten years at Loches, undergoing the remarkably balanced program of education prepared for him by the distinguished Gerson, chancellor of the University of Paris. It consisted of mornings devoted to study and afternoons to physical and military exercise. Louis departed Loches in 1433, after the crown had repossessed Amboise, and never returned. His wife, Charlotte de Savoie, came alone, grieving over her loveless marriage. As for the King, he turned the sinister "Martelet" into a prison for great personages. Already incarcerated under Charles VII, the Duc d'Alençon found himself reconfined to Loches. Cardinal Jean Balue, the son of a simple Poitevin miller convicted of treasonous allegiance to Charles the Bold of Burgundy, endured eleven years in one of the famous *fillettes du roi*, tiny cages made of wooden bars reinforced with iron. It took intervention by Pope Sixtus IV to gain his release.

In the Martelet, Louis XII also imprisoned Lodovico Sforza, the illustrious Duke of Milan, captured under the walls of Novara. A characteristic figure of the Renaissance, with his mixture of tyrannical cruelty and refined humanism, the prisoner arrived at Loches in 1506 and died there two years later. He supposedly demanded brushes in order to paint the scissors—or *sforze*—that can still be seen on the walls of his cell.

François I seldom came to Loches. Nevertheless, it was in the royal *logis*, enlarged by Anne de Bretagne, that the King received Charles V on 12 December 1539. Taking a short cut through France on his way to the rebellious Netherlands, the Emperor was lavishly entertained by his chivalrous adversary. Immediately thereafter, the old château fell out of favor, its prestigious detainees replaced by prisoners of war. After Louis XVI decided to support the American Revolution, he used Loches as a place of internment for the English. ∎

La Lorie

Restored after having been garrisoned by Revolutionary troops, the ground floor, which was once divided into billiard and dining rooms, is now one long gallery opening simultaneously on to the courtyard and the garden.

Réné Le Pelletier, who commissioned La Lorie in the second quarter of the 17th century, had enhanced his status as high provost of Anjou with that of master of the King's household. Ruined by high living, Le Pelletier saw his domain sold in 1661 to satisfy creditors, but then knocked down to his son-in-law, Gabriel Constantin, who would also fall heir to the role of high provost.

At the end of the 18th century, Charles Constantin, the Marquis de La Lorie, made his château a magnet for the cultural and social life of Anjou. A great traveler, highly educated, and intellectually curious, he generously opened La Lorie to anyone who counted in the province—most of all to pupils at the famous equestrian school of Angers.

Eager to expand the château's outbuildings—stables, carriage houses, agricultural buildings—the Marquis organized the structures about two lateral courtyards on either side of the majestic forecourt "defended" by balustrades and dry moats.

A similar concern for grandeur and symmetry governed the transformations brought to the park side. The chapel, projecting from the *logis* on the right, had already been handsomely furnished in the Louis XV manner.

Constantin also redid the façades in a discrete, Neoclassical style, while, on the left of the main courtyard, erecting a pavilion parallel to the chapel and designed to enclose an astonishing "marble salon." With this he gave the reign of Louis XVI one of its most sumptuous creations.

On the walls of the vast room, flooded with light from tall door-windows crowned by semicircular arches, red marbles from Laval and blue-gray ones from Sablé contrast with the whiteness of the Baveno marble pilasters and overdoor stuccos. Giltwood garlands and falls of flowers and medallions *à l'antique*, all adorning both trumeaux and windows, further enhance the quality of the composition, while the dome at the center of the ceiling increases its volume.

Occupied by Republican troops in December 1793, when the Vendeans were threatening Angers, the château and its outbuildings provided shelter for as many as 800 men, who not only billeted there but also installed their field equipment.

Restored by the Marquis de Marmier, *né* Constantin de La Lorie, the domain entered a new period of brilliance under the Second Empire, when the Duc de Fitz-James installed a stud farm.

Later neglected, the château underwent a fresh restoration during the first years of the present century. To create a setting for some remarkable boiseries from the château of Vitry-sur-Seine, the Marquis de Saint-Genys added a new dining room in a Neoclassical pavilion styled after the manner of the Hôtel de Salm in Paris. ∎

The "marble salon" bears the date 1780, engraved on the star-patterned floor tiles designed and laid in by Italian artisans. As for the original furniture, fortunately saved during the Revolution, it includes not only thirty pieces for sitting—canapés, marquises, bergères, fauteuils, chaises, and footstools—but also consoles and the Italian-style mantelpiece, all ordered in 1770 from the Parisian master ebenist Pluvinet.

La Lorie

*B*uilt of local schist in a somber color, the château was subsequently renovated and enlarged with limestone from the Loire, the whiteness of which contrasts dramatically with the original dark material. The outbuildings were designed at the end of the 18th century to endow a rather simple logis, erected in 1640, with a bit more grandeur. Asked to remodel the park at the beginning of this century, Édouard André cleverly but subtly shifted masses of earth in order to create broad terraces defined by balustrades and large vases and planted as parterres or lawns.

■ *Above: The small salon next to the* salle de marbre *retains the intimacy of its original scale.*

LA LORIE

Le Lude

An Angevin outpost, Le Lude belonged to Foulque Nerra at the beginning of the 11th century, when it was besieged by the Duke of Brittany. The property then passed by marriage to the lords of Beaumont-sur-Sarthe before devolving, along with the domain of Sainte-Suzanne, upon Agnès de Beaumont, who married Louis de Brienne, third son of the Crusader King of Jerusalem (1253). It was at this time, in the 13th century, that the château acquired its overall plan and shape: four mighty towers—originally six—at the corners of a regular quadrilateral, surrounded by wide fosses.

The Hundred Years War cast Le Lude in a role of primary importance. In 1370, Guillaume de Méron, the captain in charge of the site, managed to hold off the English forces led Robert Knolles, then leading a virtual death march across France. In 1425, following the disaster at Agincourt, the Earl of Warwick conquered the Maine and took possession of Le Lude, which he then bestowed upon William Blackborne. But two years later, Ambroise de Loré and Gilles de Rais, with their band of Dauphin partisans, laid siege to the château and succeeded in taking it, at the end of an *eschelade*—bombardment—by artillery.

In 1443, Jean de Daillon, who married Renée de Fontaine, lady of Le Lude, was a native of Poitou. Although originally in the camp of Dauphin Louis, he chose to side with Charles VII, who made him his counselor as well as his chamberlain. At the King's death, the vindictive actions of the new monarch forced Jean de Daillon into seven years of hiding. But with his return to grace in 1468, he entered a period of extraordinary favor. Louis XI—for all his inveterate plotting—would soon speak of him as "his comrade and master Jean of every skill." The sovereign appointed him captain of a hundred field lancers, governor of Alençon, then bailiff of Contentin and a reconquered Artois (1477), in addition to showering him with benefits, among them the viscounty of Domfort.

On the interior, the architect Louis Parent took advantage of existing elements—ceiling beams and ribbed vaults painted à la française—to create one of the most extraordinary neo-Gothic and neo-Renaissance ensembles of the late 19th century. Well preserved in the vivacity of its gilts and colors, the décor includes authentic "bravura touches," such as the monumental carved chimneypieces, the wrought-iron grillework, and the newly restored circular stairs.

By the time of his first wife's death in 1457, Jean de Daillon had found the means to repurchase the lands of Le Lude. In 1468 he launched a complete restoration of the château, in ruins since a siege in 1427, and did so with the aid of Jean Gendrot, master builder to King René of Anjou. It was at this time that Le Lude received its north façade, Gothic still.

Only in the era of his son Jacques would the structure be graced by the new art arriving from Italy. Commenced around 1514, the southern façade survives as one of the most remarkable fruits of France's First Renaissance. Seneschal of Anjou, as his successors would also be, Jacques de Daillon was, first and foremost, a military man, who would distinguish himself in 1522 during the defense of Fontarabia. He was also gravely wounded at Pavia

Le Lude

(1525) but died in 1532 "in his house at Illiers." His son Jean, Comte du Lude, oversaw the completion of the façades on the inner courtyard, in a style more representative of Henri II's reign.
In 1598, François de Daillon played host to the first Bourbon monarch, Henri IV, at Le Lude, and, in 1619, he also received Louis XIII, who was journeying into the Touraine for an encounter with his mother, Marie de' Medici. François's son, Timoléon, abandoned the royal court for retirement upon his lands, where he continued to live in a very grand manner, as reflected in the 650-foot terrace that he had built on the edge of the Loir.
Henri de Daillon, on the other hand, seldom visited Le Lude. Grand master of French artillery, and eventually Duc du Lude (1675), he had married Eléonore de Bouillé, lady of Le Rocher, who earned a reputation in the countryside for daring horsemanship.
When M. du Velaer, director of the Compagnie des Indes, acquired the domain in 1751, the château had remained virtually uninhabited since the death of the Duc du Lude in 1685. The new châtelain ordered the place put right and began to invite all manner of company. On the eve of the Revolution, he left the estate to his niece, the Marquise de La Vieuville, who commissioned Barré—the Maréchal de Contades's architect at Montgeoffroy—to rebuild the wing facing the river and the entrance to the château. As a result, the east façade and the west portico are thoroughly Louis XVI in style.
The Marquis de Talhouët—son-in-law of Comte Roy and minister of finance to Louis XVIII—inherited the domain under the Restoration. His son Auguste, minister to Napoleon III, engaged Delarue and Jules de La Morandière to rehabilitate the château, a campaign that would be renewed on a major scale by Louis Parent, beginning 1880, with the collaboration of Édouard André in the gardens. Some thirty years ago, the Comtesse René de Nicolay, *née* Princesse d'Orléans-Bragance, joined with local actors and dancers to produce the first of the historical pageants that would become a veritable school at Lassay and Le Puy-du-Fou. ■

Less tampered with by restorers, except for the upper parts, the façades of Le Lude juxtapose an extreme diversity of styles: the classical ordering of the architect Barré, on the Loir side; delicate elegance of France's First Renaissance, accented by the precious medallions à l'antique *and facing the parterres of the terraced gardens.*

■ *Page 109: The great treasure of Le Lude, the paintings in the* cabinet—*a studiolo or oratory—of the Renaissance wing were discovered and brought to light in 1853. Under a vault papered with grotesques modeled on the Vatican loggias—a mingling of putti, naiades, flowers, and fruits—unfolds a cycle of scenes taken from the Bible and the* Trionfi *of Petrarch, the latter suggested by a work in the collection of Jacques de Daillon.*

MONTGEOFFROY

Montgeoffroy holds a unique place among the great houses of the Loire Valley. Still intact since its construction, this château, more than any other, provides a sense of how *a grand seigneur* lived in the country at the end of the 18th century.

The son of a lieutenant-general of the royal armies, Louis-Georges de Contades joined a guards regiment at the age of fifteen and thereupon began a brilliant military career. Commander of French forces in Germany during the Seven Years War, and a Marshal of France in 1758, he went on to suffer a grave setback at the battle of Minden (1759), without, however, losing the confidence of Louis XV. Appointed governor of Alsace, he spent twenty-five years in Strasbourg, which did not prevent his ordering, in 1772, the reconstruction of the Château de Montgeoffroy, a property acquired by his grandfather at the end of the 17th century. Thanks to a precious journal of accounts, one can sort out the various expenses, which came to a total of 300,000 *livres*. Of particular interest is the source of the masonry, identified as sandstone from Baugé for the platform foundations, hauled in by road, and tuff stone from Chênehutte for the façades as well as limestone from Montigné for the stairs and balustrades, both delivered by water. Built between 1772 and 1776, the château and its outbuildings utilize the foundations—and probably the structural walls—of the previous edifice, from which the chapel and two towers have been preserved. Designed by the Parisian architect Jean-Benoît-Vincent Barré, the sober and even majestic arrangement of the *corps de logis* mingles a stylish Neoclassicism with certain curious archaisms favored by the Marshal. However, the steep roof simply reinforces what is a most unusual three-story elevation.

Occupied with his duties in Strasbourg, the Marshal left his son in charge of the construction team, led by the Angevin master Simier

Arranged in a double enfilade *opening on to each of the façades, the salons occupy the center of the* corps de logis. *On the east, the boiseries carved with military trophies identify the apartment as the one belonging to the Maréchal de Contades. It faces the courtyard near the service quarters. The apartments of the ladies Hérault (see opposite)—the mother and grandmother of the* conventionnel *(Hérault de Séchelles)—occupy the opposite corner, facing the park. Among the paintings at Montgeoffroy are two superb still lifes by Desportes, a portrait of Louis XIV given by the King to the Marshal's father, and a portrait of young Hérault de Séchelles executed by Hubert Drouais.*

working from plans drawn up by Barré. Meanwhile, his daughter-in-law, Julie-Victoire Constantin de Marans, oversaw the decoration of the interior and the selection of furniture, ordered from Gourdin, Garnier, Roussel, and other great Parisian ebenists of the Louis XVI period.

Marie-Jean Hérault de Séchelles often came to Montgeoffroy for a visit with the Marshal's grandchildren. The death of her father, Colonel de Séchelles, from sword wounds sustained at Minden, had profoundly affected the Marshal, who may very well have been the dead officer's natural father. After his schooling under the Oratorians at Juilly, Hérault de Séchelles became, at the age of eighteen, the King's legal representative at the Châtelet, and, later, attorney-general at the Parliament of Paris, owing to the favor of the Queen, Marie-Antoinette. Brilliant and ambitious, but also cynical and provocative by nature, he enthusiastically embraced all the new ideas leading to the Revolution. Although president of the Jacobin Club, then of the Convention, and a member of the Committee of Public Safety, he eventually antagonized Robespierre and Saint-Just, with the result that he perished on the scaffold along with the followers of Danton. While briefly imprisoned, the Marshal died in 1795, at the great age of ninety-two, without ever again seeing his native Anjou. ∎

The cour d'honneur derives its form from an older building that survives in plan only. The forecourt commands a wide view of the Loire Valley, sectioned by three long allées fanning out from the wrought-iron gate. In the outbuildings, the kitchen contains a complete batterie or set of copper and pewter utensils; the carriage houses, old vehicles and sedan chairs; and the saddle room, a full range of not only saddles but also harnesses and whips.

Montigny-le-Gannelon

Inside the turret, a wide set of spiral stairs coils its way up or down under a décor of stars, roses, and various attributes (above and opposite).

Admirably situated on the slope of a plateau, overlooking the Loir and a vast landscape of marshes and ponds, the château originated as *Mons Ignis*, a fortified outpost like so many in the Middle Ages, strategically located on high points from which alerts could be signaled with fire flashed from summit to summit. As for Gannelon, he was not the traitor in the *Song of Roland* but rather an abbot of Saint-Avit de Châteaudun, treasurer for the powerful monastery of Saint-Martin de Tours and owner of the Montigny lands in the mid-11th century. Gannelon's nephew and heir became the first of the lords of Montigny—one of the strongest castellanies in the Dunois—who would succeed one another until 1391.

Rebuilt following damage wrought by the armies of Henry II Plantagenêt, the château, like those at Blois and Châteaudun, was acquired by Louis d'Orléans, who in 1404 conferred it upon Guyot de Renty, his chamberlain and the issue of one of the most illustrious houses in Artois. A dozen years later, the garrison at Châteaudun arrived to torch and dismantle the building, thereby making it useless to the English, who now controlled France north of the Loire following the debacle at Agincourt. The reconstruction carried out in the last quarter of the 15th century was the work of Jacques de Renty and Marguerite de l'Espine.

After it passed by marriage to the Fromentières family, the Montigny castellany was broken up, leaving the château subject to all the problems of joint ownership. In 1656, Louis du Raynier managed to reconstitute the estate on very advantageous terms, while preferring to live in his château at Droué. The Comtesse de Fiennes, his granddaughter, found herself hard-pressed to bear the rising costs of maintaining the property. Finally, Adélaïde de Fiennes, the last of the Renty line, had no choice but to liquidate all her holdings. Sold by its creditors, the Montigny domain finally devolved upon Claude Thiroux d'Ouarville, thanks to feudal rights exercised by his father, Pierre Thiroux de Langey, counselor to the King's cabinet and a formidable litigator.

Again owing to marriage, a cousin of Aimée Dubuc de Rivery, the heroine of *La Nuit du Serail*, came into possession of Montigny. Briefly, the château also belonged to the Comtesse Castellofield—the wife of Manuel Godoy, the favorite of the Spanish sovereigns then exiled by Napoleon to Compiègne and Valençay (1807–14)—as well as later to the Comte de La Ferronnays, minister to the Restoration monarch Charles X (r.1824–30).

Prince Adrien de Montmorency, Duc de Laval, who acquired Mon-

The upper turret, fashioned or bonded of brick and stone, is cinctured by an elegantly twisted rope.

tigny in 1831, had achieved a brilliant diplomatic career under the Restoration. He redid the château in the historicized "Troubadour" style so dear to the Romantic age, and added a dining room large enough to display the full-length portraits of Louis XVIII, Charles X, and all the sovereigns to whom he had been accredited.
In 1886, on commission from Comte Sigismond de Lévis-Mirepoix, the architect Clément Parent rebuilt the east façade, overlooking the valley, in a stunning neo-Gothic style.

Along with very beautiful 18th-century rooms, the apartments in the Château de Montigny offer a particularly vivid historical museum in the form of a portrait gallery featuring not only the Montmorency family but also Chateaubriand, Madame Récamier—a very dear friend of Adrien de Montmorency, whom she visited at Montigny in 1836—Chevalier de Lévis, Monseigneur de Laval, both leading pioneers in Canada, and Robert de Montesquiou, a "key" figure in Proust's great *roman à clef*. ∎

A composite structure, the Château de Montigny-le-Gannelon owes much of its beauty and charm to a rather particular site on a cliff overlooking the Loir, as well as to the picturesque character of the renovations made there in the neo-Gothic period. The façade on the park side—fortunately untouched by restorers—has retained the overall order given it by the 15th-century master builder.

MONTREUIL-BELLAY

Erected at the outset of the 15th century behind a 13th-century barbican—one of the best preserved from that period—the châtelet *was renovated and enlarged by Guillaume d'Harcourt, at the same time as the construction of the large collegiate church.*

A veritable walled city, isolated from the adjacent town by a deep moat, the château spreads over nearly a thousand acres, surrounded by an *enceinte* reinforced with thirteen towers. Originally linked to the municipal ramparts as well as to fortifications in the Thouet Valley, this defensive system was so vast that it just missed being cleared away during the last century, by a local government convinced that it posed an obstacle to both economic development and railway communication.

Founded on the site of a Gallo-Roman *oppidum*, the enclosure began as a keep erected by Foulques Nerra, who wanted to protect his county from its neighbors in the Aquitaine. In 1025, the redoubtable Comte d'Anjou entrusted the site to a certain Berlay—or Bellay—whose descendants succeeded him to the very end of the Middle Ages. When one of the Bellays sought to break free of his vassalage, Geoffroy Plantagenêt laid siege to the place in 1150 and, after a long struggle, took possession of it. Following the truce signed in 1224 by Louis VIII and the Comte de Thouars on behalf of the King of England, Guillaume de Melun, the Bellays' heir, had the present *enceinte* built, reinforcing it with towers and a very interesting barbican. Well preserved, this outlying circular structure protects the entrance *châtelet* or gateway on the town side.

At the beginning of the 15th century, Guillaume de Melun, Comte de Tancarville, had the defenses modernized, a campaign evident in the *châtelet* and in several of the *enceinte* towers. His grandson Guillaume d'Harcourt made the castle his favorite residence during the reign of Louis XI. On the back of the *châtelet*, he constructed a *logis*, a large collegiate church, and several lodgings for canons. He also ordered the construction of a *château neuf* above the Thouet Valley. Erected within the wide *enceinte*, these edifices lend the old fortress the elegance, picturesqueness, and charm so characteristic of the late Middle Ages.

Passed by inheritance to François d'Orléans-Longueville, the Château de Montreuil-Bellay survived the Wars of Religion without severe damage, unlike the city, which suffered both sack and incineration. At the time of the 17th-century Fronde, during the minority of Louis XIV, the beautiful and turbulent Duchesse de Longueville, *née* Bourbon-Condé, spent two years in exile at Montreuil-Bellay, accompanied by the Duc de La Rochefoucauld and other galants eager to save her from boredom—*la désennuyer*.

Acquired by the Maréchal de La Meilleraye, then passed by marriage to the Cossé-Brissac family, and next to the clan of La Trémoïlle, the château served in 1793 as a place of internment for

The helical stairs in the château neuf unfurl beneath the spreading branches of a palm vault, with the keystones capped by the arms of Guillaume d'Harcourt and allied families. Restored during the last century, the apartments present an interesting variant of the picturesque and colorful "Troubadour" style. An exception to this 19th-century revivalism is the beamed ceiling in the dining room, carved with figures full of genuinely medieval grossness. The lower rooms have also retained their beautiful Gothic vaults, at once both robust and elegant. Vaulted as well, the small oratory is covered with painted murals of a somewhat later date (c.1480).

women suspected of royalist plotting, a group destined to be ravaged by typhus. In 1822, Adrien Niveleau bought Montreuil-Bellay in order to divide it up into rental lodgings. A Saumur merchant with a ruthless appetite for profit, Niveleau could very well have served Balzac as the model for Père Grandet. In 1860, his daughter Augustine, Baronne de Grandmaison, engaged the architect Joly-Leterme, a disciple of Violet-le-Duc, to effect major restorations. She left the château to a nephew of her husband, from whom the present owners descend. ∎

Montsoreau

Strewn with entertainments of the most dissolute sort, with murders and massacres, the period of the 16th-century Religious Wars was also marked by exquisite poetry and a court art of extreme refinement. Such contrasts could not but fire the Romantic imagination, especially that of Alexandre Dumas whose pen immortalized the amours of la dame de Montsoreau.

In reality, there were two ladies who won fame under this title. The first, Colette de Chambes, was the daughter of the château's builder. Lord of Montsoreau courtesy of his wife, Jeanne Chabot, Jean de Chambes, Colette's father, was a member of Charles VII's privy council.

Colette de Chambes married Louis d'Amboise, Vicomte de Thouars, only to become involved with the brother of Louis XI, the turbulent Duc de Guyenne, by whom she had two children. When her death occurred just a few months following that of the Prince, it gave rise—probably in error—to dark suspicions of complicity on the part of the King, for whom political ends justified such means as murder and poison. The second "lady of Montsoreau" was Françoise de Chambes, a onetime lady-in-waiting to the Queen Mother, Marie de' Medici, who fell under the charms of Bussy d'Amboise. A *mignon* of the Duc d'Anjou and the lover of his sister, Queen Margot of Navarre, Bussy d'Amboise did not hesitate even to present himself at the Louvre dressed as a Prince of the blood, attended by fifty gentlemen-in-waiting. Defeated by the Spaniards in the Netherlands and despised by the Flemish, he fell into semi-disgrace. Having opportunely arranged for Charles de Chambes to be called away from Montsoreau, by some post obtained for him in the royal hunt, he was imprudent enough to boast in writing about his mistress' attractions. The King read the note and passed it to the lord of Montsoreau, who immediately required that his wife fix a new rendezvous at Coutancière manor, on the opposite side of the Loire. There, a dozen armed men awaited Bussy d'Amboise, who, before collapsing, disabled more than half of them. Considerably chastened, Françoise de Chambes went

Around 1520, a stair turret was inserted in a corner of the courtyard in order to facilitate access to the upper apartments. Gothic in its architecture, the structure is Renaissance in the beauty of its decorative pilasters and rinceaux, applied around windows stacked within a tall narrow bay.

on to give her husband nine children. Half-ruined at the turn of this century, the Château de Montsoreau has been carefully restored. ∎

*B*uilt *on the very edge of the Loire—the intervening road came into being only in 1820—Montsoreau occupied a strategic site of foremost importance, controlling traffic on both the river and the route from Chinon to Saumur. Convoys had to cross the very courtyard of the château, which could therefore exact highly lucrative tolls. This explains the military look of the place, a quadrilateral defended by solid corner towers and originally by fosses linked to the river. The severity abates only higher up, in the trefoiled lintels of the machicolations and in the profile of the huge, two-story lanterns.*

Le Moulin

If one may believe the chronicles of Commynes, Philippe du Moulin won royal favor by saving the life of Charles VIII on 16 July 1495, during the tragic battle of Fornovo. There is no disputing, however, that, once returned from Italy, he became counselor and chamberlain to the sovereign, captain of fifty men-at-arms, and governor of Blaye. The following year, Charles VIII arranged his marriage to Charlotte d'Argouges, the widow of Jean d'Harcourt, counselor to the King of Sicily, from whom he would receive 6,000 gold *écus*. At Charles's funeral, held at Amboise in 1498, Philippe du Moulin figured among the knights who led the mourning.

On 10 October 1490, Philippe had been given clear leave by the Comte d'Angoulême to fortify his Château du Moulin. The construction work, which, according to the letter, had already begun some ten years earlier, was to continue beyond 1501. Following his death five years later at Langres, in Burgundy, where he held the governorship, Philippe du Moulin was buried locally, but his wife, Charlotte d'Argouges, arranged for his heart to be brought to the seigniorial chapel in the church of Lassay. For the wall above the gisant—unfortunately smashed by Revolutionaries—she commissioned a large painting of Saint Christopher with a staff bearing her arms and those of her dead husband. In the background—a wooded landscape—one can still easily discern the silhouette of the château with its slender entrance towers, its *logis*, and the tall cylinders at its corners. Partially demolished in the 18th century and abandoned in the 19th, the château of Le Moulin was carefully restored by the architect Chauvallon in the years 1902–10.

Built on a regular terreplein isolated by moats, Le Moulin is a *château fort* characteristic of the late Middle Ages and typified by Pierrefonds. Its brick architecture with windows and *chemin de ronde* trimmed in white stone suggests a relationship to the châteaux of the Burgundian Netherlands constructed in the 1460–80 period, such as those of Duurstede and Rambures. Framed by turrets with gun loopholes, the two portals—one for carriages and the other for pedestrians—retain their studded pan-

Of the four towers defending the corners of the terreplein, only one survives. Its chemin de ronde is characteristic of the type found in 15th-century châteaux forts. Supported upon stone machicolations, it is pierced by tiny windows as well as by embrasures for small firearms. The wide bays of windows, on the other hand, came at the beginning of the 16th century, as witnessed by the style of the dormers with Renaissance pediments.

The salle des gardes—guards hall or armory—may very well derive from an ancient kitchen. Restored at the turn of this century, the room's vault springs from a handsome polygonal pier (opposite).

els, as well as the large armorial tablet above the passageway. On the left, beyond the crenellated *enceinte* wall stands an outbuilding erected at the beginning of the 16th century.

As for the living quarters, which are curiously set apart, they contain only two halls on each of their four stories, which makes for a structure quite slender in form, an effect reinforced by the presence of two flanking turrets, one reserved for service and the other for the spiral stairs. From the base projects a charming oratory with a polygonal chevet surmounted by a fretwork crest made of lead and emblazoned with this prayer: *Mater Dei, memento mei*. Discovered in an attic with several ridge-pole finials, this precious ornament has been meticulously restored and returned to its original place. ∎

OIRON

The real history of Oiron began in 1449, when Charles VII invested Guillaume Gouffier with this extremely important domain, albeit one situated in Poitou, at some remove from the Val de Loire, where the court was in residence. A person of modest origins, Guillaume Gouffier (d.1495) appears to have owed the favor he enjoyed to Agnès Sorel, whose household he managed. Appointed first chamberlain to the King, Gouffier presided over the commission charged with investigating the affairs of Jacques Coeur, the royal banker, before becoming seneschal of Saintonge and then governor of the Touraine. On his Oiron lands, he had a château built similar to Le Plessis-Bourré, with broad, defensive moats, *logis*, and galleries opening on to a vast interior courtyard. The dimensions of the mansion—which remain the same today—bear witness to the size of the proprietor's accumulated wealth.

The two sons born to Gouffier and Philippa de Montmorency would have brief if still more brilliant careers. Guillaume, the younger, became an Admiral of France; later, he figured among those primarily responsible for the French debacle at Pavia, where he died bravely on the field of battle. At Bonnivet, the family estate in Poitou, he had erected an immense château, of which there is unfortunately no longer a trace.

In 1515, Artus, his elder brother, who had been preceptor to the future François I, emerged as grand master of the King's household—that is, his pantry, wine cellar, kitchen, greengrocery, stables, bakery, kennel, bedchamber, almonry, and chapel. According to one tradition, it was Artus who suggested that François I choose the salamander as his emblem. At Oiron, Artus Gouffier took care not to demolish his father's château. Rather, he simply updated it stylistically, erecting a tall-windowed gallery on the north, initiating work on a large chapel, and, at the center of the courtyard, adding a monumental Renaissance fountain.

Artus died prematurely in 1519. His widow, Hélène de Hengest, who became governess to the future Henri II, supervised the completion of the big collegiate church next to the château and saw it consecrated in 1538. Alas, the family tombs housed there would be vandalized after 1568 by bands of Huguenots, and then sacked by Revolutionaries in 1793.

François I extended the favor bestowed upon the brothers to Artus's son, Claude Gouffier (1519–72), who became captain of a

The décor of the beams in the salon du Roi *is more like that in the apartments at Cheverny and Beauregard than the heavy work in Oiron's own apartments.*

■ *Opposite: The north wing comprises two galleries. The one on the ground floor, opening on to the courtyard, was built by Artus Gouffier in an elegant style of flamboyant Gothic. As for the upper gallery, added by Claude Gouffier at the end of François I's reign, it was invested with the cycle of mythological paintings that are now the glory of the château.*

*A*lso built for Claude Gouffier, but concealed in the 17th century behind the classical façade of the corps de logis, *the stairway represents an harmonious combination of a medieval helix and the new Italian system of straight flights with periodic landings.*

■ *Opposite: In the 17th century, the large, upper gallery built by Claude Gouffier, one of the most prestigious works of decorative art achieved during the French Renaissance, was given a coffered ceiling painted with birds, foliage, and monograms.*

hundred gentlemen-in-waiting to the King and, in 1546, master of the King's horse. As Duc de Roannez and Marquis de Caravaz, he provided a model for the Marquis de Carabas in Charles Perrault's *Chat Botté* (*Puss in Boots*). At Oiron, Claude commissioned a remarkable stairway with a straight newel post and added a second gallery above the one built by his father. Here, the paintings, executed between 1546 and 1549 by a certain Noël Jallier, exhibit a royal quality. They comprise immense scenes taken from antiquity, presented in trompe-l'oeil frames and illuminated by cleverly staggered windows. Along with the epic life sweeping through the figures comes the lyric poetry of the landscapes in the background, the whole modeled in *sfumato* or "smoky" chiaroscuro. Here, then, was the luxurious setting in which Claude Gouffier received Henri II and the entire court in 1551.

Exiled upon his own estate by Cardinal de Richelieu, Claude's grandson undertook, around 1620, the complete reconstruction of the principal *corps de logis*. He also had erected a large corner pavilion, originally capped by a tremendous pyramidal roof, and on the interior created apartments laden with gilded garlands, the sheer heaviness of which contrasted rather shockingly with the elegance of the château's Renaissance parts. His children Artus and Charlotte became deeply attached to Blaise Pascal and his sister Jacqueline, whom they received at Oiron on several occasions. After Pascal's death, Charlotte married the Duc de La Feuillade to whom Artus ceded his dukedom before retiring to Port-Royal, the quasi-monastic Jansenist center in Paris forever associated with the mystical thought and writing of Pascal.

François d'Aubusson, Duc de La Feuillade, Maréchal de France, and Viceroy of Sicily, was an ostentatious courtier who gave Paris the Place des Victoires in honor of Louis XIV. Hoping to make Oiron into a Poitevin Versailles, he commissioned the main *corps de logis*, with its pediment displaying martial attributes. Meanwhile, he was careful to integrate without destroying the wonderful Renaissance stairs built by Claude Gouffier. On the right he added a large square pavilion to balance that of Louis Gouffier, but gave it a gently pitched roof hidden, like those at Versailles, by balustrades decorated with military trophies. Now, the last vestiges of the first château had disappeared, replaced on the south by a gallery-porch facing the Renaissance wing. Finally, he had new moats dug, thereby defining a vast, rectangular terreplein that isolated the buildings on a kind of

The equilibrium and apparent homogeneity of Oiron—the result of work carried out by the Duc de La Feuillade—obscures certain profound differences. Begun at the end of the 15th century, the left wing houses the long gallery. It concludes in a large pavilion, erected around 1685 in response to the one on the right, which dates from the 1620s. As for the opposite wing, this consists merely of a simple gallery linked to a tower constructed by Madame de Montespan in the first years of the 18th century.

■ *Opposite: Commissioned around 1630 by Louis Gouffier, the décor of the* cabinet des Muses *and of the* chambre du Roi *evinces a thoroughly provincial excess and heaviness, redeemed by the quality of certain paintings, attributed to teams of Parisian artists.*

platform and reinforced the majesty of the overall dwelling.

Of the Duc de La Feuillade's son, Saint-Simon wrote: "The most solidly dishonest man to pass this way in a long while." It was he who sold Oiron to Madame de Montespan, the first official and longtime mistress of Louis XIV, who helped finance the purchase. Banished from Versailles in the wake of the "poisons" affair, the Marquise retired to her château in 1700 and nearby had built a hospice for the elderly. Her son, the Duc d'Antin, director of the King's buildings, drew up several plans for the estate, but proved more interested in his château of Petit-Bourg, which was closer to the court. In 1736, he sold Oiron to the Duc de Villeroi, who too would divest himself of the property. This was the beginning of a long decline that came to a halt only in 1941, when the state took possession of the domain. ■

LE PLESSIS-BOURRÉ

Jean Bourré was Anjevin, born in 1424 at Château-Gontier. After entering the service of the Dauphin Louis, he shared his exile at Genappe, during which he gained not only the Prince's confidence but also a taste for the arts, then very much in force at the Burgundian court. Upon his accession to the throne, Louis XI appointed Jean Bourré controller of the royal chancellery and of the financial receipts from Normandy, as well as counselor to the chamber of audits in Paris. Soon the monarch would ennoble Jean Bourré, make him a high officer in the newly instituted Order of Saint Michael, and entrust him with supreme power over the administration of royal finances. Louis XI also placed him, together with two other *commissaires*, in charge of the education of the Dauphin Charles at Amboise. Here, Jean Bourré issued regular and precise *bulletins*, informing the King on the health of the young Prince as well as on the company he kept.

Jean Bourré had already built the Vaux manor at Miré when, in 1462, he acquired from Charles de Sainte-Maure the beautiful land of Le Plessis-le-Vent, which would become Le Plessis-Bourré. Three years later, just as he was taking possession of the property, he was also assuming responsibility for the reconstruction ordered by Louis XI at Langeais. The great tower of Le Plessis undoubtedly derives from the royal fortress, although here the comparison ceases, for it was not a stronghold that Bourré wanted but, rather, a modern dwelling pleasant to live in.

The Hundred Years War had barely concluded, and the countryside remained not entirely secure. As a result, the new château possessed certain aspects of a medieval or military apparatus—broad moats, flanking corner towers, a *châtelet* or fortified gatehouse. However, the vast space defined by the four main wings no longer had anything in common with the dark and damp interior courtyards of the old *châteaux forts*. Well organized and generously illuminated by large windows, the *logis* was accom-

Unlike those at Chaumont-sur-Loire, the defenses at Le Plessis are discreet if nonetheless real. Indeed, the big moats and glacis, the gun loopholes and machicolations of the châtelet *and the massive tower were perfectly capable of protecting the château from outside attack.*

■ *Opposite: The Louis XV boiseries in the large salon were installed by M. Vaïsse.*

panied by important outbuildings, a big chapel, and a long gallery, erected back to back with the low curtain walls. In the absence of Jean Bourré, retained at Amboise by his duties, his wife, Marguerite de Feschal, oversaw the construction work.

In 1473, the château was scarcely finished when Louis XI visited, soon followed by the Regent, Anne de Beaujeau, and young Charles VIII. When Jean Bourré retired in 1492, he was treasurer of France, by which time he preferred not Le Plessis but rather the château of Jarzé, which he had just begun to build. He died in 1506 in that beautiful mansion, unfortunately destroyed by fire in 1794. However, his tombstone can still be seen in the adjacent church, a building enlarged, embellished, and maintained by a college of canons. The choir stalls, oratory, and murals bear witness to the generous patronage of this great statesman, if not the *Entombment* he commissioned in 1504 from the sculptor Louis Mourier. From the youngest of his sons, Charles Bourré du Plessis, the domain passed to René du Plessis, Marquis de Jarzé, whose descendants held it until the 18th century. Several times sold, Le Plessis-Bourré was finally acquired in 1911 by M. Henri Vaïsse, who, after restoring the château, left it to his nephew, the Duc de Dalmatie, the ancestor of the present owners. ■

■ JEHAN DE BOURDIGÉ ■

"En ce Temps, estoit au service du roy ung trés prudent et noble chevalier angevin, nommé Messire Jehan Bourré, par l'ordonnance et conseil duquel se governoient pour lors les plus haulx affaires du royaume, esquelles choses si discrétement se porta que jamais n'en fut reprins. Cestuy chevalier fist ediffier au pays d'Anjou une trés belle et forte place appellée de son nom le Plesseys Bourré, qui est tenu ung des chasteaulx de France, pour ce qu'il contient, plus aysé et mieulx basty."
Jehan de Bourdigné. *Chroniques d'Anjou et du Maine.*

*T*he novelty of the conception at Le Plessis-Bourré—its clear plan and harmonious siting—make this château one of the first of the pleasant country houses—*résidences d'agrément*—*that would proliferate in France during the next century.*

Le Plessis-Bourré retains many features from the 15th century. Among them are the twenty-eight coffers of the precious wooden ceiling painted with enigmatic scenes evincing a thoroughly medieval earthiness, rendered in grisaille on a ground of blue-green.

Ne veulhez de nully... de leur
Enfance le ma fait faire ... de saus p
Que cette
la chichef

.PONCÉ.

Halfway up the hill near the church, the lords of Poncé—the first barons of the Vendômois—owned a *château fort* that survives only in the vestigial remains of a ruined chimneypiece and the bases of two towers. During the reign of Charles VII, the d'Angennes family sold the domain, after which the barony devolved upon a branch of a Norman family—the des Chambrays—who, towards the end of the François I period, had a leisure house built at the foot of the sloping vineyards. Although initiated by Jean IV de Chambry (d.1529) and Gilette Cholet, the residence actually came into being under the supervision of their son, Jean V, and his wife, Françoise du Tilloy. The date of 1542, relief-carved on the stairway, very likely represents the year in which the sculptural décor was completed.

Of the two *corps de logis* that once framed the stair pavilion, only one survives, coiffed in a tall pyramidal roof. The other, which disappeared in the 18th century, was replaced in 1805 by a more modest building that nonetheless evokes the overall form of the original. Fashioned of pale, strong limestone, from a local quarry, the façades present a simple, structurally clear composition. On the interior, the older wing is organized in the classic manner of seigniorial *logis*, rising from a ground floor given over to service through reception halls, apartments, and attics. Much narrower and a half-floor higher, the bays of the central pavilion illuminate the stairwell. Those on the lowest level are now flanked by entrance steps, but once gave on to a porch covered by a loggia. The classicism of the overall design had its source in Italian theory; by the same token, the dormers and tall windows echo the style favored by François I during the late phases of work on Chambord. Originally set apart by moats on three sides, the château opens on to terraced gardens extending all the way to the river Loir. These were reduced in the last century by the construction of both rail lines and highways, but the parterres, the labyrinths, and the bower still exist, sheltered by an enormous plane tree. On the opposite side, facing the cliff, a right-angled wing only a few bays

Realized some twenty years after those at Azay-le-Rideau and Chenonceaux, the stairs at Poncé have preserved in their décor all the freshness of the Early Renaissance. Separated by landings, the six flights appear to have come from two different building campaigns, or more precisely from two different sculpture workshops. The first produced the lower ramp, vaulted and ornamented with interlaced ribs or traceries, as well as the three succeeding flights covered with coffered ceilings simulating perspective or trompe-l'oeil recession into depth. Here, together with the salamander of François I, appear cherubs, masks, horns of plenty, stylized foliage, confronted dolphins, and cartouches. Even more exuberant on the landings, the décor in general is superbly crafted, combining vigor with naturalism.

■ *Opposite: Once more barrel-vaulted, the two upper flights must be the work of a second atelier. Though more varied, the subjects are also more conventional. Here one finds the arms of Gilette Cholet and Françoise de Tilly along with those of the Chambrays and the Thivilles.*

Erected in the second half of François I's reign, the Château de Poncé owes its lack of symmetry to the disappearance of the left wing, which was replaced at the beginning of the 19th century with a more modern structure. At the foot of the stair tower survive the springing points for the loggia that once covered the entrance steps.

long forms a small, flowering courtyard, bordered by a round-headed arcade recalling the architecture of Bramante. ■

Of particular note among the outbuildings is an imposing dovecote. The timberwork's master beam bears the date 1728, but it is generally agreed that the structure dates back to the Renaissance. On the interior, a mechanism of rotating ladders makes it possible to reach all fifty levels of pigeon holes.

.RAGUIN.

Raguin, at Chazé-sur-Argos, represents the last important work created in the Val de Loire by the du Bellay family that played such an important role in 16th-century France. Beginning with a 15th-century *logis*, Pierre du Bellay had the present small château built, a project dated or marked with the years 1585, 1601, and 1607. His son Guy, the Baron du Plessis-Macé, is thought to have been responsible for the decoration of the apartments, most particularly the one with the *chambre des amours* fitted out for the marriage of a grandson, Antoine, to Madeleine de Beauveau, celebated in 1648. Bankrupted by high living, Antoine du Bellay found himself forced to sell the Raguin domain in 1667. In the 18th century, the Maréchal de Contades inherited Raguin from his mother, but did nothing more than collect the income. He then left the estate to his daughter, the ancestress of Mlle de Plouer, who lived there under the Second Empire. Around 1910, the Vicomtesse de Jumilhac caused the château to be restored and added the east wing, erected on old foundations.

Originally isolated by moats only remnants of which survive, this agreeable dwelling owes much of its picturesque charm to a Henri IV manner still very much under the influence of the Renaissance.

The décor of the chambre des amours *abounds in groups of cherubs bearing the initials of the lovers. That of the adjacent salon (pages 150–151) employs a more diverse, if less original, vocabulary.*
■ *Opposite: On the château's main façade (early 17th century), the bays of windows rise above the base of the high roof, to a degree as pronounced as at Le Plessis-Macé, another property of the du Bellay family.*

The mullioned, limestone-framed windows set in narrow bays contrast rather sharply with the stucco covering the dark schist of the walls. Ridgepoles, turrets, and watchtowers have preserved several of their precious finials in fretwork lead, which originally would have been painted and gilded. The large rooms on the ground floor still have their monumental chimneypieces. Housed in a salient tower capped by an "imperial"—lantern-crowned—roof, the stone stairway leads to the "golden rooms"—the glory of Raguin—that are now thought to be the work of an itinerant workshop of Italian painters.

In the salon, pilasters, rinceaux, and garlands provide an harmonious gray and gold setting for painted still lifes, seascapes, floral bouquets, and profiles of Roman emperors.

The adjacent room, called the *chambre des amours*, is even more original. Over the paneling the artist has proliferated the figures of cherubs playing, *au naturel*, with crowns and the heraldic cyphers of Antoine du Bellay and Marguerite de Beauveau. Like the caryatids painted on the jamb posts of the chimneypiece, everything here is realized in beige and ochre grisaille or monochrome, highlit with gold and red. ■

Le Rocher

The château takes its name from the rocky spur that served as the foundation for the medieval fortress, a stronghold protected by the vast lake La Salle and its neighboring marshes. Of this structure, probably ruined during the Hundred Years War, there survive only a few remnants of masonry and the memory of a huge *donjon*, pulled down in the 18th century to make way for the farm.

At the end of the 15th century, Charles Le Maire, lord of Le Rocher, and Catherine de Favières, his wife, constructed a big right-angled *corps de logis*, flanked by numerous towers and turrets. Their son-in-law, Jean de Bouillé, must have finished the work, since his arms appear at the center of kales and rosettes on several of the dormers. He undertook as well the realization of the large Saint Catherine Chapel at the end of the main *corps*.

It was, however, the son of Jean de Bouillé who commissioned the Renaissance décor, the wonder of Le Rocher. Grand falconer of France, François de Bouillé accompanied François I on several of his Italian journeys. To him are attributed the beautiful vaults in the chapel and the adjoining oratory, the door to the spiral stairs, and the two dormers on the perpendicular wing. Most of all, he gave the château the marvelous Renaissance façade erected before the galleries giving access to the principal apartments, signing this masterpiece with his arms and those of his spouse, Marguerite de La Jaille.

The sculptural décor, carved in local granite, has come down to us in an exceptional state of preservation. One can only admire the talent of sculptors capable of extracting from such coarse-grained material motifs as finely wrought as those obtained from limestone by their Angevin peers. Together with the repertoire typical of the François I period, the artists have combined military symbols surrounding the arms and attributes of François de Bouillé, grand falconer of France.

Eléonore de Bouillé, who inherited Le Rocher in the mid-17th century, was a fearless horsewoman and huntress, whose tall figure Madame de Sévigné brings to vivid life in her letters. Married to the Duc du Lude but childless, she arranged to sell the domain to her brother-in-law, Jean-Baptiste de Roquelaure, who virtually never came there. In 1728, the Maréchal de Roquelaure sold the estate to Benoît Eynard, grand master of the waters and forests of Touraine, who had considerable work done at Le Rocher. On the site of the fortified *enceinte*, the moats, and the keep, he opened up broad perspectives on to the park and built important agricultural outbuildings. He extended the right wing of the château and, rather

As remarkable for the clarity and equilibrium of its composition as for the quality of its sculpture, the Renaissance façade of Le Rocher presents two "major" bays alternating with three "minor" ones above a five-bay gallery with anse de panier—*"basket-handle" or flat—arches. Flanked by thin pilasters, the two principal bays comprise, in stacked order, large casement windows, narrow windows inserted below semicircular arches, and large dormers resting on a Classical entablature. Laden with candelabra and flying buttresses, like the châteaux of Fontaine-Henry and Lion, the dormers have prompted an attribution of Le Rocher's façade to the Caen ateliers of around 1535, more precisely to the master builder Blaise Le Prestre.*

Viewed from the rear, the silhouette of Le Rocher is that of a late-medieval gentilhommière, *severe, a bit wild, and animated by numerous towers and gables embellished with* choux frisés—*masonry edges crinkled like "kale" (pages 156–157).*

curiously, doubled the old corner tower to provide a new entrance, ornamented with columns superposed in the manner of ancient triumphal arches. And Eynard did not overlook the apartments, which he restyled in the manner of the day. A letter from his steward in 1736 reports that overdoors "decorated with various landscapes and châteaux, with fair taste," were being installed in the bedchambers. Acquired in 1787 for Thérèse Dubois de Beauregard, on the occasion of her marriage to the Marquis du Plessis d'Argenté, Le Rocher passed by another such alliance to the de Chavagnac family.

Admirably laid out on slopes descending towards the pond, the landscaped park is the work of Bühler. ∎

SAUMUR

Situated on a promontory overlooking the Loire, at the mouth of the Thouet, the Château de Saumur commands the route along the river as well as the one leading into Poitou. The *castrum Salmuri* noted on maps as early as the 10th century could not have amounted to much more than a simple fortified tower. At the beginning of the 11th century, Foulques Nerra seized the site from the Comte de Blois and made it one of his strongholds. Destroyed in 1067, together with the church of Saint-Florent, by "the horrible fire" ignited by the Comte de Poitier, the place was reconstructed—this time in stone—by Geoffroy Plantagenêt, who made it one of his residences. Early in the 13th century, Philippe Auguste attached Saumur to the royal domain, but it was Saint Louis who, on the eve of the Vendôme Treaty, rebuilt the château and gave the complex its definitive plan: an irregular quadrangle sectioned by round towers (c.1227–30).

The Bal des sauvages *tapestry evokes one of the most tragic episodes in the reign of the unfortunate Charles VI. Following a violent fit of madness, the King's health was in a precarious state. Taking advantage of a lucid moment, the court organized a costume ball to which guests were to come dressed as beasts—that is, covered in a kind of long-haired fur. Heat from the torches illuminating the hall caused the disguises to burst into flames, with the result that several guests perished before the very eyes of the unhappy monarch.*

In the third quarter of the 14th century, Louis I, Duc d'Anjou, would largely reconstruct the edifice, endowing it with the fairy-tale aspect so beautifully captured in the celebrated miniatures of the Duc de Berry's *Très Riches Heures*. Preserved in the British Museum, the tales of Macé Dame, "*maître des oeuvres de monseigneur le duc en ses pays d'Anjou et du Maine,*" make it possible to follow the building campaign from 1367 to his death in 1376. The workshop employed from seventy to a hundred men, depending on the season. Thomas, Jean, and Odet Cailleau, natives of Tours, took charge of the sculpture.

In the following century, René d'Anjou particularly enjoyed sojourning at Saumur, which he characterized as his *château d'amour*. He gave the chapel its tower—the so-called *Tour Neuve*—had the apartments refitted, and substituted slate for lead on the upper parts of the structure, where maintenance was difficult.

In 1589, Henri de Navarre invested his faithful companion Duplessis-Mornay with Saumur, now regarded as a "new Geneva" because of the zeal with which the local citizenry embraced the Reformation. The Governor occupied the château in princely fashion—throughout a tenure lasting thirty years—and modernized its defenses. He had the Italian engineer Bartolomeo, for instance, transform the promontory that serves as the château's foundation into a veritable citadel at the bastioned corners. The Protestant academy "for the instruction of the young," founded at Saumur in 1593, would enjoy a wide reputation, until the catastrophic revocation of the Edict of Nantes assured its decline.

Converted into barracks in 1621, then into a state prison under the Empire, the château was in sad condition when the city bought it in 1906. The west wing and the northeast tower had crumbled, while the southwest tower was half-gutted. Restoration, under the supervision of the architect Magne, has made it possible to install the collection of the municipal museum, now a museum of the decorative arts, as well as of the horse, a visit to which leaves one well prepared for a performance of the famous *cadre noir*. ∎

Wonderfully situated above the town, on a spur projecting from the limestone cliff, the château retains, despite its misadventures, the picturesque charm recorded in the famous manuscript brilliantly illuminated in 1430s for the Duc de Berry. Round and battered or banked at the base, the fat corner towers become polygonal at floor level, as well as strengthened with slender buttresses that visually lighten the great masses. The châtelet—a small gatehouse flanked by corner échauguettes or lookout turrets—rises from the plan of the 13th-century fortress, but the huge windows and the apartments within the château itself reflect a totally different style of life. One must imagine what once rose above the merlons of the chemin de ronde—dormers sprouting choux frisés, roofs tapered to fine, "pepper-pot" peaks, tall, cylindrical chimneystalks, flying pennants, and a host of ornaments in fretwork lead—bouquets of weather vanes, crests, and fleurs-de-lis—all brightly painted and gilded.

Serrant

Inconsolable following the loss of her husband, lieutenant-general of the King's armies, killed while leading a cavalry charge, the young Marquise de Vaubrun honored him with a splendid mausoleum designed by Charles Le Brun. The winged Victory is by Collignon, while the three-dimensional scene of death and resurrection, as well as the bas-relief in gilt lead, representing the fatal battle of Altenheim, is by Coysevox.

In 1481, Louis XI granted Ponthus de Brie, his former chamberlain, permission to *"faire ediffier tout de nouvel ung chasteau garnys de boullevars, ponts levans, dormans, tournans, mines et contremines"* on the site of the simple manor house of Serrant, built in the 14th century by his ancestors at Saint-Georges-sur-Loire.

The foundations of the chapel, dedicated to Saint Michael, date back to 1497, but the oldest parts of the château survive from construction work undertaken between 1546 and 1593 by Magdelon de Brie and her brother Charles, who died in the thick of the Religious Wars, crippled by debt and leaving "a daughter too poor to find a husband." Seized and then awarded to the banker Scipione Sardini, Serrant would finally be acquired by Guillaume Bautru, lord of Segré.

A native of Anjou, the new proprietor had Cardinals de Richelieu and Mazarin to thank for his rapid and brilliant rise. Entrusted with several important diplomatic missions, Bautru became state counselor, master of ceremonies at court, and a member of the Académie Française. At Serrant, he completed the château's main *corps*, by giving his master masons leave to erect a *logis* and tower, which at every point were to be *"esgals et semblables d'ornemans que l'autre corps de logis et tour qu'est basty au bout."* The was finished in 1661 when Guillaume Bautru had the honor of playing host to Louis XIV. The young King was on his way to Nantes for the arrest of Superintendent Fouquet, when his carriage got stuck in the mud near Serrant. The châtelain hastened to receive His Majesty *"aussi bien que cette circonstance imprévue le pouvait permettre."* Later, Guillaume Bautru's son, also named Guillaume, erected the left, right-angled wing and its corner pavilion (1671-88), then the right wing and the second pavilion (1700), always in scrupulous harmony with the order of the main *corps*.

In the chapel, housed in the right wing, Guillaume Bautru installed a sumptuous mausoleum in memory of his son-in-law, Nicolas Bautru, Marquis de Vaubrun, struck down in 1675 at the battle of Altenheim, four days after the Maréchal Turren had himself been lost.

The Duchesse d'Estrées, sole heiress to Serrant, sold the domain in 1749 to François-Jacques Walsh, issue of an Irish family established at Nantes since England's Glorious Revolution in 1688 and charged with representing the Stuarts at the courts of France and Spain. Having become the Comte de Serrant, François Walsh arranged for the family's heraldic figure—a *cyne navré* ("wounded swan")—to be carved on the château's portals and the salons to be restyled in contemporary fashion.

In 1825, Théobald Walsh restored Serrant, where he would enthusiastically receive the Duchesse de Berry, widow of the martyred heir to the throne of France and the mother of the Comte de Cham-

*C*ommenced in the mid-16th century, the erection of the château was not completed until the beginning of the 18th century, but in strict conformity to the original architecture. Thus, only fine points of décor betray the actual period of construction.

■ *Overleaf: Under a coffered vault in the Renaissance tower, the Empire bedchamber recalls a visit by Napoleon in 1808. Delayed in his departure for Nantes, by the announcement of Bailen's capitulation, the Emperor spent only ten hours at Serrant, but cut a fine figure and praised the château's architecture, which, he said, reminded him of Italy. Louise de Vaudreuil, Comtesse de Serrant, lady-in-waiting to the Empress Josephine, had ordered from Jacob a sumptuous suite of mahogany furniture.*

bord, the Bourbon pretender after 1830. In 1870, Théobald's nephew, the Duc de La Trémoïlle, embarked upon another restoration. It was at this time that the architect Magne created the rather odd gallery circulating throughout the edifice on the third story. ∎

In Renaissance châteaux, builders often treated the grand staircase as an occasion for bravura display, nowhere more than at Serrant, whose ramps recall the installation at Châteaudun, completed in 1537. The Serrant masterwork comprises coffered barrel vaults, straight flights, and landings decorated with armorial devices, among which can be discerned those of Charles de Brie and his ancestors, as well as those of his second wife, though not the ones of his third spouse. This combination of factors makes it possible to cite 1575 as the year in which the Serrant stairs were finished.

.Sully-sur-Loire.

The timber framework within the donjon *is considered, with justice, to be one of the most beautiful to survive from the Middle Ages, as much for its amplitude—about 131 feet long—as for the technique used to distribute thrust. In the two eastern towers, rebuilt in the first years of this century, modern carpenters proved themselves worthy of their medieval predecessors.*

■ *Opposite: Now transformed into a garden, the ancient* bayle *or walled area originally encompassed the collegiate church and the huge tower put up by Philippe Auguste. It spreads before the château's entrance façade, where, on the right, two cylindrical towers, reconstructed around 1910, flank the gable of the* donjon. *On the left, the Songe tower and the* petit château *owe their big windows to renovations carried out in the 17th century by the first Duc de Sully. At center, the entrance pavilion, rebuilt in the 17th century, is contiguous with a* corps de bâtiment *reconstructed on the site of the large* logis *erected, under the Regency (1715–23), by the fifth Duc de Sully and destroyed by fire in 1918.*

Founded in the 11th century at the mouth of a small tributary of the Loire, the Château de Sully commanded both the crossing of the river and the navigation thereon. After Henri de Sully was denounced in 1218 by his bishop for excessive taxation of local trade, Philippe Auguste confiscated the property and immediately had a powerful *donjon* built there.

Towards the end of the 14th century, Guy de La Trémoïlle, high chamberlain for the ambitious Duc de Bourgogne, became the lord of Sully through marriage. Determined to have a proper château on his domain, he approached the famous Raymond du Temple, "master of works" to King Charles VI as well as to that great builder, Louis d'Orléans. In 1395, the architect arrived at Sully to "*aler et visiter la place, et la tracer.*" When Marie de Sully, widow of Louis de La Trémoïlle, halted construction in 1400, in order to retire to the *petit château* nearby, the huge oblong *donjon* had been completed, together with its enormous apartments, its crown of machicolations, and two of its four corner towers.

In 1429, Charles VII was at Sully, as the guest of Georges de La Trémoïlle, his high chamberlain, when he received the news that Orléans had been secured. And it was here that Joan of Arc came to urge his coronation at Reims. Having had the château strengthened and embellished, Louis de La Trémoïlle was able to receive Louis XI there in a grand manner. Abandoned in the 16th century, the edifice was in a pitiful state when Maximilien de Béthune purchased it for about 126,000 *livres*. Soon thereafter, he received the title of Duc de Sully, and it was as such that he would enter history. As the loyal companion of Henri IV, Sully enjoyed a quite considerable income. He renovated the apartments in the keep and the small château, while also taking care to upgrade the military aspects of the place. For Sully, the memory of the Religious Wars remained vivid. Thus, he reinforced the bases of the curtain walls and added a mighty artillery tower facing the town. Such precautions would not, however, prove relevant until 1621, when the Duchesse de Sully unwisely gave refuge to four hundred Huguenots, which resulted

in a bombardment of the château by artillery under the command of the Comte de Saint-Pol.

Disgraced following the King's death in 1610, Sully spent much time on his lands. At the end of his life, when he undertook the publication of *Oeconomies royales*—his memoirs Henri IV's reign—Sully installed the printer Jacques Bousquet and his equipment in the tower adjoining his own study in order to escape all censorship.

At the beginning of the 18th century, the fifth Duke had Philippe Auguste's tower pulled down and a comfortable *corps de logis* inserted between the *donjon* and the entrance *châtelet*. Libertine *grand seigneur* that he was, this Duc de Sully played host to a brilliant and dissolute society typified by the young Voltaire, exiled for his damaging libels against the Regent. Here one danced, performed plays, and criticized the government, but always with wit. Come the Revolution, the astonishing republican zeal shown by the eighth Duke saved the château. A member of Sully's popular republican club, he took the initiative of decapitating the *donjon* towers without even waiting for the demolition decree.

Uninhabited at his death, the château did not come back to life until the advent of the Second Empire, when the Béthune-Penin family restored the apartments of the *petit château* in the historicized manner so beloved by contemporaries. They would also reconstruct from scratch the tall, conical roofs of the keep's east towers. Repaired after the bombardments of June 1940, which destroyed the town, the château and its complex have subsequently undergone a complete restoration, directed by the Conseil Général of the Loiret, which acquired Sully in 1962. ∎

.Ussé.

Resting on a terrace backed by thick forest, overlooking the course of the river Indre, the Château d'Ussé owes its fairly-tale allure to the multiplicity of its pointed towers, dormers, and chimneys.

An ancient stronghold entrusted by the Comte de Blois to Gelduin early in the 11th century, Ussé entered the de Montejean family in the 15th century. It then passed by marriage to Jean de Bueil, onetime companion of Joan of Arc and the author of *Jouvencel*, a manual of education much admired by his contemporaries. Antoine de Bueil, his son, the Comte de Sancerre, became the brother-in-law of Louis XI by marrying the youngest daughter of Charles VII and Agnès Sorel. Now, Jean and Antoine de Bueil launched a complete reconstruction of the château, from which campaign came the fat, cylindrical *donjon*, built on the foundations of the earlier structure, the long curtain wall on the south, and a major part of the east *logis*, together with the polygonal chapel, the architecture of which recalls that at Langeais and Le Plessis-Bourré.

In addition to many souvenirs of the Duchesse de Duras, the great friend of Chateaubriand, Ussé contains an Italian-style cabinet or study decorated with a profusion of motifs in copper and tortoise shell, celebrated for the ingeniousness of their many "secret" compartments.

Jacques d'Espinay, who bought Ussé in 1485, was chamberlain to Charles VIII. Under Louis XII, he would become grand master of the royal household, while also seconding Jacques de Tournon, then in charge of the Queen's "house." At his new dwelling, close by the royal residence at Le Plessis, Jacques d'Espinay finished the east front with an entrance *châtelet* and enclosed the courtyard with a long curtain wall on the north, which would disappear in the 17th century, providing a view of the valley.

The collegiate church at Ussé, established in 1520 by the terms of Jacques d'Espinay's will, was to be realized under his son Charles and his daughter-in-law, Lucrèce de Pons, and consecrated in 1538 during the tenure of his grandson, René. It is a most beautiful sanctuary exemplifying France's First Renaissance—Gothic in architecture but Italian in its sculptural décor, and this realized with unusual finesse in both composition and execution. Over the upper arcade unifying portal and window into a single façade, the figure of God the Father presides, accompanied by the twelve

*I*nitiated around 1460 by Admiral de Bueil and finished at the beginning of the 16th century by Jacques d'Espinay, the Château d'Ussé displays all the picturesqueness and grace of late-Gothic fortresses. The machicolations are still military, and their lintels are none the less so for being delicately ornamented with flamboyant arcature. On the east front, the chapel's polygonal chevet is contiguous with the tower of an ancient châtelet, blocked up since the 16th century.

Apostles portrayed as busts surrounded by medallions. On the sober, bright interior, the door and lateral piscina, the dropped keystones and capitals, the stalls and tribune possess all the freshness and delicacy so characteristic of that privileged era.

Sold in 1557 by René d'Espinay, Ussé came under several different proprietors, none of whom appeared very attached to the place, until the arrival in 1659 of Thomas Bernin de Valentinay. This châtelain had the orangery built, as well as the grand staircase, designed by a cousin—the architect Bernin, Abbé de Saint-Hilaire—with straight ramps right-turning within a huge square cage. His son Louis was controller-general of the King's household and son-in-law of the Marquis de Vauban, Louis XIV's great military and civil engineer. He installed his apartments in the *pavillon à la romaine*, a classicized *logis* erected at the end of the 17th century in front of the medieval *donjon*. He also laid out the succession of terraced gardens that endow the château with such a pleasant air.

Restored in 1775 by Henriette Bernin, Ussé was sold to the Duc de Rohan-Montbazon and then, on the eve of the Revolution, to the Marquis de Chalabre. In 1808, upon his return from exile, Amédée de Durfort, Duc de Duras, acquired the domain in the hope of living there quietly. He married Claire de Kersaint, the daughter of the Admiral guillotined during the Terror despite his loyalty to the Republic. The Duchesse de Duras was also the author of interesting novels with antiracist themes and a confidante of Chateaubriand with whom she fell deeply in love. When the Duc de Duras resumed under Louis XVIII his role as first gentleman of the King's bedchamber, the great "Enchanter" cynically used Claire de Duras to advance his own political and diplomatic ambitions. The Comtesse Auguste de La Rochejacquelein, *née* Duras, had the château restored and left it to her nephew, the Comte de Blacas, ancestor of the present owner. ■

Fitted out by Henriette Bernin, known as "Mademoiselle d'Ussé," the bedchamber of Monseigneur became the chambre du Roi *once the Duc de Rohan-Montbazon assumed the role of châtelain. Enlarged, by virtue of four big Neoclassical columns, the room owes its éclat to the red of the original silks covering the walls, chairs, canapé, and the great bed* à la polonaise. *The Louis XIV mantelpiece came from the Bernin de Valentinay family.*

VALENÇAY

The simulated machicolations of the huge entrance pavilion rest on large consoles sculpted with beautifully wrought rosettes and foliage.

■ *Opposite: Facing the east wing, whose disappearance opened the view on to the valley, the western wing was enlarged in the 18th century and given a long classical façade articulated with monumental pilasters.*

"It is my wish that you buy a fine country estate, that you receive there brilliantly the diplomatic corps and important persons from abroad, that everyone desire to go there and that to be invited there be welcomed by the ambassadors and the sovereigns of my choosing." Thus did the First Consul—Napoleon Bonaparte—express himself to Talleyrand, his foreign minister, who then selected the magnificent domain of Valençay. Bonaparte paid the major portion of the 1,600,000 francs asked for the château and its accompanying 48,000 acres of land and forest.

After deposing the Spanish Bourbons in 1808, the Emperor remembered how well his minister understood the ways of the *ancien régime*, and also perhaps the role he himself had played in the purchase of the domain. On 9 May, he wrote to Talleyrand from Bayonne: "The Prince of Asturias, the Infante Don Antonio, his uncle, the Infante Don Carlos, his brother, leave Wednesday for Valençay. Be there on Monday evening. I desire that these Princes be treated without fanfare, but decently and with concern, and that you do everything possible to keep them entertained. If you have a theater at Valençay and can arrange for players to come, it would not be amiss. You might have Madame de Talleyrand arrive with four or five ladies. Should the Prince of Asturias become attached to some pretty woman, that would not be inconvenient, since one could observe it all the better."

Only a person as supple as Talleyrand could have dealt with such off-handedness. "I shall offer mass (for the Princes) every day," he replied, "a park in which they can walk, a forest with well-cleared paths, horses, plentiful meals, and music." Otherwise, he did not have to bother all that much about his guests. The Prince of Asturias enjoyed his stay at Valençay, where the etiquette was less burdensome than in Madrid. Even while his people were rising up, he did not hesitate to congratulate Napoleon on his victories or to denounce the royalist plots designed to let him escape. As for the Duke of San Carlos who accompanied him, he did indeed have an affair with Madame de Talleyrand, which Fouché was delighted to report to the Emperor. Once returned to Spain in 1814, following the treaty signed at Valençay, and ascended to the throne as Ferdinand VII, the Prince took care to send Talleyrand a full-length portrait of himself as well as to name a frigate after Valençay.

A bit eccentric by comparison with other dwellings in the Val de Loire, this great Renaissance château was the creation of the d'Estampes family. Robert d'Estampes, who bought the land in the mid-15th century, was seneschal of the Bourbonnais, counselor and chamberlain to Charles VII. Louis d'Estampes, who had the huge corner tower put up around 1505, was one of the principal officers in service to the crown. Governor and high baliff of Blois, he married the daughter of Jacques Hurault, *général* of finances

under Louis XII. At Valençay, he merely imitated his brothers-in-law, who were building at Cheverny and, most of all, at Veuil.

Jacques, the son of Louis d'Estampes and the son-in-law of the treasurer of Anjou, added a *logis* corresponding to the present large wing. However, it was Jean, Louis d'Estampes's grandson, who was to give the château its defining character, provided by the huge entrance pavilion known as the *donjon*. In 1578, Jean d'Estampes had married Sarah d'Happlincout, whose arms figure in the sculptural decorations.

After a brief halt at the beginning of the 17th century, construction recommenced, "with sumptuousness," at the urging of Dominique d'Estampes, Marquis de Valençay and d'Happlincourt. He doubled the length of the *corps de logis* and brought in the painter Jean Mosnier to decorate the apartments.

His financially pressed heirs attempted to sell the estate to John Law, the Scottish laird who introduced modern banking to France, and they finally managed it in 1747. Twenty years later, the domain became the property of Philippe-Charles Le Gendre de Ville-morien. Counselor to the Parliament of Paris, this châtelain had succeeded his brother-in-law as general administrator of the mails and as tax collector. Separated from his wife, he settled at Valençay and died there just before the Revolution. On the courtyard side he added a large Louis XVI façade ornamented with colossal pilasters and, overlooking the valley, a second tower in mock-Renaissance style.

Created Duc de Valençay, Talleyrand enlarged the domain still further. He died in Paris during the reign of Louis-Philippe and was buried in the chapel of the Sisters of Charity, which he had founded at Valençay. ■

Renovated at the end of the 18th century and the beginning of the 19th, save for the entrance pavilion, the décor of the apartments prominently features a superb ensemble of Empire furniture and a premier collection of portraits and historical souvenirs. Here, on the piano nobile, *large grisaille scenes recounting the story of Psyche decorate the royal bedchamber.*

■ *Overleaf: Despite its resemblance to a medieval* donjon, *the big pavilion is a structure from the end of the Renaissance period, sectioned by elegant corner towers. According to a drawing from the 18th century, the pavilion marked the axis of a vast composition flanked by two wings of living quarters.*

VILLANDRY

The Hispano-Mauresque ceiling was installed early in this century by Dr. Joachim Carvallo, who also brought to the restored château his remarkable collection of Spanish painting.

■ *Opposite: The restoration carried out at the turn of the present century left the façades articulated in a manner first sought by their builder. Above a continuous gallery, solids and voids alternate in a sober, gridlike organization governed by the intersecting coordinates of pilasters and stringcourses. Originally closed by a fourth wing—or, more likely, an "architectural wall" similar to the one at Villesavin—the* cour d'honneur *has, since the 18th century, been open on to the valley. Cleverly enough, the three remaining* corps *appear to be regular, despite the presence of a* donjon *and numerous asymmetrical features resulting from the château's medieval foundations.*

On 4 March 1532, with an offer of 35,000 *livres*, Jean Le Breton became the highest bidder for the seigniory of Colombier. Close to the Connétable de Montmorency, as well as to François I, who had appointed him chief housemaster for the Children of France, Le Breton would go on to become controller-general for war, an exceedingly lucrative post in an era of perpetual hostilities. At Villesavin, where construction was just being completed, he made himself the beneficiary of a most pleasant dwelling realized according to "modern" taste. Nonetheless, it amounted to little more than a modest *logis* modeled after Italian villas, and its proximity to Chambord had ceased to be of much interest once the King decided to establish his court in the Île-de-France. However, with Colombier—which became Villandry in the 17th century—Jean Le Breton would legitimatize his fortune. The huge polygonal *donjon* erected in the 14th century by the de Craons bore witness to the nobility and antiquity of the land. Taking care that it not disappear, he embedded the keep in the corner of the new château. Under construction beginning in 1535, this edifice would be essentially finished in 1543, at the time of the death of Jean Le Breton and his burial in the neighboring church.

By virtue of its regular plan and the quadrangular pavilions that replaced the round corner towers, this beautiful château bears the stamp of the great contemporary workshops of the Île-de-France, those of the King at Fontainebleau and the one serving the Connétable de Montmorency at Écouen. On the other hand, the gridded façades, like the richness of the dormers laden with volutes and candelabra, follow models established in the preceding period, such as the châteaux of Bury and Azay-le-Rideau. The estate remained in the hands of Jean Le Breton's descendants until 1754, when it devolved upon the Marquis de Castellane, who initiated a vast program of modernization. He had the apartments refitted, sealed the galleries on the ground floor—converting them to corridors and offices—and multiplied the windows for greater illumination. He also got rid of the spiral

stairway, inspired by the helix at Blois and a salient feature in one corner of the courtyard. The Marquis replaced it with a suite of elegant Louis XV flights, embellished with wrought-iron handrails incorporating his cypher. Finally, he transformed the approaches, by adding balustrades, a belvedere on the *donjon* terrace, an orangery, an immense forecourt, and a set of monumental stables. Acquired by Napoleon I for his brother Joseph, the domain eventually devolved upon the Baron Hainguerlot, who made the terraces disappear under slopes landscaped into an English garden.

"Ignorance and faith are two incomparable virtues that permit us to undertake tasks that are beyond our powers. If I had known that Villandry would have cost me such efforts and sacrifices, I would never had had the courage to put it right." The author of these lines, Dr. Joachim Carvallo, acquired the domain of Villandry in 1906 with the help of his wife, Ann Coleman, who had at her disposal rather considerable means, and set out to return the estate to its original splendor. First off, he recovered the Renaissance order of the façades. The windows opened in the 18th century were closed, the arcades in the courtyard reopened, and the dormers restored. Next, he attacked the park, for despite the quality of the layout, created by the *frères* Bühler, its informal landscape look clashed with the château's "new" architecture. After clearing the terraces, Dr. Carvallo replanted them as the marvelous gardens that give Villandry its present international renown.

The activities of Dr. Carvallo were to have an impact far beyond the boundaries of Villandry. With the aid of his neighbor at Rochecotte, the famous Boni de Castellane, who served as propagandist, he founded *La Demeure historique*, an association of owners of ancient dwellings who wish to keep them alive and available to the public. ■

A *model of how to utilize a privileged site, the gardens at Villandry spread across three planted terraces that, from the slopes of a stream-freshened dell, overlook a broad expanse of the Loire Valley. Although famous in the 16th century, the original garden is totally undocumented and has disappeared without a trace. The present gardens were created by Dr. Carvallo from plates in the* Plus excellents bastiments de France *engraved around 1576 by Jacques Androuet Du Cerceau. As here, Dr. Carvallo combined the tradition of the medieval monastic garden with the parterres, or flower beds, composed of clipped boxwood, herbaceous allées, and decorative features introduced at Amboise by Pacello da Mercogliano after his arrival from Italy in the suite of Charles VIII. Behind the château, the four parterres of the* jardin d'amour *translate all the varieties of love into the language of topiary hedges and floral colors. After the pleasure garden and the garden of medicinal plants comes the lower terrace, near the château, devoted to a vast* jardin potager, *or kitchen garden, embellished with fountains, hedgerows, and arbors. Arrayed in nine squares, these beds or masses bordered in box present a mélange of astonishingly diverse hues: the blue of cabbages and leeks, the yellow of sorrel, the tender green of carrot tops, the red of beets, and lettuces....*

■ JOACHIM CARVALLO ■

"One can now understand why the men who designed the gardens of Villandry arranged the terraces all about the château. It was to provide a better view of the dwelling from different angles. In their disposition, these gardens recall the hanging gardens of Semiramis [the Queen of Babylon]. They comprise three enclosures of gradated terraces, each of them a totally different garden and all extending the château's own levels. The first enclosure contains the kitchen garden, the second the ornamental garden, and the third the water garden…. The kitchen garden is the lowest, at the foot of the château and on the level of the stables. The ornamental garden is on the same plane as the château's ground floor and serves as an extension of the salon. It is an outdoor salon. Finally, the water garden corresponds to the third floor, and the terraces surrounding it prolong the château's own third story…."

Joachim Carvallo. Écrits et témoignages.

VILLEGONGIS

In 1531, when Jacques de Brizay inherited from his mother the seigniory of Villegongis, he was one of the foremost personages at the court of François I. Lord of Beaumont, a lieutenant-general under Philippe Chabot, governor of Burgundy, he married Avoye de Chabanne, the widow of Jacques de La Trémoïlle and a relative of the King. It was Jacques de Brizay who built the château, as attested to by the years 1536 and 1538 engraved on the stone capitals. By the time of his death in 1542, the *corps de logis* had been completed, with two massive corner towers and lateral galleries designed to link the towers planned for either side of the entrance.

Already a châtelain in Poitou, Geoffroy de Neuchèze, Jacques de Brizay's nephew, would not continue the construction work at Villegongis. In the 18th century, Leon-François de Barbançois was destined to win on the field of battle more glory than fortune. Thus, after having the domain elevated to marquisate, he was obliged to abandon plans for renovating the wings of the château. Indeed, he had them pulled down and the superstructure of the stairs as well.

Among all the grand dwellings erected in the early 16th century by high officials in service to the crown, Villegongis is the one that appears most directly inspired by the royal projects then under way.

Restored around 1880 by the Comte Alexis de Barbançois, the last Marquis de Villegongis, the château now belongs to the Baron Philippe de Montesquieu, *né* Barbançois, a direct descendant of the Ménous who had acquired the land in 1445.

The towers represent an original departure on the part of the master builder. The profile of the roofs, although begun at the base as a strongly tapered cone, is gracefully inflected to conclude in a *fer de hache* or "hatchet blade." On their chimneystalks—particularly monumental ones—two large niches house figures of the builders' patrons, Saint James with his pilgrim's staff and Saint Avoye in prison awaiting a visit from the Virgin.

The stairs—designed as straight, right-turning ramps, like those at Azay-le-Rideau, but placed off center so as not to interrupt the great hall—originally rose much higher than the roofline. Removed in the 18th century, the extra levels corresponded to a fifth flight and to a room forming a belvedere, the window of which was integral with the décor of the façade's upper reaches. ■

Unlike so many other châteaux, Villegongis has preserved a marvelous ensemble of portraits, historical souvenirs, and furniture—the legacy of successive generations—that make a visit to these apartments a very special experience.

*O*nly by a detailed examination of the sculpture on the façades may one fully appreciate its extraordinary quality. For a measure of this quality, one should also consider the forty capitals ornamenting the pilasters of the stairway.

■ *Opposite: The relationship with Chambord is so manifest at Villegongis that Pierre Trinqueau has often been credited with the latter's achievement. Here, one again finds massive corner towers, a gridwork of pilasters and stringcourses sectioning the façades, and, most of all, the remarkable wealth of sculpture. Cornices, dormers, and chimneystalks combine to make a décor abounding in shells, pilasters, candelabras, arcatures, and rosettes. Shaped as lozenges, circles, and tablets in imitation of Italian marble, the accents of dark schist are not, however, limited to the upper elements, as at Chambord, but extend throughout the ensemble of the façades.*

VILLESAVIN

Placed in 1820 at the center of the forecourt, this ornamental basin originally stood in the gardens, where it served as a fountain, which explains its décor of marine deities and dolphins. Like the one in the Folleville church in Picardy, this work is generally thought to have been created for export by one of the Genevan ateliers active in the early 16th century.

In 1543, on the day following the death of Jean Le Breton, lord of Villegongis and of Colombier, François I named his widow, Anne Gedoyn, superintendent of Chambord. Thus, it was she who set the pace for the master masons at work on the royal apartments in the west wing, and who as well gave proof of her devotion to the crown by lending the King more than 2,000 *livres* for "the urgent affairs of war." In 1560, her son-in-law Claude Burgensis, son of the King's chief physician, would succeed her in the superintendency, to be followed by her daughter, Léonore Le Breton, in 1568. Given all this, one could easily see in Villesavin a direct imitation of Chambord, or view its elegance as a product of the active participation of women in the building process, just as at Azay and Chenonceaux.

Reality, however, is more complex. If Villesavin provided Anne Gedoyn with a dwelling conveniently near Chambord, why would it not conform more closely to the contemporary work on the royal apartments. The dormers of the palace were already quite clearly marked by a taste for Classical antiquity, which manifested itself in the 1540s, whereas those of the modest château retain all the grace of France's First Renaissance. Like almost all the "châteaux of the Loire," the one at Villesavin was created by a prominent member of the court who was also a native of the region. Notary and secretary to the King, then *général* of finances for the county of Blois, Jean Le Breton belonged to the circle around the Connétable de Montmorency. Entrusted with a mission to the Pope in 1521, he participated in the Pavia humiliation of François I, whom he would again accompany to Italy, this time in 1528. Named chief housemaster for the Children of France, then still minors, succeeding the secretary of state Robertet, he assumed, in 1533, the post of controller-general for war.

In the 15th century the Villesavin domain could boast nothing more than a barn, and the year 1526 is generally thought to be when construction began there on a true seigniorial residence. Indeed, it was now that the King accorded Jean Le Breton the "rights of usage in the forest of Boulogne for the maintenance of his house at Villesavin." As to the completion of the work, it must have

The dwelling of Jean Le Breton comprises three courtyards, two of them on either side serving the outbuildings, stables, and farm; the third, at the center, bordered by buildings of modest elevation, consisting merely of a ground floor and a habitable attic. The corps de logis at the bottom of the central courtyard essentially houses nothing but a long hall and a formal bedchamber separated by a stone stairway. On the right, the large perpendicular service wing includes kitchens, offices, and outbuildings. On the left, the pavilion, linked to the logis by a simple wall, shelters a beautiful vaulted chapel, with a lateral oratory and an apartment for the chaplain. A wall, running between the chapel and the outbuilding pavilion, once sealed off the forecourt. Crowned by a passage—a lookout path or corridor—it was preceded by a drawbridge over moats that have recently been redug.

been around 1537, the year engraved on one of the dormers. Villesavin—and this constitutes its originality—is not a château, properly speaking. Like Cardinal du Bellay at Saint-Maur, Jean Le Breton wanted a modest abode, modeled on Roman "villas." A devoted Italianist, he would, several years later, purchase for a "certain Sienese chapel" an antique stele, whose export the Pope refused.

In February 1541, Jean Le Breton was honored to receive François I in his house at Villesavin, together with a court confined to intimates. Yet, his real projects lay elsewhere, inasmuch as he had acquired in Touraine the beautiful seigniory of Colombier, upon whose land, after some ten years, he had the great château of Villandry constructed. It was here that he would be buried in 1543. Although sold in 1611 and again in 1719, the Château de Villesavin underwent no significant modification. Jean Phélypeaux belonged to a Blésois family that had distinguished itself particularly in the 17th century through the ministers of state La Vrillière and Pontchartrain. He did little more than have the chapel painted in the decorative manner of Palma Vecchio. As for the tax collector Adine, who, thanks to John Law, became a director of the Compagnie des Indes, he appears not even to have updated the apartments in keeping with contemporary fashion.

Only in 1820 did the Comte de Pradel make unfortunate changes. Minister of the household to Louis XVIII, and entrusted with the sculpture museum in the Louvre as well as with the reconstruction of the Odéon, de Pradel opened the courtyard on to the park newly replanted as an English garden, and then added a small *avant-corps* meant to reinforce the axis of the *corps de logis*. It was also he who enlarged the windows and installed neo-Gothic portals in the lateral courtyards. ■

Erected upon a raised foundation, but a bit overwhelmed since the 18th century by the addition of a massive orangery, the rear façade opened on to gardens laid out in the Cosson Valley. Projected over the entrance steps is a charming vaulted oratory, similar to the one built, a few years earlier, by the powerful Chancellor Duprat in his Château de Nantouillet.

Index/Guide

(Wherever a ▪ appears,
it signifies a chateau
open to the public
either on a regular schedule
or at least under certain
limited conditions.)

Châteauneuf-sur-Loire

EURE-ET-LOIRE

Commune de Thiville
■ LE CHAMP-ROMAIN ■

Erected around 1755 for Claude Le Sénéchal, counselor to the parliament of Paris, the château is the work of the contractor Guillois, who had already been commissioned to construct the château of Meslay, near Vendôme (q.v.). The building is a classical one, typical of the country houses erected by the parliamentarians at the time of Louis XV.
I.S. Private property.

■ CHÂTEAUDUN ■

Châteaudun

Rebuilt between 1460 and 1532 by Jean de Dunois and his successors, the château presents a remarkable retrospective of the evolution of architecture from Gothic to the Renaissance. Its huge 12th-century *donjon* is one of the best preserved of the Romanesque period. Châteaudun has superb tapestries, and its chapel houses an extremely fine collection of statues dating from the second half of the 15th century (see main entry).
M.H. Property of the State. ■

■ COURTALAIN ■

The château was erected at the end of the 15th century on the foundations of a medieval fortress by Guillaume d'Avaugour, chamberlain to Louis XII and uncle of the poet Baïf. Sacked by the Huguenots in 1562, the building owes its present décor of high, Renaissance-style bays to its restoration under Napoleon III by the Duc de Montmorency. There are important classical outbuildings (18th century).
Private property. Visible from the road.

■ DROUÉ ■

Built from 1610 on by Isaac du Raynier, a former companion in arms of Henri IV, left to bailiffs in the 18th century, partly destroyed at the Revolution, and restored in the last century, the château is a fine Louis XIII residence of brick and stone, which has unfortunately lost the dormer windows that lightened its appearance.
Private property. Barely visible from the road.

■ MONTIGNY-LE-GANNELON ■

Established in the 11th century and rebuilt in the 13th, the château was burned down in 1416 by the French, for fear that the English would fall back on it. Re-erected at the end of the 15th century by Jacques de Renty, it was restored under Louis-Philippe by the Duc de Montmorency-Laval, and again at the end of the 19th century in the neo-Gothic style (see main entry).
M.H. Private property. • ■

■ OIRON ■

Erected from the end of the 15th century on, the château is evidence of the royal favor enjoyed by the Gouffier family, from Charles VII to Henri II. The paintings in the *grande galerie*, commissioned by Claude Gouffier, rank among the major accomplishments of the French Renaissance (1546–49). Oiron owes its classical appearance to extensive building operations undertaken at the end of the 17th century by the Duc de La Feuillade (see main entry).
M.H. Property of the State. ■

Commune of Romilly-sur-Aigre
■ LE JONCHET ■

Constructed on the side of a walled terreplein, with square towers at the corners, the château consists of a long main building dominated by a central pavilion forming the entrance porch. Erected at the beginning of the 17th century by Pierre Sublet d'Heudicourt, treasurer general of the military field mess, it belonged in the 18th century to the family of Le Bouchet de Sourches and to the Duchesse de Tourzel, who sold it in 1805.
I.S. Private property. Not visible from the road.

Commune of Saint-Jean-Froidmentel
■ ROUGEMONT ■

Erected around 1610 by Simon Franceschi, gentleman-in-waiting to Queen Marie de' Medici, the château is a fine building with the usual features of the period: brick and stone façades, with pavilions and main building in juxtaposition under steep, independent roofs.
Private property. Not visible from the road.

INDRE

■ ARGY ■

Rebuilt by Charles de Brillac, majordomo in ordinary to Louis XII, between 1474 and 1509, the year of his death in Milan, the château belongs to the new kind of country house "inaugurated" at Le Plessis-Bourré and the Isle-Savary, opening on to a vast inner courtyard and lavishly decorated in a style that is still strictly Gothic. As at Chaumont, monograms and heraldic emblems flower in profusion on the galleries overlooking the courtyard and on the great tower known as Brillac. With wings on all sides, the quadrilateral has towers on three corners and on the fourth a square entrance keep, impressive rather than formidable despite its battlemented top. The château fell into neglect beginning in the 17th century, was restored in the 19th, and then abandoned once again. Since 1966 it has been given a new lease of life by the Club du Vieux Manoir.
M.H. Property of the Club du Vieux Manoir. ■

Montigny-le-Gannelon

■ AZAY-LE-FERRON ■

The château consists of a large 15th-century tower attached to the main building, which dates from the 17th century, and two pavilions, one of monumental proportions that goes back to the Renaissance, the other smaller, erected in the 18th century. There is a fine collection of furniture and art objects, principally of the Restoration period (see main entry).
M.H. Property of the town of Tours.

XV period, combining elegance with moderation. It has been completely restored and refurnished with impeccable taste by M. and Mme Henri Viguier (see main entry).
M.H. Property of the Caisse Nationale des Monuments Historiques et des Sites.

■ CHÂTILLON-SUR-INDRE ■

The ruins of the cylindrical keep and its polygonal surround, built in about 1160 by Henry II Plantagenêt, Comte d'Anjou and King of England, still stand in the center of the town. Sold off in parcel lots at the time of the French Revolution, the *bayle*, "bailey," and the main buildings have suffered badly. The curved line of the Rue Isorée follows that of the old *enceinte*, which met the great hall—now much dilapidated—erected around 1275 by Pierre de La Brosse, chamberlain of Philippe le Hardi (the Bold), near an early 13th-century chapel.
M.H. The keep and its surroundings are the property of the commune. Visible from the road.

Commune of Clion
■ L'ISLE-SAVARY ■

L'Isle-Savary

Son of a wealthy cloth merchant of Bourges, Guillaume de Varye became Jacques Coeur's chief agent, responsible for finances and "logistics." Valet of the royal bedchamber, then bailiff of Tours, raised to the nobility by Charles VII, he escaped the proceedings against the great financier and attached himself to Louis XI, who named him *général* of finances. On the estate of L'Isle-Savary, acquired in 1464, he undertook the construction of a large château, which was continued after his death in 1469 by his widow, Charlotte de Bar, remarried to Chancellor Pierre Doriole.
Almost square in plan, the château is even more "modern" in its design than Le Plessis-Bourré, assembling for the first time under one roof the main building, chapel, kitchens, and service quarters. The three wings have the same elevation, as do three of the square corner towers. The only exception is the "keep" on the southeast corner, which has independent suites of rooms and its own fortifications.
I.S. Private property. Visible from the road.

■ LUÇAY-LE-MÂLE ■

Separated from the hill by a deep fosse, the château presents an entrance front that is medieval in appearance, reinforced by a large quadrangular tower crowned with machicolations (15th century). On the other side of the entrance, by contrast, the façade of the main building owes its Renaissance character to work undertaken by Jean de Rochefort, who was the king's standard-bearer at the battle of Pavia and his ambassador in Italy. Turned into a farmhouse and taken over in the 18th century by the Valençay estate, the château has now been restored.
I.S. Private property. Not visible from the road.

Commune of Vicq-sur-Nahon
■ LA MOUSTIÈRE ■

In 1746, Louis-Joseph Leprestre du Neubourg, treasurer of the royal household troops and of the military field mess, receiver-general for the district of Caen, bought the estates of Entraigues, Vicq, and La Moustière. There he had built "the new château of La Moustière" according to "the plans and direction" of Joseph-Abel Couture, "with the advice of M. Le Carpentier, the king's architect."
Constructed in the white stone of Luçay, it is a classical, well-proportioned residence, perfectly matched by its outbuildings—courtyards, chapel,

Azay-le-Ferron

■ BOUGES ■

Built about 1765–70 by Charles Leblanc de Marnaval, collector of taxes for the ironworks of Clavières and the cloth industry of Châteauroux, the château is a perfect example of domestic architecture at the end of the Louis

Bouges

and farmhouse. The builder's heirs sold the property after 1781 to Alexandre Godeau de La Houssaye, ancestor of the present owner.
I.S. Private property. The front of the château can be glimpsed from the road.

■ PALLUAU ■

Mentioned at the end of the 11th century, besieged by Philippe Auguste in 1188, and destroyed by the English in 1356, the château was rebuilt in the second half of the 15th century by Guillaume de Tranchelion and his sons. Abandoned in the 16th century and damaged during the Wars of Religion, it was restored under Louis XIII by Antoine de Buade and Anne Phélypeaux. Acquired in 1700 by the Duc de Saint-Aignan, it was again restored at the end of the 19th century. The towers, main building, and chapel overlook the village, which rises on the side of the hill.
I.S. Private property. Visible from the bottom of the hill.

■ VALENÇAY ■

Built in the 16th century by the d'Estampes family, altered and enlarged in the 18th by the tax collector Legendre de Villemorien, the château entered the history books under the Empire, when the future King of Spain, Ferdinand VII, exiled by Napoleon, stayed there for nearly seven years as Talleyrand's guest. It retains from the period important collections of furniture and objects of historic interest (see main entry).
M.H. Property of an association of the local Department. ■

■ VEUIL ■

Jacques Hurault, Louis XI's treasurer for war, *général* of finances under Louis XII, bailiff and governor of Blois, bought the Veuil property around 1500, secured its promotion into a castellany, and had the bulk of the château constructed in the early years of the 16th century. Over eighty years old at his death in 1517, he left Veuil to Jean Hurault, his fourth son, master of requests at the parliament of Paris. Three wealthy marriages enabled Jean Hurault to transform and embellish the building. The seat of a barony under Louis XIV, but abandoned from the end of the 18th century on and absorbed by the Valençay estate, the château was used for a long time as a stone quarry. Nothing now remains of it but some impressive ruins, recently cleared and restored to dignity by work parties of young volunteers.
The façades are "squared" in a manner characteristic of Bury and Chambord. In the courtyard are the ruins of an open gallery similar to that of Valençay, as well as numerous remains that testify to the skill of the master builder.
I.S. Private property. The ruins are visible from the road.

■ VILLEGONGIS ■

Constructed in the 1530s by Jacques de Brizay and Avoye de Chabannes, the château presents obvious analogies with those major buildings of the early Renaissance, Bury and above all Chambord. The upper parts and the staircase *à rampes droites* (with straight, right-angled flights) have lent themselves to lavish—and remarkable—carved decorations (see main entry).
M.H. Property of the Baronne de Montesquieu, *née* Barbançois. ■

Veuil

INDRE ET LOIRE

■ AMBOISE ■

Appropriated by the crown under Charles VII, the château of Amboise became one of the favorite residences of the court in the 15th and 16th centuries. Abandoned by the Bourbons and largely demolished at the beginning of the 19th century, it has been progressively restored by Louis-Philippe and his heirs (see main entry).
M.H. Property of the Fondation Saint-Louis. ■

Valençay

■ AZAY-LE-RIDEAU ■

Built on an island in the river Indre by Gilles Berthelot and Philippa Lesbahy, between 1518 and 1527, Azay-le-Rideau is one of the loveliest expressions of the French Renaissance, combining native tradition with Italian influences (see main entry).
M.H. Property of the State. ■

Commune of Bournan
■ BAGNEUX ■

Erected in the aftermath of the Hundred Years War, the château has kept its medieval appearance. It is a vast, regular, quadrilateral structure with round towers at the corners, one larger than the others, two dismantled at the

Amboise

top. Some fine chimneypieces with the arms of the Dupuy family survive in the main building, which has been destroyed by fire.
Private property. Visible from roads in the vicinity.

■ BEAUMONT-LA-RONCE ■

The square keep, dismantled at the top, is the oldest part of the château. Guy de Fromentières (d. 1546) added the high stair turret in stone and brick, together with a residential wing. Altered in the 18th century, this was extended around 1875 in the Louis XII style.
Private property. Visible from the road.

■ BENAIS ■

Of the château constructed from the 1470s onwards by Guy de Laval and his successors, only some traces remain next to a Renaissance gatehouse. In 1789, Jean-Pierre Germain bought the estate from the Prince de Robecq and his son Auguste, chamberlain to Napoleon and a Comte d'Empire, and had a Renaissance-style building erected on the ruins between two enormous Neoclassical-looking towers, roofed in slate. The orangery was added in 1850 and the stables in 1869.
I.S. Private property. Visible from the road.

La Bourdaisière

■ BETZ-LE-CHÂTEAU ■

Attributed to Pierre de Betz and Catherine de La Jaille around 1460, this squat-looking keep was once accompanied by a residential wing, which has now disappeared. The porch dates from the 17th century.
I.S. Private property. Visible from the road.

Commune of Montlouis-sur-Loire
■ LA BOURDAISIÈRE ■

Erected around 1520 by Philibert Babou, superintendent of finances, and Marie Gaudin, lady of La Bourdaisière, the château was partially demolished in the 18th century by order of Choiseul, in his attempt to secure the necessary materials for the construction of the pagoda at Chanteloup (q.v.). With the exception of the north wing, La Bourdaisière was rebuilt in the last century for Baron Angelier. It is a large, Renaissance-style mansion, approached by gardens in the French manner.
I.S. Private property. ◆

Commune of Monnaie
■ BOURDIGAL ■

A half-timbered building above a ground floor of stone, this interesting manor house is flanked by a stair turret in brick and stone. Construction is dated to between 1451, the year of its acquisition by Jacques Charrier and Martine Bérarde, and 1483, when it was sold by Pierre Marques, lord of Chenonceaux, to the abbey of Marmoutier, which turned it into a farmhouse.
Private property. Visible from the road.

Bagneux

Commune of Anché
■ LES BRÉTIGNOLLES ■

The château, built in the 15th century by the Bernard family of Tours, is a country house, despite of its large towers. The vaults of the nearby chapel bear the arms of Guy Bernard, Archbishop of Langres.
I.S. Private property. Visible from the road.

■ BRIDORÉ ■

Seat of a castellany dependent on Le Grand-Pressigny, the château was constructed in the 14th century by Jean I and Jean II Le Meingre, called Boucicaut, both marshals of France. Attributed to them in particular is the entrance tower, flanked by turrets and watchtowers. Imbert de Bastarnay, one of Louis XI's inner circle, succeeded them in about 1475, before settling at Montrésor in 1493. It was he who had the main entrance built, with its drawbridge and large tower armed with gun loopholes, and who altered the living quarters, which contain an interesting steam room.
The caponieres or shelters placed at the bottom of the deep fosses are an original feature of the château. Intended for light arms and designed with consummate command of the lines of fire, they must have been added by René de Bastarnay (d. 1580) at the time of the Wars of Religion.
M.H. Private property. Visible from the road.

Commune of Monts
■ CANDÉ ■

Built on a site overlooking the Indre Valley by François Briçonnet (d. ca. 1531), mayor of Tours and *général* of the royal finances, the château of Candé was restored, altered, and enlarged around 1855 for Santiago Drake del Castillo. Altered again in about 1930, it owes its present fame to the marriage of the Duke of Windsor, which took place there in 1938.
Private property.

■ LA CELLE-GUÉNAND ■

Seat of an ancient castellany dependent on Preuilly, the château is situated on the edge of a promontory overlooking the town. The main building, altered in the 18th century, is flanked by medieval towers. A curious arcaded gallery links one of these to a picturesque 15th-century keep, framed by watchtowers, which was turned into a residence in the last century.
I.S. Private property. Visible from the road.

Commune of Cléré
■ CHAMPCHEVRIER ■

Owned by the de Maillé family since the 13th century, the Champchevrier property passed by marriage to François de Basternay (1502), and then to Jean de Daillon (see La Lude). Rebuilt in the 16th century, the château was extensively altered at the end of the 17th by Marshal de Roquelaure, who is said to have had the wide moats constructed by the regiment under his personal command. Acquired in 1728 by Jean-Baptiste de La Rüe du Can, who had the estate raised to barony, the château was restored at the beginning of this century.
S.Cl. Private property.

■ CHAMPIGNY-SUR-VEUDE ■

Erected from 1504 on by Louis de Bourbon and his wife, Louise de Bourbon-Montpensier, the château was

205

razed in 1636 by order of Cardinal de Richelieu. All that remains are the outbuildings, converted into a residence by the Grande Mademoiselle, and in particular the remarkable Renaissance chapel, the windows of which constitute one of the finest and most complete ensembles of 16th-century stained glass (see main entry).
M.H. Private property. ◆

Commune of Amboise
■ THE PAGODA OF CHANTELOUP ■

Erected between 1775 and 1778 for the Duc de Choiseul, exiled by Louis XV, the pagoda is the only trace of the magnificent château built by the Princesse des Ursins, embellished by the minister, and demolished at the beginning of the last century (see the main entry for Amboise).
M.H. Private property. ◆

Commune of Thilouse
■ LE CHÂTELET ■

Consisting of a lodge with round turrets at the corners, this small building is flanked by a chapel with an armorial vault. Construction is attributed to René Gallebrun, who died in 1542.
M.H. Private property.

Commune of Lerné
■ CHAVIGNY ■

Replaced under Louis-Philippe by a more modest dwelling, built on the slope of the hill, the château of Chavigny was an important structure erected between 1637 and 1646 by Claude Bouthillier, superintendent of finances, and his son Léon, on land near Cardinal de Richelieu's estates. On the ground floor of the main building, its architect, Pierre Le Muet, had kept the Renaissance gallery constructed in 1543 by Louis Le Roy and framed it with two wings on the courtyard, flanked by pavilions. All that remains are the lookout turrets at the entrance and two large adjoining pavilions, one housing the chapel (with a remarkable carved vault) and the other one of the two principal staircases.
I.S. Private property. Barely visible.

■ CHENONCEAUX ■

Built between 1514 and 1527 by Thomas Bohier, administrator of

Chenonceaux

finances for the province of Milan, and Catherine Briçonnet, his wife, the château stands on the foundations of the old mill of the château of the Marques family, right in the riverbed of the Cher. Seized by François I, it was granted by Henri II to Diane de Poitiers, who built the bridge across to the other bank. Catherine de' Medici had the two-storied gallery added around 1570–75. Jean-Jacques Rousseau visited Chenonceaux when it was owned by the tax collector Dupin (see main entry).
M.H. Private property. ◆

■ CHINON ■

Established in the 10th century by Thibault le Tricheur (the Trickster) and rebuilt by Henry II Plantagenêt, King of England, who died there in 1189, the château is celebrated for having been the site of the first meeting between Joan of Arc and Charles VII, on 8 March 1429. Abandoned in the 17th century, it now consists of impressive ruins that cover over 400 yards on the promontory overlooking the town (see main entry).
M.H. Property of the town of Chinon. ◆

■ CHISSAY ■

An ancient stronghold commanding the Cher Valley, owned by Robert de L'Isle Bouchard in the 12th century and by the d'Amboise family in the 14th, the château owes its present appearance to the reconstruction undertaken by Pierre Bérard, who received Charles VII there in 1452 and 1454. Acquired by Philibert Babou de La Bourdaisière at the beginning of the 16th century and in the 18th by the Duc de Choiseul (see Chanteloup), it was restored in the 19th century by the Comte de Baillou. M. Philippe Savry has turned it into a hotel of character.
Private property. Barely visible from the road.

■ CINQ-MARS-LA-PILE ■

Of the great castle of Saint-Mars erected by the successors of Geoffroy de Saint-Médard, the first known lord of the manor, in the mid-11th century, there remain two high, round, fantastically crenelated towers. One of them was faced in the 14th century; the other was repaired with rubble in the 15th. Both contain handsome rooms with ogival vaults.
Acquired in 1630 by Martin Ruzé, the

Chinon

seniory was elevated to marquisate for the benefit of his grandson, Henri Ruzé d'Effiat—the famous Cinq-Mars—who was beheaded in 1642 on Richelieu's orders for having conspired against the state. The downfall of the château has often been attributed to a demolition "of equal infamy"; but in fact it seems to have been Cinq-Mars himself who had the building pulled down, with a view to its complete reconstruction. The only part of this plan to have been executed is an enormous bastioned terreplein lying behind deep fosses.
The present château was created out of a 15th-century dwelling, altered in the 17th century, situated in the old outer courtyard. Visible are a triangular fortified buttress and the remains of the Jewry, the ancient ghetto surrounded by its own enclosure.
I.S. Private property. ◆

Commune of Amboise
■ LE CLOS LUCÉ ■

Erected around 1475 by Étienne Le Loup, major-domo of Louis XI, this brick and stone building became the property of Charles VIII, who added a chapel, and then of François I, who used it to house Leonardo da Vinci. It was restored at the end of the 19th century by the Comte Saint-Bris.
M.H. Private property. ◆ Forty models made by I.B.M. from Leonardo's drawings are arranged in four of the rooms.

Commune of Reugny
■ LA CÔTE ■

Built on a terrace created on a slope of the Brenne Valley, this charming house consists of two wings set at right angles. Their Renaissance dormer windows are lavishly decorated with shell motifs, candelabra, and pilasters. Construction has been attributed to Marc de La Rüe, mayor of Tours in 1535.
In the chapel, which stands on its own at one end of the terrace, the stained-glass window of the Crucifixion bears the date 1597 and the arms of Jean Forget, who was also mayor of Tours.
I.S. Private property.

Commune of Seuilly
■ LE COUDRAY-MONTPENSIER ■

The great towers of Coudray, seat of an ancient castellany dependent on Montsoreau, dominate the quiet landscape of Rabelais's countryside. Born around 1495 in the neighboring hamlet of La Devinière, the writer made the château the home of his hero Grandgousier.

The oldest of the towers, dating from the end of the 14th century, goes back to Louis, Duc de Touraine, and Marie de Blois, Duchesse d'Anjou. The second was the work of Pierre de Bournan (d. 1426) and his son Louis (d. 1473), who were responsible for the main building and the chapel, consecrated in 1452. Louis, the Bourbon Bastard, and his wife Jeanne, legitimate daughter of Louis XI (d. 1519), added the north wing, the gallery, and the third tower. Little altered by their successors, the château remains one of the most remarkable examples of a seigniorial residence at the end of the Middle Ages.

Chancellor Guillaume Poyet acquired Le Coudray in 1535 but was convicted for extortion and forced to surrender it to François I. The King reassigned it to Jean d'Escoubleau, master of the royal wardrobe. Owned by the family of La Motte-Baracé until the beginning of this century, the château was restored in about 1930 by M. Pierre Latécoère, who raised the gatehouse by several stories and gave it the look of a real *donjon*. In the park are the buildings of a center for mentally handicapped children.

M.H. Property of the old Department of the Seine. Barely visible from roads in the vicinity.

Commune of Beaumont-en-Véron
■ COULAINE ■

Erected around 1470 by Jehan de Garguesalle on the foundations of an older building, this manor house owes much of its picturesque appearance to its high polygonal stair tower and to its corbeled corner turrets. The friezes, balustrades, gables, and pinnacles that decorate its upper reaches are evidence of extensive restoration at the end of the last century.

I.S. Private property. Visible from the road.

Apart from Coulaine and Velors (q.v.), the commune of Beaumont-en-Véron includes a number of old country houses. One is La Courtinière (I.S.), located among vineyards near Coulaine, an old farmhouse belonging to the priory of Beaumont. The amazingly lavish decoration that covers the entrance and several façades on the courtyard is evidence of the virtuosity of Touraine sculptors, well served, it is true, by the quality of the local limestone.

Rebuilt by the de Valory family after the fire caused in 1562 by the Montgomery troops, the manor house of Detilly was endowed in the 17th century with a beautiful monumental portal (I.S.). Montour (I.S.), a simpler building, still has its classical chapel and its silkworm nursery (17th–18th centuries). The ancient château of Razilly, where several kings of France stayed in the 15th century, has in large part collapsed.

Commune of Veigné
■ COUZIÈRES ■

Celebrated as having been the setting for the reconciliation—a temporary one—between Louis XIII and his mother on 5 September 1619, the château was rebuilt at the beginning of the 17th century by Hercule de Rohan, Duc de Montbazon, who died there in 1654. Heavily restored in the last century, the main building owes its irregular plan to two medieval towers. In the courtyard, a large Renaissance fountain bears the arms of François I, of Claude de France, and of Louise de Savoie. In the garden a large basin ornamented with foliated scrolls and grotesques serves as a fountain. The architectural grotto decorated with pilasters was built by Hercule de Rohan at the beginning of the 17th century.

I.S. Property of M. Bernard Missenard. Not visible from the road.

Commune of Louestault
■ FONTENAILLES ■

Practically rebuilt at the end of the last century for the Baronne de Boucheport, *née* Sieber, the château is a good example of the neo-Gothic residences of Touraine and Anjou, both picturesque and heavily decorated.
Private property.

■ GIZEUX ■

In the parish church are four splendid statues of kneeling figures that date from the beginning of the 17th century, signed by the Touraine artist Nicolas Guillain (d. 1638), which were fortunately concealed from the destructive passions of the Revolutionaries. They represent René du Bellay, deputy to the Estates in 1588, his son Martin, deputy to the Estates in 1614, and their wives. It was René du Bellay who had the present château erected at the end of the 16th and beginning of the 17th century, replacing a medieval structure built in the 14th century by Hugues du Bellay, of which a detached tower remains. At the beginning of the 18th century, René-Simon Grand'Homme, master of ceremonies and gentleman of the royal bedchamber, added a gallery and extensive stables. In 1786 his great-niece, Julie Constantin de La Lorie, married Louis-Gabriel de Contades, one of the Marshal's grandsons (see Montgeoffroy).

The *grand salon* and a long gallery have retained an interesting décor that dates from the beginning of the 17th century, completed in the 18th: painted panels, beams decorated with foliated scrolls, and large landscape paintings set in trompe-l'oeil frames.

M.H. Private property. Visible from the road.

Coulaine

Le Coudray-Montpensier

■ LE GRAND-PRESSIGNY ■

Built on the edge of the plateau overlooking the small town and the valley of the Claise, the château owes to the Middle Ages its oblong *enceinte*, reinforced by a 13th-century *châtelet*, or fortified gatehouse, and towers (the latter now more or less dismantled at the top), and above all its Romanesque *donjon*. Erected in the 12th century, crowned with a row of machicolations in the 15th, this quite modestly sized tower (about 29½ feet at the base by some 115 feet high) unfortunately half-collapsed in 1988.

Acquired in 1523 by the family of Savoie, the barony of Le Grand-Pressigny devolved upon Honoré III de Savoie, Marshal and Admiral of France, governor of Loches, who had the château converted into an attractive residence between 1550 and his death in 1580. Spared from damage are the double Renaissance gallery (c. 1550, now a museum of prehistory), the covered well, and an interesting architectural grotto, framed by pilasters with vermiculated bosses.
M.H. Property of the commune and the Department. ●

Le Grand-Pressigny

■ LA GUERCHE ■

First mentioned in the 11th century, the château of La Guerche commanded the crossing of the river Creuse, on the borders of Touraine and Poitou. André de Villequier acquired it in 1450 but died before he could undertake its reconstruction. Antoinette de Maignelais, his wife, replaced her aunt, Agnès Sorel, in the King's favors, before attaching herself to the Duc de Bretagne. On her death, Artus de Villequier inherited a considerable fortune and had the present château erected in the 1490s. Altered around 1650 by César d'Aumont, governor of Touraine, the building was restored at the end of the last century.

Of the original quadrilateral there remain a large main wing framed by imposing towers on the banks of the Creuse and the perpendicular frontage, with its entrance keep. Inside, the principal staircase winds around a central newel wall. The two floors of low rooms allowed supplies to be stored and were used as carefully ventilated artillery casemates.
M.H. ●

Commune of Vernou-sur-Brenne
■ JALLANGES ■

Seat of an ancient fief dependent on Amboise, the estate of Jallanges belonged to Nicolas Gaudin, uncle of Philibert Babou, at the beginning of the 16th century. Raised to castellany in 1631, it was for a long time the property of the Lefebvre de La Falluère family, before passing through the hands of several owners in the 19th century.

The main building, in brick with bands of limestone, goes back to the end of the 15th century, as can be seen from its stair turret, with its high projecting chamber, and its dormer windows decorated with rosettes and floral motifs. The wings were added as extensions at the beginning of the 16th century, as were the chapel and the entrance, the latter framed with Renaissance pilasters. In the forecourt, the outbuildings were erected in the 18th century. The whole was restored about 1925.
I.S. Property of the Ferry-Balin family.
● Available for receptions and overnight guests.

■ LANGEAIS ■

Built in the 10th century by Foulques Nerra on a promontory overlooking the Loire Valley, the *donjon* is one of the oldest in France. There are remains of two lateral walls. Destroyed in the course of the Hundred Years War, the château was rebuilt beginning in 1465 on Louis XI's orders, though never finished. The marriage of Charles VIII and Duchesse Anne de Bretagne took place there on 6 December 1491. M. Jacques Siegfried, who

Langeais

bought the château in 1886, had it restored, installed a fine collection of furniture and tapestries, and bequeathed it to the Institut de France (see main entry).
M.H. Property of the Institut de France. ●

Commune of Azay-sur-Cher
■ LEUGNY ■

André Portier, who bought the Leugny estate in 1740, was an architect, the pupil and collaborator of Gabriel. It was he who built this beautiful neo-classical house, with its sober, well-balanced lines. Before it lies a majestic view framed by outbuildings of the same period. To the north it looks on to the sweeping landscape of the valley of the Cher.
I.S. Private property. ●

■ LOCHES ■

Established in the 9th or 10th century on a long spur overlooking the Indre, the château was endowed by the counts of Anjou around 1100 with a *donjon* that is one of the most impressive works of the Romanesque period. Reinforced by Henry II Plantagenêt, King of England, it withstood two sieges before being seized by Philippe Auguste for the French crown. One of Charles VII's favorite residences, the château was turned into a state prison by Louis XI (see main entry).
M.H. Property of the commune. ●

■ LUYNES ■

Built on the site of a Roman *castrum*, the château belonged in the 11th century to Gelduin de Saumur, who sided with Eudes II, Comte de Touraine. It was seized by Foulques Nerra and turned over to one Gosbert, ancestor of the de Maillé family, who had the estate raised first to barony—one of the oldest in the Touraine—and then to county or earldom. In 1519 Charles d'Albert, lord of Luynes in Provence, acquired the de Maillé county and obtained from Louis XIII its elevation to duchy under the name of Luynes. Within the fortified *enceinte*, reinforced and altered on numerous occasions, the brick and stone residence was built by Hardouin de Maillé in the 15th century and heavily restored at the end of the 19th. The adjoining wing was added in about 1650 by Le Muet for the second Duc de Luynes.

I.S. Property of the Duc de Luynes. Clearly visible from the small town that it overlooks.

■ MARCILLY-SUR-MAULNE ■

With its irregularly spaced windows, the main part of the château owes its origins to the residence erected at the end of the 15th century by François Laval. In 1608 Charles Fouquet, receiver general of finances at Tours, completely altered the building by the addition of pavilions, two in the center of each façade and four in the form of bastions at the corners. Fouquet was also responsible for creating the broad fosses, constructing the great staircase *à rampes droites*, and decorating the reception rooms with paintings, of which some interesting traces remain.
I.S. Private property.

Commune of Azay-sur-Cher
■ LA MICHELINIÈRE ■

Framed by round pepperpot turrets, this small house was built in the 16th century by the successors of Jean Source, who owned the property in 1431. With the exception of a little window at the back, the bay windows have been enlarged and have lost their mullions. The low doorway, on the other hand, has kept its Renaissance character intact.
I.S. Private property.

■ MONTBAZON ■

Established by Foulques Nerra on a promontory standing out from the plateau, the *donjon*—longer on one side than the other—was probably rebuilt in the mid-11th century. Its *enceinte* was altered in the 15th at the time the residence and chapel were erected. Raised to the status of duchy by Henri III, the Monbazon estate remained in the hands of the de Rohan family from the 15th to the 19th century.
I.S. ■

Montpoupon

Commune of Céré-la-Ronde
■ MONTPOUPON ■

Seat of a castellany dependent on Montrichard, the château belonged to Richard de Beaumont in the 13th century and in the 15th to Antoine de Prie, lord of Buzançais, who initiated its reconstruction, continued by his successors in the 16th century. After a period of abandon, it was renovated in the 18th century by the Marquis de Tristan. Its most recent owners have restored it in the spirit of the late Middle Ages.
Around the courtyard, enclosed by a wall that has been lowered, are the main building, dating from the end of the 15th century and adjoining a large round tower earlier in origin; a tower standing on its own; remains of the chapel, which was destroyed at the Revolution; and an interesting square entrance keep whose Renaissance decoration goes back to the 1520s. The impressive service quarters were rebuilt in the 18th century. Grisaille paintings of foliate scrolls have been brought to light on the beams of the dining room.
M.H. Property of Mlle de La Motte-Saint Pierre. ■

■ MONTRÉSOR ■

Said to have been built by Foulques Nerra on a rocky spur overlooking the course of the Indrois, the first château was destroyed by order of Philippe Auguste. Jean de Bueil undertook its reconstruction at the end of the 14th century, but it was Imbert de Bastarnay, former counselor to Louis XI, who took it up and saw it to a successful conclusion at the end of the 15th century. Acquired in the 17th by the Duc de Saint-Aignan, the château had long been uninhabited when Comte Xavier Branicki bought it in 1849 and had it restored. Situated in the middle of the small town, the structure occupies the summit of a long spur, surrounded by walls. The entrance keep, in ruins, goes back to Jean de Bueil at the end of the 14th century. The artillery towers that reinforce the base of the spur are the work of Imbert de Bastarnay at the end of the 15th, as is the main building, restored around 1850. This houses interesting collections of art (gold- and silversmith's work) and of the history of Poland. The large collegiate church nearby (1520–40), as elegant as the churches of Ussé and Champigny-sur-Veude, contains the tomb of Imbert de Bastarnay, his wife, and their son François.
I.S. Property of Comtesse Stanislas Rey. ■

Commune of Sonzay
■ LA MOTTE-SONZAY ■

Rebuilt in the 14th and 15th centuries by the de Bueil family, which distinguished itself during the Hundred Years War (see Ussé), the château formed a quadrilateral with round towers at the corners, which was surrounded by moats. Two sides of the building have disappeared. The façades of the other two were altered under François I and Henri II by Antoine de Loubes, pantler to the King, and Renée de Daillon, lady of La Motte, and their heirs.
I.S. Private property.

Commune of Athée-sur-Cher
■ NITRAY ■

Begun in 1517 by Aimery Lopin, master of requests to Louise de Savoie and mayor of Tours, the building was finished for Jean Binet, another mayor of Tours (1543–44). Restored in the 19th century by Baron Liébert, it has two interior staircases. Access to the main courtyard lies between two 15th-century towers, one of which houses a Renaissance chapel.
I.S. Private property. ■

Plesis-lès-Tours

Commune of La Riche
■ PLÈSSIS-LES-TOURS ■

In 1463 Louis XI bought the property of Les Montils from Audouin Touchard de Maillé and turned it into Le Plessis-du-Parc, which he used as a hunting lodge and secure retreat. From 1475 on, increasingly haunted by the risk of attempts on his life, he lived there immured, in the company of his dogs and closely guarded, surrounded by relics. Soon he was joined by the hermit François de Paule, who was present at his death in 1483. The Scots and Swiss Guards occupied the first courtyard. In the second were the royal apartments, the chapel, and the audience chamber. Abandoned in the 17th century and largely demolished in the 19th, Le Plessis now consists of only the southern portion of the royal quarters, built in brick highlighted with bands of stone.
I.S. Property of the town of Tours. The building contains a museum in which the bedrooms of Louis XI and of Saint François de Paule have been reconstructed.

Commune of Preuilly-sur-Claise
■ LA RALLIÈRE ■

Samuel Gaudon, who came from Preuilly, settled in Paris as a *partisan*, responsible for levying taxes. He rapidly made a large fortune, and ended in the Bastille in 1649. In his native town he erected a residence flanked by two pavilions, one capped with a roof *à l'impériale*, the other housing a great stone staircase. This fine building, whose architecture and decoration show exceptional skill, would have represented only a quarter of Gaudon de La Rallière's initial project. The château, now completely surrounded by adjacent buildings, is the site of a hospital.
Visible from the street.

Commune of Chouzé-sur-Cisse
■ LES RÉAUX ■

The property of Amaury Péan at the end of the 14th century, then of Jeanne de Montejean and Antoine de Bueil, the king's lieutenant in Touraine (see Ussé), the château of Le Plessis-Rideau was in ruins when acquired by Jean Briçonnet, mayor of Tours (d. 1473). His grandson Jean Briçonnet, treasuer-general of Provence (d. 1559), is credited with its rebuilding.
Gédéon Tallemant des Réaux, a burgess of Paris, bought the property in 1650 and obtained permission to change its name to that of an estate he owned in Bourbonnais. Said to have had the wickedest tongue of the century, but also the wittiest, Tallemant des Réaux became famous for his ferocious *Historiettes*. At the beginning of the 18th century his widow ceded Les Réaux to Louis Taboureau, who added a large wing in stone. Having changed hands several times during the last century, the château has been completely restored by its latest owners.
The main building owes much of its character and originality to the brick and stone masonry—worked in check or chevron patterns—that enlivens the monumental entrance, its two towers, and the stair turret. A fine doorway of the François I period opens onto the courtyard.
M.H. Property of M. Goupil de Bouillé. Visible from the road. The château receives guests.

■ RICHELIEU ■

In 1631 Cardinal de Richelieu decided to create a new town on the estate he had inherited, recently elevated to duchy by Louis XIII. The gates, the enclosure walls and ditches, the houses in the main street, and the two squares were finished in 1642, but the town declined after the Cardinal's death. Jacques Lemercier, who had drawn up the plans, was also responsible for the design of the château, reared out of the modest dwelling erected under Henri III by the Cardinal's father. Known through the engravings of Marot, Pérelle, and Silvestre, this huge and magnificent building, its niches filled with statues, was approached by way of expertly laid out grounds that anticipated the art of the second half of the century. All that now remains of the château, which was given up for demolition under the Restoration, is one of the pavilions of the forecourt and grottoes in the park.
M.H. The grounds of the old château are free to visitors.

Commune of Lémeré
■ LE RIVAU ■

The château owes its rectangular plan, with corner towers, to the 13th century; but the present buildings were erected after 1442, the date at which Pierre de Beauvau obtained permission from Charles VII to fortify the structure, acquired through his marriage with Anne de Fontenay.
Lacking its chapel, which was pulled down around 1880, and one of the four sides of the building that surrounded the courtyard, the château now consists of a large main wing recalling that of Langeais (c. 1467), framed by a wing on either side. The one on the right meets a large keep and quadrangular porch combined, like that at Argy, machicolated at the top, with a drawbridge in front.
I.S. Private property.

Commune of Saint-Paterne-Racan
■ LA ROCHE-RACAN ■

All that remains of the château erected around 1636 for Honorat de Bueil, Baron de Racan, one of the poets at the court of Louis XIII (see Champmarin), are part of the main wing and one of the pavilions that framed it, designed by Jacques II Gabriel, whose son became the king's architect. Restored about forty years ago, the building contains a staircase *à rampes droites* and several rooms vaulted with herringbone-work.
I.S. Private property.

■ SACHÉ ■

"Saché is a remnant of château on the Indre in one of the loveliest valleys of

Saché

the Touraine," wrote Balzac, who made several profitable sojourns there between 1814 and 1848, enjoying the hospitality of M. de Margonne. Built at the beginning of the 16th century, but with an interior "renewed" under the Restoration, the manor house retains the author's small bedroom and some beautiful polychrome wallpapers in the reception rooms that simulate draperies.
I.S. Property of the town of Tours.

Commune of Varennes
■ SAINT-SENOCH ■

Erected in the 1760s by the architect Joseph-Abel Couture for Alexandre-Bernard Haincque, collector of taxes

Les Réaux

on gunpowder and saltpeter, the château is a handsome Louis XVI structure in white stone, unified as much in the design of its façades as in its interior layout and the organization of its courtyards and outbuildings.
I.S. Private property. One of the façades is visible from the road.

■ SEPMES ■

Attributed to Jean de Thaïs, pantler to François I, who died in 1553 at the siege of Hesdin, the château has been turned into a farmhouse and in part demolished. Recently restored, it owes its interest to a remarkable staircase, comparable in quality to that of Azay-le-Rideau (q.v.).
I.S. Private property. Barely visible from the road.

Commune of Rigny-Ussé
■ USSÉ ■

The château was begun at the end of the 15th century by Jean and Antoine de Bueil, and finished early in the 16th by Jacques and Charles d'Espinay. Its rooms have been repeatedly altered—by the Bernin de Valentinay family in the 17th century, by the Duc de Rohan-Montbazon in the 18th, and by the Comtesse de La Rochejacquelein in the 19th (see main entry).
M.H. Property of the Marquis de Blacas. ⌂

Ussé

Commune of Chançay
■ VALMER ■

Erected around 1525 for Jean Binet, major-domo to Marguerite de Navarre and mayor of Tours, and restored in the 19th century by Félix Duban, the château was destroyed by fire in 1948, together with its furniture and collections. All that remains of it is "Little Valmer," an attractive Louis XIII building. The adjoining chapel, consecrated in 1647 and marked with the arms of Thomas Bonneau, replaced an earlier one, consecrated in 1529, which had been hollowed out of the local limestone. In the garden, four columns supporting urns come from Chanteloup (q.v.).
I.S. Private property.

Commune of Saint-Christophe-sur-le-Nais
■ VAUDÉSIR ■

Built around 1530 for René Bonamour, a merchant of Tours, this small château owes its present appearance to the alterations effected at the beginning of the 17th century by Claude Testu, treasurer of France in the same town. Standing alone on a square terreplein surrounded by moats, it originally consisted of two main wings linked by two galleries, one of them open at ground level.
I.S. Private property.

Commune of Beaumont-en-Véron
■ VELORS ■

This picturesque manor house, which goes back to about 1500, is a curious example of the combination of brick and stone in checkerwork. It was altered in the 17th century.
I.S. Private property.

Commune of Vou
■ LE VERGER ■

Situated on a slope overlooking the Ligoire, this ancient dwelling was the seat of a fief dependent on Preuilly, which belonged to the Beauregards in the 15th and 16th centuries and to the Boistenant and Dangé d'Orsay families in the 18th century. Long since turned over to agricultural use, it retains a large round corner tower, a spiral staircase, and several Gothic and Renaissance windows.
I.S. Private property.

Villandry

■ VERNEUIL-SUR-INDRE ■

In his memoirs, Dufort de Cheverny recalls the figure of Eusèbe-Félix Chaspoux, second Marquis de Verneuil, a man "proud, lofty, and vain," who was secretary of the king's cabinet and then grand cupbearer. He speaks also of his friend Sedaine, the playwright, who as a child lived with his father, an architect and contractor, who died prematurely in 1734 while working at the château of Verneuil for Eusèbe-Jacques Chaspoux, diplomatic gentleman usher.
This very classical building seems crushed by the huge dome *à l'impériale* that covers the fore-part. It was altered in the last century, as can be seen from the dormer windows, the lateral wings, and the nearby tower, remains of the medieval château.
I.S. Property of the foundation for the Orphelins Apprentis d'Auteuil (horticultural center). Visible from the road.

■ VILLANDRY ■

Built under François I by Jean Le Breton, controller-general for war, on the foundations of a fortress that had belonged to the de Craon family, the château was remodeled in the 18th century by the Marquis de Castellane. At the beginning of this century, Dr. Carvallo restored the façades to their original appearance and replaced the 19th-century landscaped grounds with a terraced garden that is unique in the world (see main entry).
M.H. Property of M. Robert Carvallo. ⌂

Commune of Pont-de-Ruan
■ VONNES ■

Attributed to Horace Desjardins, controller-general for war and mayor of Tours, who bought the estate in 1612, this château consists only of a ground floor and an upper story lit by large stone casement dormers. It contains several monumental chimneypieces,

carved with scrolls, foliage, and military trophies. Balzac described it under the name of Clochegourde, home of the Comtesse de Mortsauf, in *Le Lys dans la vallée*.
I.S. Private property. Visible from the road.

LOIRET

Commune of Gien
■ ARRABLOY ■

Attributed to Pierre d'Arrabloy, who was chancellor of France in 1316, but in ruins since the 16th century, this château is an interesting example of architecture at the beginning of the 14th. The fairly low *enceinte* encloses an area over 98 feet square, with polygonal towers at the corners and an entrance keep that is quite well preserved.
I.S. Private property.

■ BEAUGENCY ■

Erected at the beginning of the 12th century by Raoul de Beaugency, a companion of Godefroi de Bouillon in the Holy Land, the *donjon* is a superb Romanesque tower, 118 feet high, whose large windows were created at the end of the Middle Ages. In 1442, Dunois, the "Bastard of Orléans" (see Châteaudun), settled in the neighboring château and had a comfortable residence constructed, which was finished around 1530 by his grandson, Cardinal de Longueville. Turned into a workhouse in the 19th century, the whole complex has now been restored.
M.H. Property of the commune. The "Château Dunois" houses the Musée des Arts et Traditions Populaires de l'Orléanais.

■ BELLEGARDE ■

A stronghold mentioned as early as the 12th century, Soisy devolved under Charles V to Nicolas Braque, counselor and chamberlain to the King, who built the great quadrangular *donjon*. Sold in 1645 by the Duc de Vitry, the estate was acquired by Roger de Saint-Lary, who obtained permission to transfer to it his duchy of Bellegarde. The property passed by inheritance to the Duc d'Antin, governor of Orléans and director of the king's buildings, who added the main building, service quarters, fountains, and garden in the French manner. Sold in 1844, the estate was split up and several buildings were demolished. Some fine early 18th-century paneling is now in the town hall.
M.H. Property of the commune and of different private owners. ▲ There is free access to the approaches to the *donjon*.

Gien

Commune of Ardon
■ BOISGIBAULT ■

In the 16th and 17th centuries this was a manor belonging to the Mauberts, lawyers and counselors to the high court of Orléans. The present château, with its chapel consecrated in 1752, was built by the Charpentier family, tax receivers and then presidents of the *Cours des aides* or Customs Court. Although it became the seat of an estate of some 7,400 acres, this attractive house is an example of authenticity without ostentation. In the 19th century, the Marquis de Gasville turned the property over entirely to hunting.
I.S. Property of the de Mathan family. The façade is visible from the road.

Bellegarde

Commune of Ligny-le-Ribault
■ BONHOTEL ■

Constructed between 1875 and 1882 from plans by Louis Parent for M. du Pré de Saint-Maur, this impressive building is one of the best examples of the great houses erected in Sologne at the end of the 19th century. Designed around a vast English-style hall, two stories high, it presents a décor inspired by the Renaissance.
Private property. Barely visible from the road.

■ LA BUSSIÈRE ■

Lying on the edge of an immense body of water, the château owes the regular plan of its terreplein, with round towers at the corners, to the 13th century. With a few exceptions, the present buildings go back to the reconstruction effected around 1560 by Jean du Tillet, secretary to the king and recorder to the parliament of Paris. Altered in the course of the centuries that followed, they were restored—and in certain cases rebuilt—at the end of the Second Empire by the Comte de Chasseval. The fine, monumental outbuildings were the work of Charles du Tillet, Marquis de La Bussière (1679), president of the *Grand Conseil*, and the forecourt with its grilles and pavilions, of his son Jean Baptiste (d. 1714). Le Nôtre is said to have been responsible for the design of the large park and the lake. Since 1962 the château has housed interesting collections devoted to fishing and fish.
I.S. Private property. ▲

Commune of Chilleurs-au-Bois
■ CHAMEROLLES ■

The château was built by Lancelot du Lac, governor of Orléans, cupbearer and chamberlain to Louis XII, between 1495 and 1536, the date of his death. Acquired in 1672 by the Marquis de Saumery, governor of Chambord, and in 1764 by Claude-Guillaume Lambert, a parliamentarian of Paris who was controller-general of finances under Brienne, the château was in a state of abandon in 1987, when it was bought by the governing body of the Department. It has since been completely restored.
Altered and enlarged in the 18th and 19th centuries, the buildings occupy three sides of a quadrangular terreplein with round towers at the corners, accessible through a detached *châtelet* or gatehouse. On the left, the early 16th-century seigneurial residence has an elegant pierced gallery at ground level reminiscent of the Louis XII wing at Blois. The back looks out on to gardens that have recently been restored.
M.H. Property of the Department of Le Loiret. ▲

■ CHÂTEAUNEUF-SUR-LOIRE ■

Established in the 11th century, but entirely rebuilt at the beginning of the 14th by Philippe le Bel (the Fair), the château was altered and enlarged between 1396 and 1407 by Louis d'Orléans. Surrounded by fortifications, it was a vast mansion, with terraced gardens and a large pavilion designed as a bathhouse or steam rooms. Somewhat neglected and then ravaged during the wars of the Fronde, the château was completely restored in the second half of the 17th century by Louis Phélypeaux de La Vrillière, master of ceremonies of the Orders of the King. Acquired by the Duc de Penthièvre on the eve of the Revolution, the château was demolished beginning in 1801, with the exception of certain pavilions, galleries, and outbuildings.
I.S. Property of the Department of Le Loiret. The offices of the town hall and the Musée de la Marine de Loire are installed in the what is left of the château. There is a fine funerary monument to Louis Phélypeaux de La Vrillière in the church.

■ CHEVILLY ■

The château was erected around 1732 by Nicolas Hatte, receiver-general of finances, and for a few years was the property of Étienne de Silhouette, who was briefly controller-general of finances (1759). It was enlarged and altered from 1763 on by the intendant of Orléans, Perrin de Cypierre, who made it the setting for a brilliant life. Majestic grounds lined with trees lead up to the entrance façade, which is decorated with Louis XV sculptures comparable in quality to the carved paneling in the chapel. Altered in the Neoclassical period, the façade at the back looks out on a flower garden *à la française*, decorated with urns and with statues symbolizing the parts of the world.
I.S. Property of the Baronne Bazin de Caix de Rembures. Not visible from the road.

■ COMBREUX ■

Owned by Antoine Picot under Louis XIII and by Augustin Picot, Marquis de Dampierre and General of the Armies of the North at the beginning of the Revolution, the château was a classical brick-and-stone building, surrounded by moats. Around 1890, the Duchesse d'Estissac, *née* Ségur, had it heightened and enlarged, and considerably "enriched" the decoration on its façades, giving it an astonishing neo-medieval silhouette, picturesque and florid.
Private property. Visible from the road.

Commune of Saint-Cyr-en-Val
■ CORMES ■

On an ancient feudal motte, or mound, Pierre Briçonnet, pantler to the queen and treasurer-general for the province of Milan, had an elegant building erected about 1520. The remarkable state of preservation of its sober Renaissance décor is due to the quality of its stone.
I.S. Private property.

■ LA FERTÉ-SAINT-AUBIN ■

Erected by the de Saint-Nectaire family, the château consists of a late 16th-century wing, the main building, which dates from the 1620s and remains unfinished, and vast outbuildings—stables and coach houses—added around 1675 (see main entry).
M.H. Property of M. Jacques Guyot. ■

■ GIEN ■

Remodeled by Anne de Beaujeu, daughter of Louis XI and regent during the minority of Charles VIII (1483–91), the large residence overlooking the town was inspired by Le Plessis-lès-Tours (q.v.). Its brick façades have little stone and as a result few sculptures, but there is a rich geometric decoration in glazed bricks. The property of Chancellor Séguier in 1654, bought by the Department of Le Loiret in 1823, and restored by Lisch at the end of the Second Empire, the château was for a long time used as public offices. Restored once again, after the bombardments and fire that ravaged the town in 1940, it has been the home of the Musée International de la Chasse since 1952.
M.H. Property of the Department. ■

■ MEUNG ■

Property of the bishops of Orléans, the château owes its origin to the quadrangular keep, flanked by round towers, that was erected against the church by Manassès de Garlande (1146–85). The nucleus of the present building goes back to Manassès de Seignelay (1207–21), but after being damaged during the Hundred Years War, it was restored and enlarged by François and Christophe de Brilhac (1473–1514). The large classical façade was the work of Mgr Fleuriau d'Armenonville (1716–33). The chapel and summerhouse were due to Mgr de Jarente, who probably employed Le Camus, the architect of his friend Choiseul (see Chanteloup).
I.S. Property of M. François Tachon. ■

Commune of Ouzouer-sur-Trézée
■ PONT-CHEVRON ■

Built for the Comte Louis d'Harcourt, in the middle of a vast estate of woods and ponds, the château is one of the best examples of those great mansions erected towards the end of the 19th century that were based on classical 18th-century models. In one of the outbuildings is an interesting Gallo-Roman mosaic, discovered in 1962.
I.S. Property of the Comtesse Robert de La Rochefoucauld. ■

■ SAINT-BRISSON-SUR-LOIRE ■

Burned down in 1135 by Louis VI le Gros (the Fat), the château of Saint-Brisson was rebuilt by the counts of Sancerre. Erected on a fairly steep promontory overlooking an old branch of the Loire, the construction took the form of a regular hexagonal, with alternately round and quadrangular towers at the corners. The premier barony of Berry, Saint-Brisson belonged in the 15th century to Jean de Courtenay, and then to Guillaume Jouvenel des Ursins. In 1567, Guillaume Séguier, king's attorney to the parliament of Paris, acquired the seigniory from the Duchesse de Nevers. His grandson Louis, provost of Paris, obtained its elevation to marquisate under Louis XIV. One of Louis's descendants was an ardent disciple of Jean-Jacques Rousseau.
Partly demolished at the Revolution and altered several times during the 19th century, the château was bequeathed to the commune by the daughter of the last Marquis de Saint-Brisson.
I.S. Property of the commune. ■
Access to the park is free.

La Ferté-Saint-Aubin

Commune of Olivet
■ LA SOURCE ■

Owned by the de Meulles family in the 17th century, the estate of La Source was rented from 1720 on by Lord Bolingbroke, former minister of Queen Anne, who had the château rebuilt and the gardens redesigned. Acquired in

Sully-sur-Loire

1784 by Thomas de Montaudouin, the château passed through several hands in the 19th century. Since 1959, it has been the property of the Department and of the town of Orléans.
The grounds of La Source are the site of the university and of a public garden.

■ SULLY-SUR-LOIRE ■

Reconstructed towards the end of the 14th century by Raymond du Temple, King Charles VI's architect, for Guy de La Tremoïlle, grand chamberlain to the Duc de Bourgogne, the *donjon* is one of the biggest and best preserved of the period. It has a superb timbered roof. Rebuilt in the 15th century, the towers and the living quarters surrounding the courtyard were altered and reinforced at the beginning of the 17th century by Maximilien de Béthune, Duc de Sully and prime minister under Henri IV (see main entry).
M.H. Property of the Department. ■

Commune of Baccon
■ LA TOUANNE ■

Built in the 17th century by the Bigot de Saint-Pierre family, who came from the Caux region, the château owes the Neoclassical appearance of its façade on the courtyard side to alterations effected around 1830.
I.S. Private property. Visible from the road.

Commune of Sennely
■ LA TURPINIÈRE ■

Surrounded by moats expanded into broad stretches of water and approached by a large courtyard of outbuildings, this country house, with its pleasingly colored brickwork, presents all the charm and authenticity of the old dwellings of Sologne. Erected at the end of the 16th century by the family of La Rable, it was altered around 1774 by Jérôme Massuau de Villars, ancestor of the botanist Augustin Prouvensal de Saint-Hilaire.
I.S. Property of M. Pierre de Dreuzy. Not visible from the road.

LOIRE ET CHER

Commune of Saint-Agil
■ ALLERAY ■

Built in the 15th and 16th centuries by the de Vendômois family, on a motte or mound surrounded by water, this picturesque manor house juxtaposes two pavilions in ashlar and red sandstone, two half-timbered residential wings, and a stair tower completely covered with scales of oak. In the 18th century it was attached to the estate of Saint-Agil.
I.S. Private property. Not visible from the road.

■ AVARAY ■

Construction of the château was started in 1621 by Jacques de Bésiade, who retained the corner towers of a 13th-century building, and finished in 1736 by Claude-Théophile de Bésiade, second Marquis d'Avaray, man of war and diplomat. The reception rooms were restored at the beginning of the 19th century by Claude-Antoine de Bésiade, created Duc d'Avaray as a mark of gratitude for the loyalty of his son to the cause of Louis XVIII.
I.S. Private property. Not visible from the road.

Commune de Cellettes
■ BEAUREGARD ■

Around 1550, Jean du Thier, secretary of state to Henri II, had the château constructed out of a late 15th-century house. He commissioned the paneling of the famous *cabinet des grelots*, with its décor of small bells, from Scibec de Carpi. The extraordinary design of the central gallery, executed from 1617 onwards, came from Paul Ardier, his son, and his granddaughter. It consists of 327 historical portraits, walls and beams painted by the Mosniers, and a floor entirely covered with costly Delft tiles.
M.H. Private property. ■

Commune of Mehers
■ BEAUREGARD ■

This small manor house constitutes one of the best examples of an early 16th-century country seat. Flanked by a stair tower with a low door and a *bretèche*, or corbeled chamber, the building has minuscule watchtowers at the corners. It retains a beautiful dormer window decorated with flamboyant arcades.
I.S. Private property.

Commune of Feings
■ BELLYVIÈRE ■

Erected at the beginning of the 16th century, this manor house decorated with fine Renaissance dormer windows consists of four rooms with chimney-pieces and a closed courtyard. M. Pierre Moriceau, who had it restored from 1962 on, created an interesting garden in the spirit of the Renaissance.
I.S. Property of M. Jean-Marie Legendre. Barely visible from the road.

Beauregard

■ BLOIS ■

Blois is probably the château that best evokes the succession of kings who took up residence in the Loire Valley. The Renaissance, already discernible in the Louis XII wing, came to flower in that of François I, celebrated for its pierced spiral staircase and for its façade with loggias, in the Italian style. The Gaston d'Orléans wing marks the beginning of the complete reconstruction of the château planned by Louis XIII's brother (see main entry).
M.H. Property of the town of Blois. ■

Blois

Commune of Gué-du-Loir
■ BONAVENTURE ■

At the end of François I's reign, Nicolas Girard de Salmet, surgeon to the King, in the service of Antoine de Bourbon, organized some joyous festivities at the "Bonaventure *au gué*" (at the ford). Fortified by his son, the manor house passed by marriage to the ancestors of Alfred de Musset, who made a drawing of it in 1822. Abandoned and turned into a farm, the buildings have been restored from 1962 onwards.
I.S. Property of the Magnant family. Barely visible from the road.

Commune of Josnes
■ CERQUEUX ■

Secluded in a hamlet at the head of the river Beauce, the château is a classical building, erected around 1660 by Paul Texier, attorney to the parliament of Paris and lieutenant in the seneschalship of Orléans.
I.S. Property of the Mestivier family. Visible from the road.

■ CHAMBORD ■

Probably designed by Leonardo da Vinci, this extraordinary building, one of the greatest and most original in France, was erected beginning in 1519 on the orders of François I. Its construction, unfinished at the King's death in 1547, was continued by Henri II, and taken up again at the end of the 17th century by Louis XIV (see main entry). The park of Chambord, a hunting preserve, is the largest space enclosed by walls that exists in France.
M.H. Property of the state. ■

■ CHAUMONT-SUR-LOIRE ■

Razed in 1465 by order of Louis XI, the château was rebuilt by Pierre d'Amboise (d. 1473) and his sons Charles (d. 1481) and Georges, the last named being Cardinal-Legate and chief minister of Louis XII. Altered in the 18th century by the shipowner Le Ray, it was restored from 1875 onwards by Sanson for the Prince and Princesse Amédée de Broglie (see main entry).
M.H. Property of the state. ■

Chaumont-sur-Loire

■ CHÉMERY ■

The château was rebuilt by the de Husson family in the second half of the 15th century, on the site of a structure mentioned in the 13th. In the 16th century it became the residence of René de Beauvilliers, younger son of

Chambord

the Comte de Saint-Aignan (q.v.), gentleman of the royal bedchamber and pantler to the king. Turned into a farmhouse by the dukes of Saint-Aignan, it has been undergoing restoration for the last ten years or so.
I.S. Private property. ■

■ CHEVERNY ■

Constructed around 1630 by a colleague of Salomon de Brosse for Henri Hurault, Comte de Cheverny, and his wife, Marguerite Gaillard de La Morinière, the château is a building typical of the early 17th century, with wings and pavilions juxtaposed under independent roofs. It is famous for its magnificent reception rooms, whose polychrome decoration goes with a fine collection of furniture, tapestries, and art objects (see main entry).
M.H. Private property. ■

■ CHITENAY ■

Built in the 1750s by Guy-Guillaume Mahy, receiver of taxes for the county of Blois and the duchy of Vendôme, the château was sold soon after by his son Thomas, Marquis de Favras. The latter was to perish in 1790 in the Place de Grève, probably a victim of the ambitions of the Comte de Provence.
The estate became the property of the Abbé d'Espagnac, who amassed an enormous fortune in supplying the army and was guillotined with the followers of Danton. It was acquired in 1846 by the Guilhem de Pothuau family, who had the interior of the château restored.
I.S. Private property. Not visible from the road.

Cheverny

■ COUR-SUR-LOIRE ■

In 1492, Jacques Hurault, Louis XI's treasurer for war, acquired the Cour estate and erected a building facing the Loire, flanked by a polygonal stair turret. Governor of Blois under Louis XII, Hurault enlarged the château and had the choir of the nearby church rebuilt. In the hands of the Marquis de Rostaing in the 17th century and taken over in 1671 by the de Menars estate, the château was again enlarged in 1829, when the Marquise de Bellemare, ancestress of the present owners, added a low wing.
I.S. Private property. Visible from the Loire.

■ LA FERTÉ-IMBAULT ■

Established before the year 1000 by Imbault, son-in-law of the Comte de Blois, Thibault le Tricheur, and destroyed by the English in 1356, the château was rebuilt at the beginning of the 16th century by Jean d'Étampes. In 1562, it was destroyed again, this time by the Huguenots. Beginning in 1627, it was re-erected in its present form for Jacques d'Estampes, Marshal of France and ambassador to London.
The château is an impressive brick-built house, highlighted with the occasional detail in stone, which owes to its medieval substructure the corner towers and vertical lines that give it character.
I.S. Private property. Visible from the road.

Commune of Suèvres
■ LES FORGES ■

Built at the end of Louis XII's century by Jacques Lebordier, this manor house consisted of a large rectangular pavilion crowned with machicolations, containing a great hall and three rooms. Enlarged in the 17th century by Étienne de Verneson, it has recently been restored.
I.S. Property of M. and Mme Jacqmin. Visible from the road.

■ FOUGÈRES-SUR-BIÈVRE ■

Begun around 1480 by the de Refuge family, royal officials from Blois, and finished in the early 16th century, the small château of Fougères was one of last medieval-type buildings to be erected in the Loire Valley. Deprived of its fosses and turned into a spinning mill in the 19th century, it has now been restored (see main entry).
M.H. Property of the State. ■

Commune of Villefrancoeur
■ FRESCHINES ■

Jean-Baptiste Bégon of Blois, receiver general of finances at Montauban, had this impressive classical building erected beside a modest, late 15th-century manor house, which still exists. The château owes its fame to its second owner, Antoine-Laurent Lavoisier, tax collector, gunpowder director, and above all chemist of genius. Returned to his widow after his execution, with its estate of almost 1,500 acres, then sold again, the château belonged for a long time to the de Vibraye family.
I.S. Private property. Not visible from the road.

Commune of Authon
■ LE FRESNE ■

The château was erected from 1766 onwards for François-Joseph Le Grand de Marizy, grand master of the waterways and forests of Burgundy and the Franche-Comté. The architect was Amoudru, who came from the Franche-Comté and was a pupil of Louis Blondel. General Perron, who acquired the property in 1805, had distinguished himself in India in the service of the Great Mogul, fighting the English. Constructed in the limestone of Touraine, the château is a compact building, with service quarters laid out around majestic views. The landscaped park was altered by Duchêne about 1900.
M.H. Property of the Marquis de Brantes. Not visible from the road.

Commune of Souday
■ GLATIGNY ■

Martin du Bellay, the brother of the Cardinal, had the château erected and probably received Rabelais there as a guest on several occasions. Acquired in the 17th century by the de Chennevières family, the estate passed at the end of the 18th to Bochard de Saron, presiding judge, an astronomer and mathematician, who was guillotined in 1794.
This impressive building rises on the edge of the plateau, its tall, brick-built façade highlighted with glazed details. Within is a stone staircase *à rampes droites*. The monumental stables were added around 1895 by the d'Arsigny family.
Property of the Vicomte Olivier de Pontbriand. Visible from the road.

Commune of Huisseau-sur-Cosson
■ LES GROTTEAUX ■

Consisting of a ground floor with an upper story lit by large dormer windows, under a steep roof *à la française*, this charming house was the work of Jean Daguier, son of a lieutenant-general of the high court of Blois (c. 1615–20). Anne Daguier, who inherited it in 1627, had married Guillaume Ribier, counselor of state and trusted adviser of the Queen Mother, Marie de' Medici, who refused Richelieu's offer of a seat on the King's council, preferring to devote himself to literary studies.
I.S. Private property. Not visible from the road.

Commune of Monthou-sur-Cher
■ LE GUÉ-PÉAN ■

Begun around 1540 by François Alamand, president of the audit chamber, with a 15th-century dwelling as his point of departure, construction was not finished until the mid-17th century, when the château was completed by Charlotte Alamand and François de Picques. The beautiful landscaped grounds were laid out in the 19th century in a broad wooded valley by the Baron de Cassin (see main entry).
M.H. Property of M. de Kéguelin. ■

Commune of Neuvy
■ HERBAULT ■

Appointed superintendent of works at Chambord, Nicolas de Foyal took advantage of an interruption in the building program in 1524 to employ some of the workmen to reconstruct the church at Neuvy, and probably also his château of Herbault. In the 17th century, Raymond Phélypeaux, secretary of state and one of Richelieu's most highly regarded diplomats, gave the château greater presence by adding long outbuildings organized around the courtyards and views. Several times restored in the 19th and 20th centuries, Herbault has kept much of its charm, including *corps de logis* and large towers in brick highlighted with glazed motifs, capped by steeply pitched roofs.
I.S. Private property. Barely visible from the road.

■ LAVARDIN ■

Rebuilt at the end of the 12th century by Bouchard IV, Comte de Vendôme, the château withstood the siege laid by the Plantagenêts in 1188. Beginning in 1380, Catherine de Vendôme and Jean I de Bourbon, Comte de La Marche, transformed it into a veritable palace. The so-called truce of Lavardin was signed there by Charles VII in 1447. In 1589, the Prince de Conti ousted the members of the League after a three

Lavardin

Le Gué-Péan

weeks' siege, and had the place pulled down.
The ruins, which occupy a long triangular spur, stretch from the two towers of the gatehouse to the superb keep, built in the 12th century but greatly altered in the 14th and 15th centuries.
M.H. Private property. The Club du Vieux Manoir has organized several campaigns to clear and excavate the site.

Commune of Verdes
■ LIERVILLE ■

Like the medieval towers to which they are attached, the main buildings have recently been stripped of their neo-Gothic and neo-Renaissance décor, added during the overall restoration undertaken under Louis-Philippe by the Marquis de Courtarvel. Louise de Théligny, daughter of Admiral de Coligny, withdrew to Lierville after the assassination of William the Silent, who was her second husband. The park was laid out in the 19th century by Chatelain.
Private property. Barely visible from the road.

Commune of Candé-sur-Beuvron
■ MADON ■

Formerly a residence of the abbots of Saint-Lomer and then of the bishops of Blois, the château owes its origins to the building in which Louis XII was received by Abbot Louis Pot in 1498 and 1505. Erected in the immediate vicinity around 1775, the present château was designed by the architect Collet for Mgr de Termont. Sacked in 1792, restored by the Marquise Amelot de Chaillou, it was given a very fine landscaped park by the Comte d'Etchegoyen, but disfigured in 1850 by changes to its roofs.
I.S. Private property. Visible from the road.

■ MENARS ■

Grandson of a master of the horse at Montlivault, Guillaume Charron became treasurer-general of the artillery and then of the military field mess. He had the château built from 1644 onwards and left it to his nephew Jean-Jacques, brother-in-law of Jean-Baptiste Colbert, who had it enlarged and the estate elevated to the rank of marquisate. From 1728 to 1732, King Stanislas Leszczynski took refuge there in the summer, escaping the unhealthy conditions at Chambord. In 1759, Madame de Pompadour acquired the property and engaged Gabriel to remodel the château and to add two service wings on the courtyard. At her death, Menars passed to her brother, the Marquis de Marigny, director of the King's buildings, who commissioned further alterations from Souffot, in particular the garden *fabriques*. In 1804, the château became the property of Marshal Victor, succeeded under Louis-Philippe by the Prince de Caraman-Chimay, who created an experimental college in the service quarters. Despite the ravages wrought by revolutions, changes in ownership, and restorations, Menars still has fine examples of an art of outstanding quality: the stone staircase; the decoration of the *salle du dais*, library, and boudoir; and gardens laid out in terraces as far as the Loire.
M.H. Private property. Visible from the road and above all from the opposite bank of the Loire.

Menars

Index

■ MESLEY ■

In 1589, René de Fromentières received Henri IV here for several days during the siege of Vendôme. Built on the edge of the Loir, the château went back to the Middle Ages. In 1732, Jean-François de La Porte, tax collector and senior official of the Compagnie des Indes, undertook construction of the existing château; the plans were by Jules-Michel Hardouin, nephew of the great Hardouin-Mansart, who had assumed responsibility for reconstructing the town of Châteaudun after the fire of 1723.
I.S. Property of the de Boisfeury family. Visible from the road.

■ MONTRICHARD ■

Established by Foulques Nerra, Comte d'Anjou, on a promontory created by two tributaries of the Cher, the château was rebuilt in the 12th century by Hugues d'Amboise. Louis XI acquired it from his descendants in 1461 and had two residential buildings erected. Taken by the League in 1589, the château was partially dismantled on the orders of Henri IV. Still more than 65 feet high (it was originally over 78), the *donjon* is a handsome square structure, of medium size (it measures 49 feet along the side) but constructed with care.
M.H. Property of the town. ■

Montrichard

Commune of Onzain

■ MONTEAUX ■

Erected around 1515 by Odin de Montdoucet, who had been chief barber and valet in ordinary of the Duc d'Orléans—the future Louis XII, the original pavilion, with its flanking turrets, was enlarged in the 17th century by a long *corps de logis* at right angles. The entire structure was remodeled in 1772 by the Marquis de Montebise, ancestor of the present owner.
I.S. Private property. Not visible from the road.

Commune of Mur-de-Sologne

■ LA MORINIÈRE ■

This charming country seat, which dates from the 1540s, was the work of René des Roches, Ronsard's brother-in-law. Acquired at the beginning of the 17th century by Gallerand Gaillard, it was restored early in the 20th by Paul Besnard, regional poet and painter. Its brick-and-stone construction is typical of the Louis XII period, but the design of its windows recalls that of François I, more particularly Chambord. Located inside the main building, the turret of the spiral staircase rises above the great roof.
Private property. Not visible from the road.

Commune of Chailles

■ LA PIGEONNIÈRE ■

Built between 1635 and 1643 by Nicolas Carré de Chambon of Blois, light horseman of the king's guard and master of the goblet in the royal household, this attractive house is approached by a terrace framed with corner pavilions, overlooking the valley of the Loire. At the end of the 18th

Le Moulin

century, it was owned by the history painter Jean-Baptiste Robin. He was succeeded in 1850 by Eugène de Froberville, who had the right wing transformed into a remarkable library and music salon, frequented by Offenbach and other well-known artists.
I.S. Private property. Visible from the road.

Commune of Marolles

■ PEZAY ■

The château is a very long building with small towers at the corners, erected from 1680 onwards by Jacques Belot, lieutenant to the bailiff's court of Blois, and enlarged by his son. It belonged in the 18th century to Jean Masson, called the "Marquis de Pezay," a celebrated wit who gave lessons in tactics to the future Louis XVI before dying in exile on his estate. The property was acquired in 1783 by Presiding Judge de Salaberry, and sold after his death on the scaffold.
Private property. Barely visible from the road.

■ LE PLESSIS-SAINT-AMAND ■

Begun in 1600 by Bernard de Fortia, counselor to the parliament of Paris, construction of the château was completed only around 1638 by de Fortia's daughter-in-law, Anne de La Barre. At the end of the 18th century the château was owned by the financiers Charles Goury and Étienne Sanlot, who allowed the physicist Charles to conduct experiments there. It is a fine Louis XIII building, with a large lateral wing in the Neoclassical style.
I.S. Property of Mr. Cummings. Not visible from the road.

■ MONTLIVAULT ■

The main body of the existing château, which was enlarged under Louis XV by a low wing, was built on land acquired in 1593 from Jean d'Estampes, lord of Valençay, by Jacques Le Maire, master of the exchequer. In 1760, Marie-Angélique Le Maire brought the estate in marriage to Eléonor Guyon de Diziers, great-grandson of Mme Guyon, the celebrated foundress of Quietism, and ancestress of the present owner.
I.S. Private property. ■

Commune of Lassay-sur-Croisne

■ LE MOULIN ■

Constructed between 1480 and 1506 by Philippe du Moulin, counselor and chamberlain of Charles VIII, the château is an interesting brick building that belongs to the last phase of Gothic. It was carefully restored at the beginning of this century (see main entry).
M.H. Private property. ■

Commune of Couture-sur-le-Loir

■ LA POSSONNIÈRE ■

At the end of the 15th century, Olivier Ronsart and Jeanne d'Illiers built a manor house flanked by a polygonal stair turret, along with a small chapel and service quarters partly hollowed out of the rock. Their son Loys, gentleman of Louis XII's establishment, frequently accompanied the court to Italy. He added an original decoration to the façades, combining sculptures inspired by the Italian Renaissance with maxims engraved in Latin. His son, the future poet Pierre de Ronsard, was born at La Possonnière in 1524 and spent the first eleven years of his life there. Converted to agricultural use in the 17th century, the manor house has now been restored. It contains a fine Renaissance fireplace.
M.H. Property of M. Bernard Hallopeau. ●

Commune of Fontaines-en-Sologne

■ LA RAVINIÈRE ■

François de Refuge, pantler to the Duc d'Orléans, had this country house erected following a deal made in 1499 with a local *bricquier*. Under Henri IV, Daniel de Launay enlarged the original building with short wings and with pavilions. The extensive restoration undertaken about 1930 unfortunately sought to return the whole to its medieval style, but the timber-framed service quarters have kept their character intact.
Private property. Barely visible from the road.

Commune of Thoré-la-Rochette

■ ROCHAMBEAU ■

A descendant of Mathurin de Vimeur, falconer to the Duc de Vendômois, and of Christine de Belon, lady of Rochambeau in the early 16th century, Jean-Baptiste de Vimeur, Marquis de Rochambeau, headed the expeditionary force sent by Louis XVI to aid the American insurgents and led them to victory at Yorktown. Marshal of France in 1791, he died in 1807 at his château of Rochambeau. Erected on the edge of the Loir at the foot of a cliff, the original building was enlarged by the Marshal with two large lateral pavilions.
I.S. Property of the Comte and Comtesse Michel de Rochambeau. Not visible from the road.

Commune of Thenay

■ LE ROGER ■

Erected at the end of the 15th century, enlarged and decorated in the 16th, the house at Le Roger retains a marvelous Renaissance gallery, unfortunately walled up and in some disrepair. The building is attributed to Jean-François de La Roque, once the playmate of the future François I and the unfortunate *maître d'oeuvre* on Jacques Cartier's third expedition to Canada.
Private property. Not visible from the road.

Commune de Fresnes

■ ROUJOUX ■

Built in about 1540 by Pierre de Villebresme, the château owes its present appearance to the alterations effected around 1620 by René de Maillé-Bénehart, captain of the hunt in the county of the Maine, and Dorothée Clausse, his wife. Practically abandoned by the end of the 18th century, it was restored from 1889 onwards by Gabriel de La Morandière.
Private property. ●

■ SAINT-AGIL ■

The château was erected around 1475 by Odard de La Vove on the foundations of a fortified structure going back to the 12th and 13th centuries. On the courtyard side it has the typical appearance of manor houses in the Perche, with its polygonal stair tower and corbeled turret. Its fine Renaissance gatehouse, built in brick and framed by tall round towers (c. 1510–29), was due to Antoine de La Vove, Canon of Chartres. In 1726, Louis Angran, an inspector of the Compagnie des Indes, acquired the estate and altered the living quarters to meet contemporary taste.
I.S. Property of the Comte Jean de Lussac. ●

■ SAINT-AIGNAN-SUR-CHER ■

Established in the 11th century by the counts of Blois on a promontory overlooking the town and the Cher Valley, the medieval château was largely laid waste in the course of the Hundred Years War. Its rebuilding was undertaken in the 15th century by the de Husson family, and continued in the 16th with the erection of two Renaissance wings, the work of Claude de Husson and his daughter, Louise de Beauviller. Captain of the guard of Gaston d'Orléans, François de Beauviller (d. 1687) became governor of the Touraine, a member of the Académie Française, and Duc de Saint-Aignan. "Forgotten" by his successors, who were occupied at court, the château was extensively restored in the 19th century. The chapel and polygonal "keep" were added under Louis-Philippe, followed by the stair pavilion in 1868 and the northwest façade in Renaissance style.
I.S. Private property. There is access to the forecourt.

■ SAINT-DENIS-SUR-LOIRE ■

In 1340, Jean Hurault acquired the seigniory of Saint-Denis. His heirs held important offices first with the dukes of Orléans and then with the French kings from the 15th to the 17th centuries. In 1812, the last of the Huraults of Saint-Denis married the Comte de Beaufort-Créqui, ancestor of the present owners.
Built on a terrace at mid-slope from the edge of the plateau, the château owes its classical façade to work done slightly before the Revolution. Nearby is an interesting seigniorial chapel on two levels, decorated with 17th-century mural paintings.
I.S. Private property. Visible from the embankment of the Loire.

Saint-Aignan-sur-Cher

Commune of Huisseau-sur-Cosson

■ SAUMERY ■

Once owned by Jacqueline Salviati, sister of the celebrated Cassandre de Ronsard, the Saumery estate passed by marriage to the La Carre family at the beginning of the 17th century. Originally from Navarre, the family is known for its association with the post of captain-governor of Chambord, which was held by several of its members from 1642 to 1777.
Situated at the very gates of the Chambord estate, the château is a vast residence, altered around 1755 and in the

last century. The service quarters, which are more interesting, consist of an entrance that is medieval in appearance, a large pavilion with incurved façades, used as a gatekeeper's lodge, and two long outbuildings with an original well.
I.S. Private property. The château is occupied by a clinic.

■ SELLES-SUR-CHER ■

Established in the 10th century by Thibault le Tricheur, the château occupies a strategic site at the point where the Châteauroux road crosses the Cher. Rebuilt from 1212 onwards by Robert de Courtenay, it was a mighty triangular structure bounded by the Cher, a small tributary, and a broad fosse. There, in 1492, Georges de La Trémoille received Charles VII, who mustered the army assigned to liberate the Orléans region. Sacked in 1563 by the Huguenots, the château was acquired in 1604 by Philippe de Béthune, the younger brother of the Grand Sully (see Sully-sur-Loir), who erected a magnificent residence designed by Jacques II Androuet Du Cerceau. Demolition of the main building, begun in 1787, was almost complete under the Empire.
The monumental entrance, with its structural wall and high lateral pavilions, is one of the most remarkable architectural compositions of the early 17th century. The pavilion on the right, the last bays of the main building (the only ones to survive), and the old *châtelet* or gatehouse overlooking the countryside contain interesting remains of the decoration executed for Philippe and Hippolyte de Béthune: painted coffered ceilings, carved paneling, and chimneypieces.
M.H. Property of the family of Le Moulinet d'Hardemare. ■

■ TALCY ■

Bernard Salviati, a banker connected with the court, acquired the Talcy estate in 1517 and some years later obtained leave to build on it a solidly fortified residence. In 1562, his son Jean received Catherine de' Medici, who met there with the Prince de Condé. Cassandre, his sister, was the inspiration for one of Ronsard's most beautiful works. As for Diane, his daughter, she fed the passions of the fierce Agrippa d'Aubigné, who expressed his ardor in *Le Printemps*, and again at the end of his life, in *Les Tragiques*. Restored and modernized around 1770 by Jérémie Burgeat, a parliamentarian of Metz, the château still had an outstanding collection of furniture when it was acquired by the state in 1930.
With machicolations at the top and turrets at the corners, the big *donjon*-porch leads to the courtyard, which is given a human touch by the existence of a charming well and a gallery (early 16th century). Also to be seen are a remarkable dovecote, a press-house, and a box garden.
M.H. Property of the State. ■

Commune of Cheverny
■ TROUSSAY ■

Constructed at the end of the 15th century and beginning of the 16th, this charming country house passed in 1828 to Louis de La Saussaye, rector of the Lyons Academy and a member of the Institut de France, who made it the setting for his collection of objects left from the demolition of the great Renaissance dwellings of the region. Notable items are a capital and a superb Renaissance door from Bury, a porcupine and polychrome stained-glass windows from the Hurault and Sardini town houses in Blois, grisailles attributed to Jean Mosnier, paving, paneling, and some interesting furniture.
Private property. ■ A small museum of regional folk art, the Musée des Arts et Traditions Populaires Solognotes, is installed in the outbuildings.

Commune of Tour-en-Sologne
■ VILLESAVIN ■

Built between 1526 and 1537 by Jean Le Breton, *géneral* of finances and later controller-general for war, this small Renaissance château has the distinction of being derived from Roman "villas" (see main entry).
M.H. Private property. ■

Commune of Saint-Lubin-en-Vergonnois
■ LA VRILLIÈRE ■

A simple farmhouse in the 15th century, La Vrillière owes its fame to the Phélypeaux, counselors to the bailiff's court at Blois in the 16th century. Louis Phélypeaux, who built the château, became secretary of state in 1629 and then grand master of ceremonies of the Orders of the King. In 1770, one of his descendants, who was living at Châteauneuf-sur-Loire (q.v.), had the domain elevated to duchy.
Private property. Not visible from the road.

Talcy

MAINE ET LOIRE

Commune of Saint-Sulpice-sur-Loire
■ L'AMBROISE ■

In 1436, Foucquet du Merle acquired from Jehan Benoist the house and property of "Lambrèze." In 1555, Simon de Maillé, Archbishop of Tours, inherited them from his brother, Philippe de Maillé-Brézé. On the archbishop's retirement to L'Ambroise some years later, he began the construction of a vast residence, which was continued by his successors Jean des Vignes (1598–1614), Jean de Loubes (1614–68), and in particular Jean Chérouvrier des Grassières (1702–32), naval inspector in Brittany.
The *corps de logis* was built on to two older towers. The main door still has its handsome Louis XIII leaves, carved with masks and lion's heads. In the chapel is an early 18th-century retable. The outbuildings bear the arms of Simon de Maillé and his monogram, as well as slate cartouches engraved with Latin maxims.
I.S. Property of the Comtesse d'Orglandes. The château overlooks the Loire Valley.

■ ANGERS ■

Erected by Saint Louis on a promontory already occupied in Roman times, this enormous fortress served as the residence of the dukes of Anjou in the 14th and 15th centuries, when reconstruction of the living quarters, chapel, and outbuildings took place. Despite the loss of their crowning features in the 16th century, the château's seventeen towers are still a splendid sight. The museum displaying the *Apocalypse Tapestries* was erected within the boundaries of the *enceinte* (see main entry).
M.H. Property of the town of Angers. ■

Commune of Chaudefonds-sur-Layon
■ LA BASSE-GUERCHE ■

Erected around 1450 by Jean de Beauvau, lord of La Roche-sur-Yon,

enlarged in the 16th century by René de Sanzay, and turned over to agricultural use in the 18th, the château of La Basse-Guerche had been spared the ravages of revolution and war, and constituted one of the most remarkable dwellings to survive from the period of King René. Pleasantly situated in the midst of vineyards, in a bend of the river Layon, it had retained not only its main building, with its towers, dormer windows, and watchtowers, but also its chapel, gateways, and *enceinte*, with towers at the corners and moats surrounding it. After World War II, extensive repairs were needed. In the more than forty years that have elapsed since then, despite the formal protection of the Monuments Historiques, the consequences of neglect have become practically irremediable.
I.S. Private property.

■ BAUGÉ ■

Established in the 11th century, destroyed at the end of the 14th, and rebuilt in 1430 by the Duchesse d'Anjou, the château was one of the principal residences of King René, who had the large existing structure erected at a cost of 1,400 gold *écus*. On 26 September 1455, Guillaume Robin, mason and "master of the king's works in the land of Anjou," was appointed contractor for the masonry, with its four spiral staircases, thirty-five windows, and twenty-six fireplaces. The three heads carved below a watchtower are said to represent those of the chief masons.
The building has kept its outward appearance, reinforced by extensive restoration. The interior layout of its rooms, on the other hand, has been completely altered by the installation in the 19th century of the town hall, the law court, a theater, a museum, and the engines of the local fire brigade. The only elements to survive are the vaults of the royal chapel and a *cabinet* or small study, and the remarkable "palm-tree" vaulting over the main, spiral staircase.
M.H. Property of the town. ■ Visible from the main square of Baugé, the old market place filled in with material from the *enceinte* in the 19th century.

Commune of Saint-Martin-de-la-Place
■ BOUMOIS ■

Built in the vicinity of the priory of the Madeleine, established in 1118, the original château—described as "*l'hostel, chastel et forteresse de Bommaye, situé en l'isle du Plessis*"—was destroyed by the English during the Hundred Years War. Still in ruins in 1498, it was rebuilt by René de Thory, who erected a chapel in 1520 (consecrated in 1546). René Gaultier, advocate-general to the Grand Conseil and superintendent of Fontevrault, bought Boumois in 1613. René Berthelot, auditor in the audit chamber of Brittany, who acquired it in 1673, was the ancestor of Gilles Aubert and Aristide Dupetit-Thouars, the first a botanist, the second a seaman who died a hero at the battle of Aboukir. After the estate was sold in 1833, the château was stripped of most of its chimneypieces and the stained-glass windows in the chapel (acquired by a museum in the United States). Its restoration has been under way since 1980.
Approached through a vast courtyard enclosed by an old curtain wall, the main building presents a picturesque juxtaposition of pavilions and turrets with dormer windows decorated with Flamboyant motifs. The façade at the back is framed by round towers. In addition to a superb Renaissance door in carved wood, the château has an important collection of 15th- and 16th-century arms and armor, together with furniture and paintings of the same period.
M.H. Property of M. Pierre Mieg de Boofzheim. ■

Commune of Bouzillé
■ LA BOURGONNIERE ■

Constructed from 1445 onwards by Jacques du Plessis and Alnette Chapperon, lady of La Bourgonnière, the château passed to the D'Acigné family and later to the Cossé-Brissacs. Acquired in 1670 by Louis de Grimaudet, it was burned down in 1793 and replaced under the Directory by a vast Neoclassical residence.
The old château survives in a great *donjon*, crowned with machicolations and surmounted by a high lookout tower, as well as a tower, a curtain wall, and remains of the living quarters. Spared by the incendiaries, the chapel is a remarkable 16th-century building, richly decorated with sculptures of outstanding quality.

Boumois

It contains a fine Renaissance retable and a large crucifix, on which the figure of Christ is clothed and crowned.
M.H. Property of the De Saint-Pern family.

■ BRÉZÉ ■

Established in the 11th century and destroyed in the course of the Hundred Years War, the château passed in the 15th century to Gilles de Maillé, chamberlain of King René, who was allowed to renew the fortifications. Construction was actively pursued by Guy de Maillé, governor of Anjou under François I, and in 1565 his son Artus had the honor of receiving at Brézé Charles IX and his mother, Catherine de' Medici. Richelieu favored the marriage of his niece Claire-Clémence de Maillé-Brézé with the Grand Condé, who sold the château in 1682 to Thomas Dreux de La Galissonnière, counselor to the parliament of Paris and grandfather of the Marquis de Dreux-Brézé, grand master of ceremonies under Louis XVI and Louis XVIII.
Surrounded by very deep fosses dug into the limestone hill, the château owes the look of its curtain walls to the "embellishments" added between 1838 and 1865 by the architect René Hodé (see Challain-la-Potherie). The main building has kept its Renaissance appearance.
I.S. Property of Comtesse Bernard de Colbert-Cannet, *née* Dreux-Brézé. Barely visible from the road.

Bauge

Commune of Brissac-Quincé
■ BRISSAC ■

Rebuilt by Pierre de Brézé in the mid-15th century and dismantled at the end of the 16th, the château owes its present appearance to construction undertaken between 1611 and 1621 by Charles II de Cossé, which was never completed. The principal façade is one of the most characteristic examples of Baroque tendencies in French architecture at the beginning of the 17th century (see main entry).
M.H. Property of the Marquis de Brissac. ■

■ CHALLAIN-LA-POTHERIE ■

Erected between 1847 and 1854 for Comte Albert de La Rochefoucauld-Bayers, counselor-general, the château is one of the earliest works of René Hodé, a native of Anjou, and certainly his most important. The "flowery" Gothic style that flourishes in the upper reaches of the main building, in the orangery nearby, and in the amazing water tower contrasts with the martial air of the towers framing the impressive gatehouse. Within, the château retains almost intact its décor of neo-Gothic paneling. The design of the landscaped park has been attributed either to Chatelain or to the Comte Paul de Choulot.
I.S. Property of the Société Européenne de Gestion Immobilière. Visible from the road.

Brissac

Commune of Fontaine-Guérin
■ MANOIR DE CHAPE ■

In 1586, Ambroise Guérin sold the seigniory of Chape to Jean Cupif de La Robinaie, who was mayor of Angers from 1602 to 1604 and who had this charming house erected. At the corners of the long *corps de logis* are quadrangular turrets constructed in a checkerwork of brick and limestone. Two of the turrets house spiral staircases, the other two *cabinets*. Located on the second floor because of the marshy nature of the site, the great hall still has its monumental fireplace and a floor paved in terracotta tiles. The manor house, which for a long time was used as a barn, has just been restored.
I.S. Private property. Visible from the road.

Challain-la-Potherie

Commune of Brion
■ CHAVIGNÉ ■

Jean de Launay acquired the Chavigné estate in 1580. In 1660, Jeanne de Caignou, widow of Gabriel de Launay de La Mothaye, settled there and had the château and chapel rebuilt. Through the marriage of her granddaughter Catherine de La Bretesche the property passed into the hands of the Baudrys d'Asson, who left it to live in Poitou. In 1788, Louis de Launay de La Mothaye bought Chavigné back. In 1806, his daughter Adélaïde, soon after her marriage with Scévole de Livonnière, had the château—by then in considerable disrepair—pulled down and replaced by a more modest dwelling, conceived in the spirit of the 18th century and probably erected by the builders of Montgeoffroy (q.v.).
I.S. Property of the Comte de Livonnière.

Commune of Vihiers
■ LE COUDRAY-MONTBAULT ■

In the 12th century, Geoffroy de Pontail established a church and priory within the *bayle*; in the 13th century, the Papins had a fortified castle erected; at the end of the 15th century, Pierre de La Haye and Catherine de Beaumont added new living quarters, completed by their son Honorat, vidame of Chartres in 1506. In 1793, after the retreat of the Vendeans, Santerre had the buildings sacked and in part burned down.
Surrounded by moats, the terreplein contains the 13th-century ruins and the 16th-century château, the latter built of bricks fired on the spot, with framing and decorative elements highlighted in limestone. At a distance are the remains of the chapel: a 12th-century nave in ruins, a 15th-century choir, and above all a side chapel with a remarkable *Entombment of Christ*, the funerary effigy of Honorat de La Haye, and traces of murals.
M.H. Private property.

■ DOUÉ-LA-FONTAINE ■

The medieval remains in the middle of the commune are those of the oldest *donjon* known in France. Measuring about 75 feet long and 56 wide, it was erected around the year 900, and then heightened and furnished with a motte in the 11th century.
M.H. Property of the commune. Visible from the road.

■ DURTAL ■

Durtal

Established in about 1040 by Geoffray Martel and later owned by the Mathefelons, the château passed by marriage to Olivier de Husson, chamberlain of Charles VII, and then to François de La Jaille, son-in-law of the minister Jean Bourré (see Vaux and Le Plessis-Bourré). In the 16th century, François de Scépaux, Maréchal de Vieilleville, who was to die of poisoning, received Henri II there, followed in 1571 by Charles IX, his mother, and his brothers. In 1620, Louis XIII visited the château as a guest of Marshal de Schomberg. Sold in 1808 by the Duc de La Rochefoucauld-Liancourt, the place is now a home for the aged. Its high 15th-century towers and the huge *corps de logis*, which dates from the 16th and 17th centuries, dominate the town and the course of the river.
Recent alterations have brought to light some interesting murals in the old gallery: large hunting and battle scenes, accompanied by flowers, landscapes, and the monogram of Henri de Schomberg (end of the 16th century).
M.H. Property of the town.

Commune of Grez-Neuville
■ LA GRANDIÈRE ■

In 1788, Palamède de La Grandière embarked on the construction of the present château, whose Louis XVI façade is attributed to Victor Mars of Anjou. Work was interrupted by the Revolution, and it was not until the Second Empire that the upper parts of the building, roofs, and dormer windows were completed. Surviving from the earlier structure are the vast pentagonal terreplein, surrounded by broad moats, and the picturesque entrance keep, framed by round towers and capped by a steep, pyramidal roof (16th century).
I.S. Property of Vicomte Jacques de La Grandière, representing the twenty-third generation since Luc de La Grandière (13th century).

Commune of Champagne
■ LA HAMONNIÈRE ■

This charming country house owes its name to Antoine Hamon, squire, who owned the property in the 15th century and may have erected the modest dwelling overlooking the courtyard: built in the local schist, but highlighted in pale limestone, it has kept its crocketed dormer windows and its turret with spiral staircase.

The rest of the structure goes back to work done by Antoine Le Gay from about 1560 to 1575, the date engraved in a cartouche. The most interesting part is a corner pavilion, as impressive as a tower, armed with stepped loopholes and crowned by corbels where the three heraldic parrots (*papegays*) of the family of Le Gay are represented. From the 17th century onwards, the owners limited themselves to keeping up the main fabric. With its conversion into a farmhouse and the loss of its chapel during the Revolution, La Hamonnière was threated with ruin after World War II. It was restored about twenty years ago.
M.H. Property of M. Hubert Dehollain.

Commune of Saint-Aubin-de-Luigné
■ LA HAUTE-GUERCHE ■

In 1452, Charles VII granted leave to modernize the fortifications of the château, which had been built in the 13th century on a schistose promontory commanding the course of the river Layon. Owned by the Goulaines in the 16th century and the Barrins de La Galissonnière in the 17th, it was burned down in 1793 by General Moulin. A team of volunteers, which received an award in 1970, made it possible to clear the vast *bayle*, with the chapel and granaries, the barbican and its watchtowers, as well as the château itself, with its *corps de logis* and remaining three corner towers.
I.S. Private property.

Commune of Villebernier
■ LAUNAY ■

King René of Anjou bought the château from Étienne Bernard, former treasurer of Duc Louis II, his father, in 1444. He made a gift of it to his wife, Isabeau de Lorraine, stayed there for long periods in the summers, and organized the famous Pas de Saumur festivity there in 1447. After the Queen's death, he gave it to his second

Montreuil-en-Bellay

wife, Jeanne de Laval, who kept it until 1498.
More than a château, Launay consists of a complex of living quarters and outbuildings arranged around two large courtyards, displaying the "elegant fantasy" of the King. Several elements escaped the excessive restoration work undertaken around 1830 by the Marquis d'Armaillé, notably the galleries in the outer courtyard, the vaults of the chapel, and remains of painted decoration in certain rooms.
I.S. Private property.

Commune of La Chapelle-sur-Oudon
■ LA LORIE ■

Built in the 17th century by René Le Pelletier, grand provost of Anjou, the château was altered and enlarged at the end of the 18th century by Charles Constantin, Marquis de La Lorie, who was responsible in particular for the execution of the great *Salle de Marbre* (see main entry).
M.H. Property of the Marquise de Saint-Genys. ■

Commune of Denée
■ MANTELON ■

This classical residence was erected on the eve of the Revolution by the Anjou contractor Victor Mars for Jean-François Daburon de Mantelon, counselor to the audit office of Nantes, on an estate that had belonged to the Tillons and to the family of Lefebvre du Tusseau.
Private property.

■ MARTIGNÉ-BRIAND ■

Owned by the Briants in the 11th century, the fief of Martigné was a dependency of Montreuil-Bellay. Around 1400 the château passed by marriage to the family of La Jumellière, and was rebuilt in the early 16th century by René de La Jumellière. In 1565, Charles IX and his court were received there by Baudouin de Goulaine. Repeatedly sold, it was destroyed by a fire at the end of the 18th century.
Apart from the romantic aspect of its ruins, bristling with gigantic fireplaces, the decoration of its façades makes it one of the most remarkable examples of sculpture in the period of Louis XII. Especially spectacular is the carving on the window bays and on the loggia, which recalls that of Blois.
I.S. Princesse de Croÿ, *née* Chaponay, has donated the château to the Association "La Jeanne d'Arc." Clearly visible from the vicinity of the church, whose choir is the old fortified seigniorial chapel.

La Hamonnière

Commune de Bouzillé
■ LA MAUVOISINIÈRE ■

Originally a simple manor house dependent on La Bourgonnière (q.v.), the château was built beginning in 1664 by Olivier Subleau, treasurer-general of the navy. Acquired in 1760 by the Comte de Chavanne, it was fortunately spared by the Republican soldiers, who took refuge there following their liberation at Saint-Florent. In 1860, Comte Anatole de Gibot had it restored and installed eighteen statues from Richelieu either on the façades or in the park, the latter redesigned by MacAllister.
M.H. Private property.

■ LA MÉNITRÉ ■

Erected by King René of Anjou, La Ménitré belonged to his second wife, Jeanne de Laval, who there restored the charter of the county of Beaufort on 2 May 1471. Long used as a farmhouse, the building retains two residential wings at right angles, with gables and dormer windows decorated with floral motifs, and a vaulted chapel, lit by a large Gothic window.
I.S. Private property.

Commune of Beaucouzé
■ MOLIÈRES ■

The house and its entrance keep, both flanked by turrets, were built early in the 16th century by Jean de Tinténiac, Abbot of Saint-Aubin in Angers, who received François I there in 1518. In 1523, he retired to Molières, where he died several years later.
Private property.

Commune of Mazé
■ MONTGEOFFROY ■

Built between 1772 and 1776 by Marshal de Contades from plans by the architect Barry, the château, with its high Louis XVI façade, stands in profile at the end of a majestic vista. It is one of the rare *ancien régime* dwellings to have preserved intact the décor and furnishings of its rooms (see main entry).

M.H. Property of the Marquis de Contades. ■

■ MONTREUIL-BELLAY ■

Established by Foulques Nerra on the site of a Gallo-Roman town, facing the Poitou, the château contains within its 13th-century *enceinte* a group of 15th-century buildings: the gatehouse, the "new château," a canons' residence, the collegiate church, and an older kitchen. It was restored in the 19th century (see main entry).
M.H. Property of Mme Xavier de Thuy. ■

Commune of Coutures
■ MONTSABERT ■

The property of Guy de Pommerieux at the beginning of the 14th century, the château devolved upon Jeanne de Laval, who in 1371 married the renowned Bertrand du Guesclin. Altered at the end of the 16th century by the d'Aubigné family, who added a chapel, it was restored in the 19th by the architect René Hodé (see Challain-la-Potherie).
I.S. Private property. Barely visible from the road.

■ MONTSOREAU ■

Built around 1455 by Jean de Chambes, member of King Charles VII's council, the château is one of the few in the Loire Valley to be situated at the very edge of the river. The adventures of Françoise de Chambes and Bussy d'Amboise under Henri III have been rendered famous by Alexandre Dumas (see main entry).
M.H. Property of the Department. ■
The château has long been the home of a military museum, the Musée des Goums Marocains.

Commune of Saint-Martin-des-Bois
■ LE PERCHER ■

Erected in the 1500s by Simon de Tinténiac, formerly gentleman carver to King René of Anjou, and Jean de Tinténiac, Abbot of Saint-Aubin, the château comprises two residential wings at right angles, furnished with a high stair tower recalling that of the Barrault house at Angers, and handsome dormer windows whose sculpture typifies the evolution from Gothic to Renaissance style.
Abandoned by the family of de Tinténiac as early as the reign of François I, the château was acquired in the 17th century by Guillaume Bautru. Antoine Walsh bought it with Serrant (q.v.) in 1749, but sold it in turn to the Marquis de Scépaux, ancestor of the present owners.
M.H. Property of M. François Colas des Francs.

Commune of Saint-Barthélémy-d'Anjou
■ PIGNEROLLES ■

The heir of a real dynasty founded around 1680 by François Avril, squire

Pignerolles

of the royal stables, Marcel Avril de Pignerolles was the director of the Académie d'Equitation of Angers at the end of the 18th century. The riding academy, as famous as it was prosperous, numbered among its pupils the De Witt brothers, William Pitt, Buffon, and the future Duke of Wellington. It was for Marcel Avril, in about 1780, that the architect Bardoul de La Bigottière built Pignerolles, a "folly" often compared with the Petit Trianon for the elegance of its Neoclassical lines.
Under the Occupation, the château was selected by Admiral Doenitz as the headquarters for the defense of the Atlantic coast, and it became the hub of an impressive network of blockhouses and underground shelters.
Turned into a lodging center after World War II and for a long time neglected, Pignerolles has recently been restored by the town of Angers. There is a Neoclassical orangery in the

Montsoreau

Le Plessis-Bourré

old gardens, together with some statues and large mythological urns.
M.H. Property of the town of Angers. The park is open to the public. The interior of the château has been completely altered in recent years to allow for the installation of a Musée de la Communication.

Commune of Grézillé
■ PIMPÉAN ■

Bertrand de Beauvau, who acquired the estate in 1535, was counselor and chamberlain to Charles VII and president of the audit chamber of Paris before entering the service of King René of Anjou, who made him grand master of his establishment and seneschal of Anjou. It was he who had the château erected beginning in 1443, and whose device accompanies the wonderful paintings on the vaults and walls.
The main building, the vaulted passage of the entrance pavilion, and the lateral curtain wall surmounted by machicolations were included in an ambitious program of reconstruction undertaken in the 17th century by the Baron de Cholet and continued by René Robin de La Tremblaie, which remained unfinished.
M.H. Private property. Barely visible from the road.

Commune of Écuillé
■ LE PLESSIS-BOURRÉ ■

Built around 1465-70 by Jean Bourré, minister of Louis XI and in the King's confidence, the château is one of the most remarkable dwellings of the late Middle Ages, still protected by curtain walls and moats, but graced by galleries and opening on to a large courtyard (see main entry).
M.H. Private property. ■

■ LE PLESSIS-MACÉ ■

Macé du Plessis, who left the château his name, retired to the abbey of Saint-Serge at Angers in the 11th century. In the 15th, Catherine de La Haye-Joulain, lady of Le Plessis-Macé, made a gift of the seigniory to her cousin Louis de Beaumont, chamberlain of Kings Charles VII and Louis XI, seneschal of the Poitou, who had the château rebuilt and received Louis XI there in 1472. René du Bellay, his successor, welcomed François I and the court to Le Plessis-Macé in 1518; in 1598, Henri IV was three times the guest of his grandson René II. Barons and then marquises of Le Plessis, the Du Bellays were obliged in 1678 to sell the property to Guillaume Bautru. The château was acquired in 1749 by Antoine Walsh (see Serrant), and its interior restored by the Comtesse Walsh beginning in 1868. In 1967, M. Philippe Langlois-Berthelot donated it to the Department.
Rebuilt in the 15th century on the 12th-century foundations and in ruins since the 17th century, the quadrangular keep occupies a motte surrounded by broad fosses. The living quarters and outbuildings date from the same period; in dark schist highlighted by limestone, they are backed against the old, irregular *enceinte*. Worth noting are the gable end of the large chapel (c.1470), which contains interesting 15th-century woodwork, the sharp-angled stair turret, and a curious balcony resting on immense carved consoles.
M.H. Property of the Department of the Maine-et-Loire. ■

Commune of Distré
■ POCÉ ■

The château merits attention above all for its entrance keep. Consisting of two round towers linked by a fore-part, it still has three long grooves for the old drawbridges and its machicolated top with a trilobed lintel.
Private property. Visible from roads in the vicinity.

■ LES PONTS-DE-CÉ ■

Established by Foulques Nerra to control navigation on the Loire, rebuilt at the beginning of the 13th century, and restored in the 15th, the château occupied a major strategic position, commanding the bridges across the river, which is split here by islands into three branches. It fell into the hands of the Huguenots and was then entrusted by Henri III to his cousin Henri de Navarre in 1589. On 7 August 1620, the château was again at the center of a battle, in which the three thousand men of the Queen Mother, Marie de' Medici, were pitted against the troops of her son, King Louis XIII. There remains a polygonal tower with machicolations at the top and a triangular buttress.
I.S. Property of the town. The château houses the Musée des Coiffes d'Anjou.

Commune of Louresse-Rochemenier
■ LE PONT DE VARENNE ■

In the early years of the 16th century, on an estate formerly owned by the abbey of Saint-Florent, Jean Thoisnon erected a château surrounded with wide moats fed by the brook of Varenne. Altered on the inside at the beginning of the 19th century, it retains several corner towers, windows with flamboyant decoration, and a chapel with ogive vaults.
I.S. Private property. Visible from the road.

Commune of Chazé-sur-Argos
■ RAGUIN ■

Built in the early years of the 17th century with a 15th-century manor house as its starting point, the château is known in particular for its "gilded rooms," decorated around 1650 by order of Guy du Bellay for the marriage of his son Antoine (see main entry).
M.H. Property of Dr. Henry Quinque. ■

Pocé

Commune of Daumeray
■ LA ROCHE-JACQUELIN ■

On the site of the château where Guillaume Le Maire, Bishop of Angers in 1300, had been born, François Richer de Neuville had an attractive residence built about 1735; its thoroughly classical appearance recalls that of a town house. The Louis XVI paneling inside is still intact.
I.S. Private property.

■ SAUMUR ■

First erected in the 10th century, rebuilt by Louis I, Duc d'Anjou, in the third quarter of the 14th, turned into a barracks and then a prison, the château was restored at the beginning of the 20th century. It is the site of the Musée des Arts Décoratifs and the Musée du Cheval (see main entry).
M.H. Property of the town of Saumur.
■

Commune of Saint-Georges-sur-Loire
■ SERRANT ■

Begun in the second half of the 16th century by the de Brie family, the construction of this impressive residence was continued after 1640 by Guillaume Bautru and completed in the early 18th century. Restored in the 19th by Théobald Walsh and then by the Duc de La Trémoïlle, the château houses one of the finest collections of furniture and art objects in the region (see main entry).

Saumur

M.H. Property of the Prince de Ligne-La Trémoïlle.

Commune of Chemillé
■ LA SORINIÈRE ■

Burned down and rebuilt on several occasions, the château retains two towers and above all a chapel with admirable murals painted for Jean de Brie and Françoise de Mathefelon under François I.
M.H. Private property.

Commune of Doué-la-Fontaine
■ SOULANGER ■

The château, destroyed at the Revolution, was built in the years 1771–74 for J.F. Foullon by Cailleau of Saumur, from plans attributed to the architect Jacques-Denis Antoine, who was responsible for the Hôtel de la Monnaie in Paris. The only parts to survive are the foundations of the living quarters, an entrance lodge, and above all the stables, evidence of an architecture full of power and monumentality. Recently saved from total ruin, these remains are undergoing extensive restoration and are due to become the setting for a museum of folk art and traditions.
M.H. Property of the commune.

Commune of Soeurdres
■ LA TOUCHE-MOREAU ■

This manor house, built of brick with framing elements in limestone, dates from 1552. It now serves as a Protestant church. The chapel goes back to the end of the 15th century.
M.H. Private property

Commune de Fontaine-Guérin
■ LA TOUR-DU-PIN ■

Nothing is known of the builder of this extraordinary dwelling, a real château in miniature, built in the 15th century and today in ruins. Framed by small square towers crowned with machicolations, its elegant façade is arranged in relation to a polygonal stair tower, surmounted by a square terrace borne on graceful corbels.
I.S. Private property.

Commune of Miré
■ VAUX ■

The small château of Vaux, which goes back to the 1450s, was the first of Jean Bourré's residences. His wife, Marguerite de Feschal, is said to have lived there while Le Plessis-Bourré was under construction. Completely abandoned early in the 20th century, this charming building has been rescued from an already advanced state of ruin in the years since 1970.
Erected on an artificial island, the *corps de logis* is flanked by two corner towers, a square fortified tower, and a polygonal stair turret. It is framed on the courtyard side by two low wings—the chapel and the service quarters—that meet two half-towers reduced in height. The bulk of the building is in local schist, with the cornices, framing elements, *bretèche* or small corbeled chamber, and ogive lintels in the limestone used for Le Plessis.
M.H. Private property.

Commune of Seiches-sur-le-Loir
■ LE VERGER ■

Named Marshal of France in 1475, Pierre de Rohan, lord of Gié, was one of the four men appointed to govern during Louis XI's last illness. Head of the King's council under Louis XII, disgraced by Anne de Bretagne, de Rohan was exiled to the château of Le Verger, which he had just had built. This magnificent residence, one of the finest to be erected in the early years of the Renaissance, was pulled down beginning in 1776 by the Prince de Rohan-Guémené. All that remains are the towers and the buildings around the forecourt.
I.S. Private property.

MAYENNE

Commune of Meslay-du-Maine
■ LES ARSIS ■

Erected on two sides of a rectangular terreplein, the main building faces an impressive quadrangular keep, the fortified summit of which goes back to the period of Henri IV. Construction of the château, between 1565 and 1622, is attributed to Charles de Cervon, whose successors continued operations into the 18th century.
After the death of Jean-Baptiste de Montesson in 1769, the estate of Les Arsis was acquired by Joseph Duchemin de La Jarossaie, a banker of Laval. With the marriage of his daughter, it passed to Marcel Avril de Pignerolle, head of the riding academy of Angers (see Pignerolles) and ancestor of the present owner.
I.S. Private property.

Commune of Vaiges
■ AUBIGNÉ ■

Made of reddish ashlar, with a stair turret and Flamboyant dormer windows, this manor house is the work of François d'Aubigné, who built the chapel in 1521. Under Henri IV, René d'Urban added certain exterior fortifications. Long since turned into a farmhouse, it is in the process of being restored.
Private property. Visible from the road.

■ CRAON ■

Erected from 1773 to 1779 by the architect Pommeyrol for the Marquis d'Armaillé, the château is one of the most remarkable examples of the Louis XVI style in the west of France. It is surrounded by a beautiful landscaped park (see main entry).
M.H. Property of Comte Louis de Guébriant.

Commune of Daon
■ L'ÉCOUBLÈRE ■

The haunt of birds of prey known as *escoubles*, if the etymology of the name is to be believed (the modern French for kite is *écoufe*), this 16th-century country seat owes its fortified appearance and defenses to the marauding bands that roamed the region of Château-Gontier during the Wars of Religion. Framed by towers, the gatehouse leads to a polygonal terreplein surrounded by broad moats. Erected about 1535, enlarged about 1570, and remodeled in the 17th century, the main building is the work of the de Salles family. Originally from Normandy, the family had been settled in Anjou since the marriage of Philippe de Salles, page of the Comte d'Alençon, with Denise de Nogen, lady of "L'Escoublère," around 1370.

On the Renaissance wellhead, a verse from the Psalms engraved in 1570 implores the peace of God. On the gatehouse, another inscription recalls the passage of the fierce Chouan Joseph-Just Coquereau, killed in 1795 by Republican soldiers when attempting to flee his refuge.
I.S. Private property.

Commune of Saint-Georges-sur-Erve
■ FOULLETORTE ■

Built around 1570, the château must have been repaired and enlarged after the siege withstood in 1590 by Antoine de Vassé against the royal troops of the Prince de Conti. Acquired in 1711 by the Abbé Hardy, counselor to the parliament of Paris, it devolved by successive bequests to the Marquis de Saint Georges (d.1806) and then to the Comte de Malherbe.

L'Escoublère

An elegant staircase pavilion, decorated with columns and pilasters, juts out in the middle of the main building, which is of skillfully dressed stone. Corresponding on the left to the long, high wing on the right was once a gallery and a chapel, which have long since disappeared.
M.H. Private property. Visible from the road.

Commune of Ménil
■ MAGNANNES ■

In 1429, Jehan de Recappé became the owner of the Magnannes estate. In 1701, in recognition of his services with the army of the Rhine, Henri-François de Recappeé obtained the elevation of his seigniory—"one of the most beautiful in the province"—to marquisate. He had the château reconstructed as a handsome classical building in brick and stone, erected over vaulted cellars that go back to medieval times. The reception rooms have remarkable paneling, part of it dating from the Regency and part from 1730. Through the marriage of the daughter of the Marquis de Magnannes, the estate passed into the hands of the La Tullaye family, whose descendants kept it until 1923.
I.S. Private property.

Commune of Châtres
■ MONTECLER ■

Gentleman in ordinary of the bedchamber of King Henri IV, captain of fifty men-at-arms, and counselor of state, Urbain de Montecler was buried in 1641 in the church of Châtres. It is he who must have been responsible for erecting the château, beginning in 1600. Partly restored in 1910, the main building has a great deal of charm, with its deep walled moats and, behind the drawbridge, its entrance keep capped with a bell-turreted roof.
M.H. Private property. Barely visible from the road.

Commune of Saint-Quentin-les-Anges
■ MORTIER-CROLLES ■

Pierre de Rohan, Maréchal de Gié, was born in 1453 in this château, which had come into his family's possession through marriage with a Du Guesclin. It was de Rohan who had it entirely reconstructed at the end of the 15th century, before settling at Le Verger (q.v.) after he had been disgraced.

The vast trapezoidal terreplein (687 feet by 360 to 458 feet), with towers at the corners, embraces gardens, farmyard, and forecourt. Constructed like the chapel in alternate courses of brick and limestone, the gatehouse has considerable elegance. Restored on several occasions, the main building owes its picturesque appearance to its steeply gabled dormer windows, covered with sculptures. Even without its vaulted ceiling, which collapsed in the 19th century, the chapel is a Gothic structure, except for a side door and a Renaissance piscina (c.1510).
M.H. Private property. Barely visible from the road.

Commune of Saint-Oüen-des-Vallons
■ LA ROCHE-PICHEMER ■

With a dwelling going back to the 13th century as their starting point, Louis du Plessis and Françoise de Feschal had the château erected in the years 1550–60, as the classical Renaissance façade testifies. Begun by *le beau Jarzé*, exiled to his estates on Mazarin's orders, the decoration of the interior was continued by Charles de Montesson, who acquired the property in 1645. Marie de La Haye de Bellegarde, heir to La Roche-Pichemer, married Jean-François de Hercé who, as a widower, took holy orders and became Bishop of Nantes.
I.S. Private property.

La Roche-Pichemer

Le Rocher

Commune of Mézangers
■ LE ROCHER ■

Rebuilt at the end of the 15th century, the château owes its Renaissance façade to François de Bouillé, grand falconer of France under François I. The sculptures on the façade, carved in granite, are exceptionally well preserved (see main entry).
M.H. Property of the de Chavagnac family. ■

Commune of Chemazé
■ SAINT-OUEN ■

Guy Leclerc de Goulaine, confessor to Anne de Bretagne and to her daughter Claude de France, had the château of Saint-Ouen erected near a chapel dependent on the abbey of La Roë, of which he was titular Abbot. To the main building, constructed from 1495 onwards, he added a splendid square stair tower, whose Renaissance décor shows it to be later in date (c.1505–20). Several rooms have retained their handsome fireplaces, and the Abbé's bedroom still has it original vaulted ceiling. The château remained the property of the abbey of La Roë until 1792, and was restored in 1880 by Comte Henri de Sèze.
M.H. Property of Vicomte Gabriel du Pontavice.

SARTHE

■ ARDENAY ■

Built in the 17th century on medieval foundations, the château owes its appearance to the extensive alterations undertaken in the mid-18th century for Charles Huguet de Sémonville and his successor, Jean-Baptiste Le Prince, a wholesale chandler of Le Mans, who became mayor of the town in 1790. Inherited by the de Gastines family, who continued to own it until recent years, the château has just been completely restored.
I.S. Private property. Not visible from the road.

Commune of Bazouges-sur-le-Loir
■ BAZOUGES ■

Seat of a seigniory dependent on the barony of La Flèche, the château belonged to the de Champagne family from the 12th to the 14th century. Baudouin de Champagne was chamberlain to Louis XII and François I; Brandelis, Baron de Bazouges, seneschal of Anjou and Maine. Owned by the de Durfort family in the 17th century, it was acquired in 1762 by François Aumont, whose descendants kept it until 1910. M. Adrien Mithouard, the Symbolist poet, president of the municipal council of Paris, then acquired the château, which has remained in his family.
The main building was transformed in the 18th century, but the old entrance survives, with its big round towers, armed with gun loopholes, machicolations, and 15th-century dormer windows steeply gabled in limestone.
M.H. Property of M. and Mme François Serrand.

Commune of Roëzé
■ LA BEUNÈCHE ■

Probably built in the 14th century by Pierre de Saulnier, who owned a "lodging" there in 1387, the manor house owes its Henri II façade, with its interesting sculptures, to Claude de Jalesnes and his brother Guillaume, Archdeacon of the Dunois. Turned into a farmhouse when the neighboring château was erected, it has been restored since 1973.
I.S. Private property. Not visible from the road.

Commune of Précigné
■ BOIS-DAUPHIN ■

In the second half of the 15th century, Thibault de Montmorency-Laval had a large manor house erected near the remains of the château of Les Pointeau. Jean and René de Laval extended it with new living quarters, a staircase pavilion, and a gallery. Urbain de Laval, Marquis de Sablé, Marshal of France, and governor of Anjou, settled at Bois-Dauphin and lived there in great style. Abandoned after his death, acquired by Abel Servien and then by Colbert de Torcy, the building fell into disrepair, and most of it was pulled down when the château of Sablé (q.v.) was constructed. The present château consists of the large old stair pavilion and two wings built in 1860 and 1910 by the de Rougé family.
Private property.

Commune of Amné
■ LES BORDEAUX ■

Erected in the years 1745–50 by the Marquis de Courceriers, the château of Les Bordeaux is an extremely elegant Louis XV residence, with its side pavilions curving gracefully inward on the forecourt. The greater part of its interior decoration has been preserved. Long abandoned, it has been completely restored since 1965, and with considerable taste.
M.H. Private property. Not visible from the road.

Commune of Changé
■ LA BUZARDIÈRE ■

The construction of this large manor house is attributed to Guyon de Clinchamps in the middle of the 15th century. Enlarged by his son Jean at the beginning of the 16th, then under Louis XIII by Pierre Girard de l'Espinay, governor of Saint-Denis, the building lost its residential status early in the 19th century, when Charlotte de Murat and Raymond de Nicolay left it for Montfort-le-Rotrou. It is today in ruins, with the exception of the large chapel (early 16th century), which has recently been restored.
I.S. Private property. Not visible from the road.

Commune of Aubigné-Racan
■ CHAMPMARIN ■

"M. de Racan," wrote Conrart, "was born in a house called Champmarin, half of which is in Maine and the other half in Anjou." Honorat de Bueil, future lord of Racan and a fashionable poet under Louis XIII, was indeed born in this country seat in 1589. Taken over by the neighboring estate of Mangé since the 17th century, the manor house was not restored until the early years of the 20th.
I.S. Private property. Not visible from the road.

Le Grand-Lucé

■ COGNERS ■

Mentioned as early as the 13th century, the seigniory belonged for a long time to the Le Vasseurs, ardent supporters of the Reformation. Rebuilt by Joachim Le Vasseur, governor of the Vendôme in 1564, the château was enlarged in the 17th century by his successors, who held the title of Marquis de Cogners. In 1771, Louis-François de Musset had more than half of it pulled down, but his son made it his home and entertained his godson Alfred de Musset there.
Private property. Barely visible from the road.

Commune of Bessé-sur-Braye
■ COURTANVAUX ■

Jacques de Berziau, who became controller-general of finances under Charles VIII at the end of an outstanding career, acquired the fief of Courtanvaux in 1455 and had the château erected. With his daughter's marriage, the estate passed into the possession of the de Souvré family, whose most brilliant member, Gilles de Souvré, was Marshal of France under Henri IV. In 1662, Anne de Souvré brought the marquisate of Courtanvaux with her in marriage to Louvois, son of Chancellor Le Tellier and minister of Louis XIV. Residents of the château in the early 19th century were Baron Pierre de Montesquiou, grand chamberlain of Napoleon, and his wife, née Le Tellier, governess of the King of Rome. In 1882, it passed to Princess Marie Bibesco, who had the interior remodeled in the "historical" style then in vogue. Emptied of its furnishings and mementos, the château has been bought by the commune.
I.S. Property of the commune of Bessé-sur-Braye.

Commune of La Quinte
■ ÉPORCÉ ■

Erected around 1675 by Charles de Caillau on the site of a medieval "lodging," the château was altered in 1814 and enlarged by means of lateral pavilions. In 1926, it was furnished with a mansard roof better suited to the design of its façades.
Private property. The façade is visible from the road.

Commune of Lavenay
■ LA FLOTTE ■

René du Bellay, Baron de La Flotte, who had the château built around 1550, was the great-grandfather of the "divine Hautefort," for whom Louis XIII conceived a grand passion. Sold in the 18th century by the Marquis d'Hautefort, it was completely transformed in the Troubadour style by the Le Mans architect Delarue around 1840.
Private property. Visible from the valley.

Le Lude

Commune of Luché-Pringé
■ GALLERANDE ■

The house of Clermont, originally from Anjou, became owners of the Gallerande estate in 1210 and kept it for nearly six centuries. A simple "lodging" in 1265, the château had an important *donjon* in 1427, when it was besieged by the Connétable de Richemont. Rebuilt by Louis de Clermont-Gallerande (d.1477), chamberlain of King René, and embellished by his grandson, major-domo of François I, the château served as a place of refuge for a member of the Catholic League during the Wars of Religion. Sold in 1808 by the last Marquis de Gallerande, heavily restored by M. de Sarcé and then by Gustave de Beaumont, the château was left by Mlle de Ruillé to the Oeuvres Hospitalières of the Order of Malta.
Private property. Visible from the road.

■ LE GRAND-LUCÉ ■

Long owned by the de Coesmes family, the barony of Lucé was acquired in 1716 by Baron Pineau de Viennay, counselor to the parliament of Paris. In 1760, Jacques de Viennay, intendant of Alsace, engaged the architect Bayeux to rebuild the château in its entirety in magnificent, classical Louis XVI style. The *corps de logis*, graced on the garden side by a curved fore-part, is accompanied by numerous outbuildings: stables constructed in a crescent, coach-houses, service quarters, an orangery, and parterres laid out in series.
I.S. The château is today the site of a medical center. Visible from the road.

■ JUIGNÉ ■

Erected under Louis XIII by the family of Le Clerc de Juigné (see Verdelles), the château underwent radical restoration around 1936. The main building is framed by pavilions capped with steep independent roofs.
Private property.

■ LE LUDE ■

Rebuilt from 1468 onwards by the de Daillon family on the foundations of a medieval fortress, the château is famous for its Renaissance façade, attributed to Jacques de Daillon (c.1520). Remodeled on the eve of the Revolution by the Marquise de La Vieuville, it was restored in the 19th century (see main entry).
M.H. Property of Comte Louis-Jean de Nicolay.

■ MALICORNE ■

Malicorne

Owned by the de Chaource family since the end of the Middle Ages, the château passed in the early 17th century to Jean de Beaumanoir, Marquis de Lavardin and Marshal of France, who had the honor of receiving Marie de' Medici and the young Louis XIII. The Beaumanoir-Lavardins, governors of Maine, made it the center of a brilliant existence, celebrated by Madame de Sévigné. Their successors, the dukes of La Châtre, ruined themselves with good living and were forced to sell the estate to the Comte de Choiseul-Praslin, who had a large part of the château pulled down.
Private property. Visible from the road.

Commune of Parigné-le-Pôlin
■ LES PERRAIS ■

Erected in the mid-18th century by the Marquis de Broc, the main building is attached to an older wing, which was constructed about 1630 by Sébastien de Broc against round towers dating from the Middle Ages. At the end of the 19th century, the last Marquis de Broc had the château remodeled by the architect Sanson and the gardens laid out by the landscape designer Achille Duchêne.

Verdelles

Private property. The château houses the Collège Saint-Michel of Les Perrais. Not visible from the road.

Commune of Avoise
■ LA PERRINE-DE-CRY ■

Situated above the valley of the Sarthe, this picturesque manor house was rebuilt after the Hundred Years War and remodeled at the beginning of the 16th century.
Private property. Visible from the road.

■ PESCHESEUL ■

Destroyed in 1370 by Robert Knolles, the château was rebuilt after 1477 "with every kind of fortification" by Pierre de Champagne, a marshal under King René. Jean de Champagne, grand master of artillery, had new living quarters erected, and there received Henri II and later, in 1571, Charles IX. Under Louis-Philippe, M. Tessié de La Mothe had the château reconstructed in the Troubadour style. A new *corps de logis* was added at the beginning of this century.
Private property. Not visible from the road.

Commune of Saint-Ouen-en-Belin
■ LA POISSONNIÈRE ■

With quoins in dressed sandstone and dormer windows gabled in limestone, this manor house was evidently built with particular care. It has kept most of its mullioned windows, its great carved chimneypiece, its doors with ogive lintels, and interesting remains of paneling. Olivier Moreau, who married Huette Cordeau, lady of La Poissonnière, in 1417, is credited with its construction. The adjoining oratory probably goes back to the beginning of the 16th century.
I.S. Private property. Not visible from the road.

Commune of Poncé-sur-le-Loir
■ PONCÉ ■

At the foot of the ruins of the castle that dominated the Loir Valley, Jean de Chambray had a gentleman's residence erected at the end of the reign of François I. Its staircase is one of the most remarkable achievements of the French Renaissance (see main entry).
M.H. Private property. ●

Commune of Château-du-Loir
■ RIABLAY ■

Built at the end of the 15th century and beginning of the 16th by the Percauld family, the château belonged in the 17th century to the Couettes de La Couetterie and in the 18th to the Le Hayers, clerks at the salt warehouse of Château-du-Loir, who had the terrace and the interior remodeled. Destruction in the 19th century reduced the building to a single wing, flanked by a high spiral staircase whose stone lantern recalls, with due allowance for the different proportions, the lanterns of Tours Cathedral.
I.S. Private property.

■ SABLÉ ■

Owned by the de Beaumont, de Nevers, and de Craon families, and later by the dukes of Anjou and of Lorraine, the château of Sablé was once an important stronghold, remains of which survive in the gatehouse and some traces of the *enceinte*. Admirably sited above the river and town, the present château is an impressive classical building, erected in the closing years of Louis XIV's reign for Jean-Baptiste Colbert, Marquis de Torcy, from plans by Desgots. The entrance façade, at the back, was altered after 1870 at the behest of the Duc de Chaulnes, and left unfinished.
M.H. The château is the conservation center for the Bibliothèque Nationale (Centre Technique de Conservation des Documents). Visible from the town and the park. ●

Commune of Saint-Symphorien
■ SOURCHES ■

The old château was built at the end of the 15th century by Guillaume du Bouchet and Jeanne de Vassé, lady of Sourches. Beginning in 1761, Louis du Bouchet, high provost of France, erected a new residence on the site, designed by Gabriel de Lestrade. This huge building, completed in 1780, became the home of Olivier du Bouchet, future Duc de Tourzel, from 1815 onwards. He had the interior decorated and left the property to his sister, the Duchesse des Cars. Based on the traditional U-shaped plan, the château already has a Neoclassical look, with an attic and gently pitched roof.
I.S. Private property. Barely visible from the road.

Commune of Luché-Pringé
■ VENEVELLES ■

Rebuilt in the 15th century, enlarged in the 16th and 17th centuries, this manor house groups a number of structures full of picturesque charm in the midst of broad moats fed by the waters of the Aulne. The Venevelles estate was raised to marquisate in 1654 for the benefit of Henri-Paul d'Espaigne, governor of Belfort. After his assassination, his widow, Suzanne Le Vasseur, made the manor house one of the centers of the Protestant religion.
I.S. Private property. Not visible from the road.

Commune of Poillé-sur-Vègre
■ VERDELLES ■

At the end of the 15th century, Nicolas Leclerc de Juigné undertook the construction of a dwelling "in the form of a castle and fortress," which led to his prosecution by Hardouin de Maillé, his suzerain. Some years later, Colart Leclerc was authorized to complete the building, but without the moats and fortifications originally planned. Possibly he consoled himself for this loss by furnishing the upper parts with a particularly elegant decoration. Grafted to the corners of a square core are four towers and turrets, square or polygonal, armed with machicolations and watchtowers. After years of neglect, the château has been restored since 1975.
M.H. Private property. The approaches to the château are accessible to the public.

VIENNE

Commune of La Roche-du-Maine
■ PRINÇAY ■

Standing alone on a hill in an immense, bare landscape, the château is the work of Charles Tiercelin (1483–1567), who distinguished himself on the principal battlefields marking the reigns of François I and Henri II. Despite the presence of big, medieval-looking towers, this is one of the finest residences of France's First Renaissance, evident in the care devoted to its construction and the quality of its decoration. Particularly notable are the equestrian statue of the builder, placed in a niche above the entrance, the spiral staircase, the gallery with its coffered ceiling, and the great hall originally decorated with antlers. The château, which had long been abandoned, is now undergoing restoration.
M.H. Private property. ●

Bibliography

The literature on the Val de Loire, and especially on the "Châteaux of the Loire," is enormous. From this abundant resource, we recommend the following publications, mainly for their relevance to the particular theme and aim of the present volume.

Congrès archéologique de France, 1961: Maine; 1964: Anjou; Blésois-Vendômois; 1984: Bas-Berry (Indre).

Blunt, Anthony. *Art and Architecture in France, 1500-1700*. Harmondsworth, 1953.

Babelon, Jean-Pierre. *Châteaux de France au siècle de la Renaissance*. Picard: Paris, 1990.

Bourin, André. *The Châteaux of the Loire*. Paris, c.1973.

Cloulas, Ivan. *La Vie quotidienne dans les Châteaux de la Loire au temps de la Renaissance*. Paris: Hachette, 1986.

Du Cerceau, Jacques Androuet. *Les plus excellents Bastiments de France*. 1579. Édition Destailleurs, 1868.

Dunlop, Ian. *Châteaux of the Loire*. New York, c.1969.

Eydoux, Henri-Paul. *Monuments méconnus, Pays de Loire*. Librairie académique Perrin, 1983.

Fenwick, Hubert. *The Châteaux of France*. London: Robert Hale & Co., 1975.

Gébelin, François. *Les Châteaux de la Renaissance*. Paris, 1927.

———. *The Châteaux of France*. New York, c.1964.

Hautecoeur. Louis. *Histoire de l'architecture classique en France*. Paris, 1943 and later.

Hibbert, Christopher. *Châteaux of the Loire*. New York: Newsweek, c.1982.

Lesueur, F. *Le Château de Blois*. Paris, 1970.

Levron, Jacques. *Châteaux of the Loire*. New York: Nagel, c.1971.

Martin-Demézil, Jean. *Chambord*. Société française d'Archéologie.

Pérouse de Monclos, J.M., ed. *Architectures en région Centre*. Paris: Hachette, 1988.

Port, Célestin. *Dictionnaire historique, géographique et biographique de Maine-et-Loire*. Paris and Angers, 1874 and later.

Sarazin, André. *Manoirs et gentilhommières de l'ancienne France, Anjou*. Garnier, 1980.

Seydoux, Philippe. *Châteaux et manoirs du Blésois*. Éditions de la Morande. 1990.

———. *Châteaux et manoirs du Maine*. Éditions de la Morande, 1990.

———, and Thierry Ribaldone. *Châteaux de la Beauce et du Vendômois*. Éditions de la Morande, 1987.

———, and Thierry Ribaldone. *Châteaux et demeures de l'Orléanais*. Éditions de la Morande, 1989.

Soulange-Bodin, H. *Châteaux du Maine et de l'Anjou*. Paris, 1934.

Vacquier, J. *Les Anciens Châteaux de France, la Touraine*. Paris: Content, 1931.

Wheeler, Daniel. *The Châteaux of France*. New York: Vendome Press, 1979.

Wismes, Baron de. *Le Maine et l'Anjou, archéologiques et pittoresques*. n.d. (19th century).